Grant Wood's Studio
Birthplace of *American Gothic*

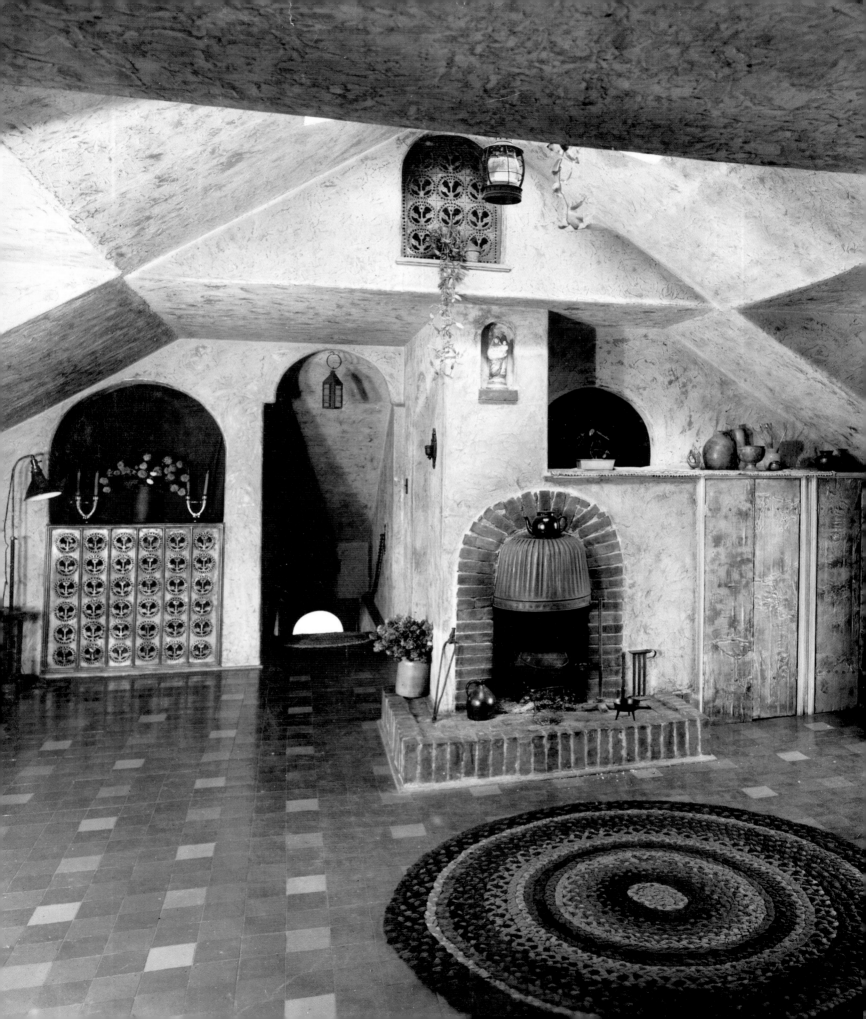

Grant Wood's Studio
Birthplace of *American Gothic*

Edited by Jane C. Milosch

With contributions by
Wanda M. Corn
James M. Dennis
Joni L. Kinsey
Deba Foxley Leach
Jane C. Milosch

CEDAR
RAPIDS
MUSEUM
of ART

Cedar Rapids, Iowa

PRESTEL
Munich · Berlin · London · New York

This book has been published in conjunction with the exhibitions: *Grant Wood at 5 Turner Alley*, presented at the Cedar Rapids Museum of Art, Cedar Rapids, Iowa from September 9 to December 4, 2005; and *Grant Wood's Studio: Birthplace of American Gothic*, presented at the Renwick Gallery of the Smithsonian American Art Museum, Washington D.C., from March 10 to July 16, 2006.

The exhibition was organized by the Cedar Rapids Museum of Art with major support from the Archer Daniels Midland Company, Henry Luce Foundation, and Hometown Perry, Iowa.

Front cover: Grant Wood, *American Gothic*, 1930 (detail). Oil on beaverboard, 29 $^1/_4$ × 24 $^5/_8$ in.
Friends of American Art Collection, All rights reserved by the Art Institute of Chicago and VAGA, New York, NY. 1930.934. Reproduction, The Art Institute of Chicago. See plate 3.

Back cover: Interior view of 5 Turner Alley, looking west, *c*. 1925. Courtesy of Figge Art Museum, Grant Wood Archives. Photo: John W. Barry. See page 78.

Frontispiece: Interior view of 5 Turner Alley, looking east, *c*. 1925 (detail). Courtesy of Figge Art Museum, Grant Wood Archives. Photo: John W. Barry. See page 86.

Prestel Verlag
Königinstrasse 9, D-80539 Munich
Tel. +49 (89) 38 17 09-0
Fax +49 (89) 38 17 09-35
www.prestel.de

Prestel Publishing Ltd.
4, Bloomsbury Place, London WC1A 2QA
Tel. +44 (020) 7323-5004
Fax +44 (020) 7636-8004

Prestel Publishing
175 Fifth Avenue, Suite 402,
New York, N.Y. 10010
Tel. +1 (212) 995-2720
Fax +1 (212) 995-2733
www.prestel.com

Library of Congress Control Number: 2005900591
The Deutsche Bibliothek holds a record of this publication in the Deutsche Nationalbibliographie; detailed bibliographical data can be found under: http://dnb.dde.de

Prestel books are available worldwide. Please contact your nearest bookseller or one of the above addresses for information concerning your local distributor.

Editorial direction: Philippa Hurd
Design, layout, and typesetting: Rainald Schwarz, Munich
Origination: Reproline Genceller, Munich
Printing and binding: Passavia, Passau
Printed in Germany on acid-free paper

ISBN 3-7913-3325-9 (hardcover edition)
ISBN 3-7913-6048-5 (paperback edition)

Contents

O thou sculptor, painter, poet!
Take this lesson to thy heart:
That is best which lieth nearest;
Shape from that thy work in art.

Henry Wadsworth Longfellow

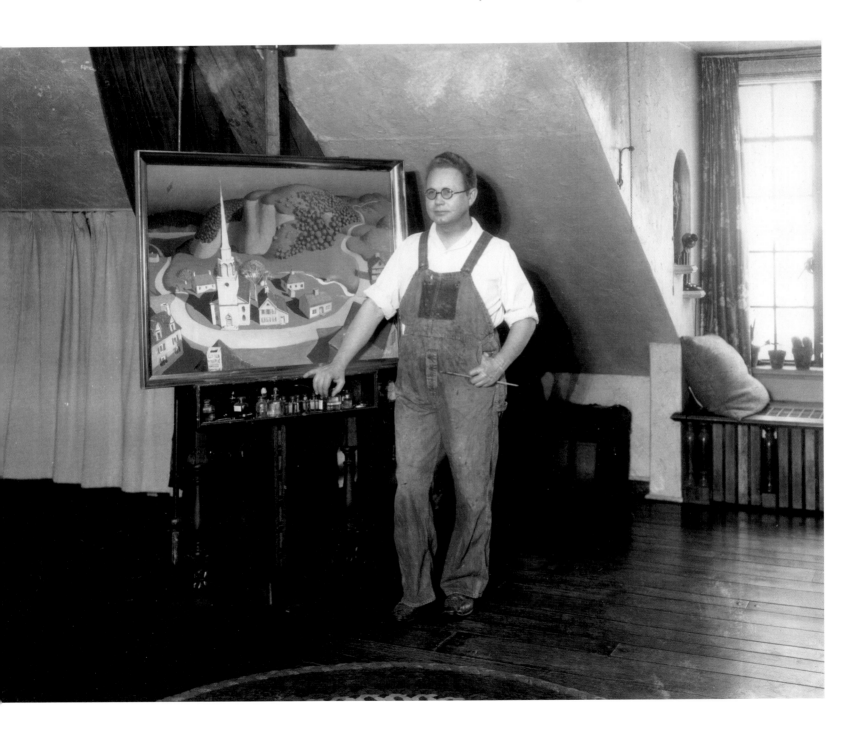

Foreword

The idea for a new monograph and exhibition on Grant Wood originated when the Cedar Rapids Museum of Art acquired Grant Wood's Cedar Rapids, Iowa studio and residence known as 5 Turner Alley. In 2002 the studio, which was originally a carriage house behind one of the town's great mansions, was generously donated to the Museum by Audrey Linge and Cedar Memorial so that it could be preserved and shared with the public. As we began researching the history of 5 Turner Alley and the role it played in Wood's creative life, it became clear that there was an important story to be told.

The remarkable trajectory of Grant Wood's career is inextricably tied up with his life in Cedar Rapids. His formative explorations as a student artist occurred here and, after a short time in Chicago and his military service during World War I, Wood returned to Cedar Rapids determined to make a living as an artist. He succeeded in large part because the community fostered his aspirations and supported him financially. At a critical time he found employment as an art instructor in the local school district, while the community sponsored his artistic efforts through numerous commercial and private commissions. In return, Grant Wood helped turn Cedar Rapids into a vibrant art center and he left an important legacy of commissioned art throughout Cedar Rapids.

Wood's primary patron was his close friend David Turner who, in 1924 asked Wood to help convert a local mansion into a new funeral home for the Turner's family business. While working on the funeral home Wood was offered the loft in the rear carriage house to convert into a studio. It was in this loft, which became known as 5 Turner Alley, that Wood created some of the most well-known and popular paintings in the history of American art, including *American Gothic*.

This is the first monograph and exhibition to fully integrate and examine Wood's many decorative art works into the well-known body of his paintings, drawings, and prints. The project has been expertly guided from the beginning by Jane Milosch, who has inspired everyone with her expertise, commitment, and energy. A project this massive and important could never have been accomplished without the dedication and expertise of the museum's registrar Teri Van Dorston and our invaluable volunteers and museum Trustees Deba Foxley Leach and Candace Wong. This publication and the related exhibition *Grant Wood at 5 Turner Alley* received crucial early support in the form of a major grant from The Henry Luce Foundation, which has helped fund critical costs for this publication and the conservation of art works, some of which have never been exhibited before. I am grateful to Ellen Holtzman, Program Director for the Arts, The Henry Luce Foundation, for her assistance with our grant, and to Mark Tade of Gazette Communications for his exceptional photography of many of the works and sites reproduced in this publication. I also wish to thank the numerous museums and collectors who generously allowed us to reproduce works in this publication and, in many instances, to include them in the exhibition. Finally, I salute the scholars whose essays follow. Each of them has made valuable contributions to our knowledge of Grant Wood and of the era in which he worked.

Throughout his years in Cedar Rapids Grant Wood was closely associated with the Cedar Rapids Museum of Art (then called the Cedar Rapids Art Association) as a volunteer and advisor, and he had the first of his several exhibitions here in 1920. Therefore it is exciting for us to be able to present this publication and a major Grant Wood exhibition as a celebration of the centennial year of the Cedar Rapids Museum of Art, which was founded in 1905.

Terence Pitts
Executive Director
Cedar Rapids Museum of Art

Fig. 1: Grant Wood with his unfinished painting, *Midnight Ride of Paul Revere*, at 5 Turner Alley, 1931. Courtesy of Figge Art Museum, Grant Wood Archives. Photo: John W. Barry.

Acknowledgments

This book, which was planned in conjunction with the exhibition, *Grant Wood at 5 Turner Alley* and published to coincide with the opening of Grant Wood's 5 Turner Alley Studio in Cedar Rapids, Iowa was made possible by the generous cooperation of many people.

The contributions of my fellow authors throughout the creation of this book and accompanying exhibition have ensured a new look at the life and work of Grant Wood. The four essays consider different aspects and periods of Wood's career—before, during, and after his tenure at 5 Turner Alley (1924–1935)—and his success with *American Gothic*. Jim Dennis lent his expertise during the grant-writing stage of this project and has written an account which highlights Wood's humor and graphic skills. Joni Kinsey's introductory essay succinctly traces Wood's life and work and incorporates new research on Wood's controversial tenure as Professor of Art at the University of Iowa. Wanda Corn's luminous essay places Wood's work in a new light by examining his work within a grander, art-historical frame work in which appears the advent of industrialization and modern life.

I would like to thank the many individuals and institutions which facilitated the loan of works for the exhibition and the necessary photography for the publication of this book. I am grateful to: Jane Munoz, Senior Design Administrator, Abbott Laboratories; Rick Stewart, Director, Rebecca Lawton, Curator of Painting and Sculpture, and Melissa Thompson, Registrar, Amon Carter Museum; James N. Wood, former Director and President, James Cuno, Eloise W. Martin Director and President, Daniel Schulman, former Associate Curator, Modern and Contemporary Art, Judith A. Barter, Field-McCormick Curator of American Arts, Darrell Green, Registrar, Loans and Exhibitions, and Amy Berman, Photo Rights Coordinator, The Art Institute of Chicago; Peggy B. Whitworth, Executive Director, and Jennifer Pustz, Historian, Brucemore, A Historic National Trust Site, Cedar Rapids; Martha Aldridge, Executive Director, Byron Preston, Curator, and Mark Hunter, Historian, Carl and Mary Koehler History Center; Steve Graham, Executive Director, Office of Business Services, and John C. Fitzpatrick, Fine Arts Facility Director, Cedar Rapids Community School District; Russell Panczenko, Director, Maria Saffiotti Dale, Curator of Paintings, Sculpture, and Decorative Arts, and Andrea R. Selbig, Registrar, Chazen Museum of Art, University of Wisconsin-Madison; Timothy Rub, Director, Julie Aronson, Curator of American Painting and Sculpture, and Rebecca Posage, Associate Registrar, Cincinnati Art Museum; James Phifer, President, John Beckelman, former Chair, Art Department and Delores Chance, former Gallery Director, Coe College; David Whitehouse, Executive Director, Tina Oldknow, Curator of Modern Glass, and Warren Bunn, Registrar, Corning Museum of Glass; Susan Lubowsky Talbott, former Director, Jeff Fleming, Deputy Director/Senior Curator, Patricia Hickson, Gallery Manager/Associate Curator, Amy N. Worthen, Curator of Prints, Rose Wood, Registrar, and Mickey Koch, Associate Registrar, Des Moines Art Center; Randall W. Lengeling, Trustee, Geri Shafer, former Director, and Stacy Gage, Collections and Exhibitions Manager, Dubuque Museum of Art; Linda Downs, Executive Director, Michelle Robinson, Curator, Patrick Sweeney, Registrar, and Herb Metzler, Chief Preparator, Figge Art Museum; J. Brooks Joyner, Director, Janet L. Farber, former Associate Curator of 20th-Century Art, Ted James, Collections Manager, and Penelope M. Smith, Registrar of Collections, Joslyn Art Museum; Philippe de Montebello, Director, Gary Tinterow, Engelhard Curator of 19th-Century European Painting, Ida Balboul, Research Associate 19th Century, Modern and Contemporary Art, and Cynthia Chin, Assistant Registrar, Metropolitan Museum of Art; Robert D. Jacobsen, Acting Associate Director of Collections and Exhibitions, Christopher Monkhouse, Curator of the Department of Decorative Arts, Sculpture, and Architecture, Jennifer Komar Olivarez, Associate Curator of Decorative Arts, and Tanya Morrison, Associate Registrar, Minneapolis Institute of Arts; William I. Koch, President, and Gisela Garneau, Assistant to President, Oxbow Corporation; Joan Liffring Zug Bourret, Penfield Press; Janice Driesbach, Director, and Laurie Simms, Image Resources, Sheldon Memorial Art Gallery and Sculpture Garden, University of Nebraska-Lincoln; Rachel Allen, Deputy Director, Marie Elena Amatangelo, Exhibitions Coordinator, Melissa Kroning, Registrar, Richard Sorensen, Rights and Reproduction Assistant, Smithsonian American Art Museum; David Vollmer, Executive Director, Nathan Richie, Curator of Collections and Programs, and Lisa Petrulis,

Registrar, Swope Art Museum; Howard Creel Collinson, Director, Kathleen Edwards, Curator of Prints, Drawing, Photograph and New Media, Pam Trimpe, Curator of Paintings and Sculpture, and Donald J. Martin, Registrar, University of Iowa Museum of Art. I am also grateful to the private collectors who were willing to share their works with the public: Sutherland and Josephine Cook, Ernest Johnston Dieterich, Red and Lysiane Grooms, Tee Miller, Larry Newell, Stanley Resor, Brian and Molly Evans Scott, and Richard and Leah Waitzer.

Many individuals, colleagues, libraries, and archives offered me their assistance: Chris Botti, Botti Studios of Architectural Arts, Evanston, Illinois; Kevin Burford, Library Associate, and Loren Horton, Former Field Services Coordinator and Senior Historian, State Historical Society of Iowa, Iowa City; Neil Cockerline, Director of Field Services, and Nathan Otterson, Associate Objects Conservator, The Upper Midwest Conservation Association, Minneapolis; Leslie Gilmore, Gilemore Franzen Architects; Gary Grant, Member of Veterans Memorial Building Commission; Darcy Evons; Don Hanson; Jim Hayes; Patricia Lynagh, Assistant Librarian, Smithsonian American Art Museum and the National Portrait Gallery Library; Annette Schöningh, Neumeister Münchener Kunstauktionshaus, Lowell Soike, Deputy, State Historic Preservation Office, Des Moines; Jan Schobert; Judy Throm, Head of Reference, Smithsonian Institution, Archives of American Art. Over the past four years, several curatorial assistants and interns aided my research and assisted with organizational details: Erika Fry and Christina Larson, researchers; Polly Benes, Liz Miles, Lindsay Peterson, Elena Vetter, interns, and Morgan Wylie, curatorial assistant, at the Cedar Rapids Museum of Art; Patricia Edema, Ana Lopez, Alixine O'Malley, and Leah Oren also assisted with research. During the final stages of writing my essay, I began my new position as curator at the Renwick Gallery of the Smithsonian American Art Museum, Washington D.C., and I am grateful to Elisabeth Broun, The Margaret and Terry Stent Director, Smithsonian American Art Museum, and Robyn Kennedy, Chief, Renwick Gallery, for support which allowed me to complete my essay for the book.

Many staff and board members at the Cedar Rapids Museum of Art lent their talents and time towards the completion of this book and the organization of the exhibition. Terry Pitts, Executive Director, encouraged me to develop and refine my ideas for this project and to expand it from a modest exhibition and catalogue to a major reassessment of Wood's work in conjunction with the renovation of 5 Turner Alley. Michael Denney, President of the Board of Trustees, offered his support for this project. Candace Wong, Vice-President of the Board of Trustees, spearheaded the promotion of the exhibition and, because of her fundraising and marketing expertise, together with her vision that "every kid in Iowa has an opportunity to see the Grant Wood exhibition," many will benefit. Deba Foxley Leach, Trustee, contributed in countless ways, assisting with research and producing the chronology for this book. Her energy and talents continue to inspire, as does her new children's book, *Grant Wood: The Artist in the Hayloft*, published by Prestel in conjunction with this book. The CRMA's small but hardworking staff outdid itself to make this book a success, especially Teri Van Dorston, Registrar, assisted by Judy Frauenholtz, Preparator, orchestrated a myriad of details to ensure that all works could be photographed and properly documented for this publication.

Prestel designed and produced this handsome volume, the first major book on Grant Wood to be published in Europe. I would like to thank Jürgen Tesch, publisher, for his interest in the project, Philippa Hurd, editor, for her able guidance on this project and triumph over a tight schedule, Stephen Hulbert, US sales and marketing director, for promoting the idea and importance of such a book, and Rainald Schwarz, designer, for the handsome layout. Most of the photography in this book was masterfully completed by Mark Tade, and his talent is apparent in the reproductions of Grant Wood's work. Ben Marion, Steve Frederiksen, and Jeff Martinovici, with Creative Gene, Cedar Rapids, Iowa scanned numerous archival materials for reproduction.

Several friends guided and encouraged me in my work on the exhibition and completion of the essay. Michelle Robinson, Curator, Figge Art Museum, and Brady Roberts, Curator of Modern and Contemporary Art, Phoenix Art Museum, offered erudite observations regarding my essay. Fabrizio Amore, Deborah Cobb, Mary Ann Cull, Brigitte and Karl-Werner Curtius, Mila Grady, Dawn Stewart-Walker, Suzanne and Luigi Tanzi and CL amici, Julie and Andrew Vander Veen, to name only a few, offered hospitality so that I could complete my research in Chicago, Iowa, Munich, New York, and Washington D.C. Mary Ann Milosch, my mother-in-law, assisted me in innumerable ways to complete this book, offering her consummate editorial skills that triumphed over too much information. Dennis Milosch and my mother Nancy Dailey Simpson attended to many things, including meals that I would have otherwise missed, to aid me along the way. Lastly, I would like to thank my husband Mark Milosch, historian and friend, who encouraged and aided me with all aspects of the project, offering endless insight together with humor that helped to get me out the woods, for Wood's sake.

Jane Milosch
Curator
Renwick Gallery of the Smithsonian American Art Museum

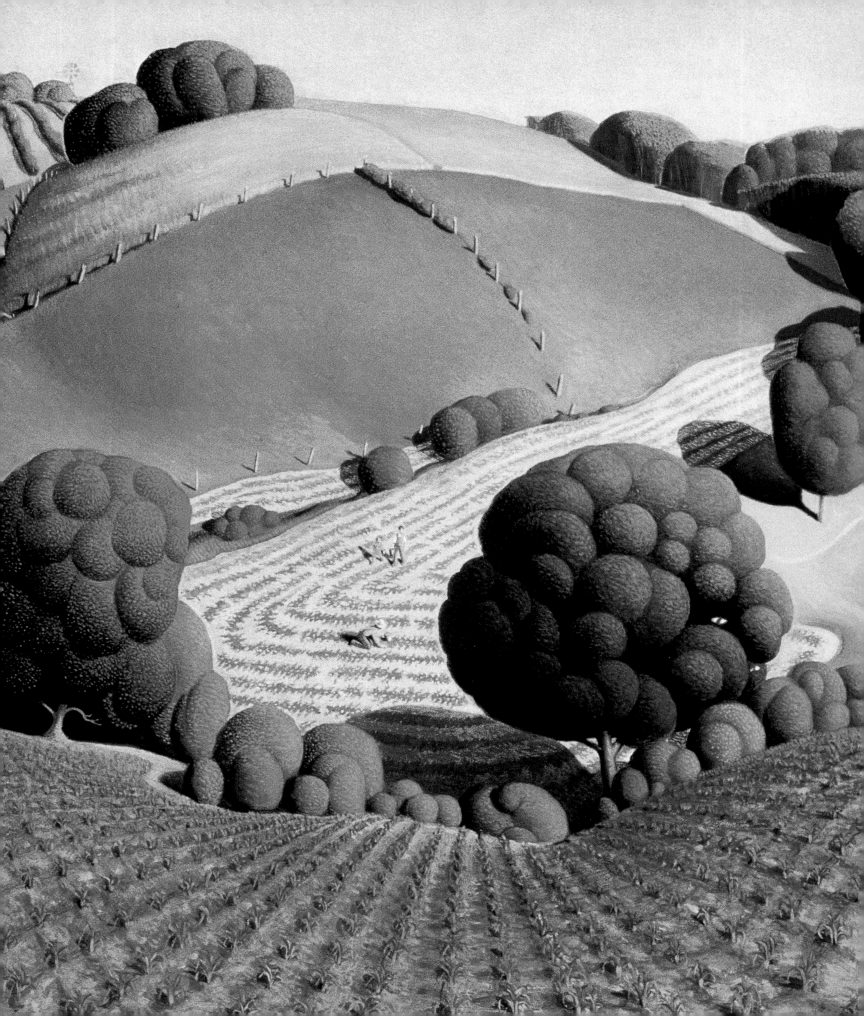

Cultivating Iowa: An Introduction to Grant Wood

Joni L. Kinsey

Tucked behind the large brick mansion that houses the Turner Funeral Home in Cedar Rapids, Iowa stands a modest carriage house (fig. 67) that once was the studio of one of America's most celebrated artists. Grant Wood (1891–1942) is still a household name in his native Iowa and many of his paintings, especially the famous *American Gothic* (pl. 3), have become cherished national icons. But even in Wood's hometown the significance of the former hearse garage as the birthplace of many of his most important aesthetic achievements has almost been forgotten. Nevertheless it was there that Wood arrived at his mature style and painted his best-known canvases, and it was there that he refined the theories that would distinguish him as one of the most beloved, and controversial, of the Regionalist painters.[1]

Wood spent more than ten years in the studio at 5 Turner Alley, a decade that would prove the most significant of his career. He obtained use of the space, rent free, from funeral director David Turner, a long-time friend who hired him to decorate the adjacent mansion. Wood spent considerable time converting the garage attic into a remarkably efficient and charming space (figs. 54, 55) where he lived with, and painted portraits of, his mother and his sister Nan (pls. 2, 19). When he acquired 5 Turner Alley in 1924 he was painting in a modified Impressionist style and spending his time doing a variety of odd jobs, including interior decoration for Cedar Rapids' homes; by the time he left for Iowa City in 1935 his work had undergone a complete transformation. He had eschewed artistic borrowings for his own distinctively crisp style, was state director of the federal Public Works of Art Project (PWAP) and teaching mural painting at the University of Iowa (then called State University of Iowa), and he had attracted the attention of the national press and the American art world. Most significantly, he was devoting his art exclusively to the people and landscape of the Midwest, portraying both with a clarity and monumentality that emphasized their innate strength and virtue, qualities he believed lay at the heart of the American character.

Grant Wood, *Young Corn*, 1931 (detail). Oil on Masonite panel, 24 × 29 7/8 in. Cedar Rapids Museum of Art, Community School District Collection.

Wood lived and worked most of his life in Iowa, drawing most of his subjects from his immediate surroundings and personal experience. More than simple portrayals of everyday life, however, his art always seems to recognize the epic within the ordinary, a universality that may account for the reactions of the diverse range of viewers who see something of themselves in his images and regard them as compelling and provocative. Even as it celebrates its subjects, however, Wood's art is tinged with humor, irony, and even satire, and the artist himself was a paradoxical figure. Most popularly pictured as a genial, homespun man in bibbed overalls who embodied many of the down-to-earth ideals he painted (fig. 1), Wood was actually far more cosmopolitan, had traveled frequently to Europe, had studied at the Académie Julian in Paris and the Art Institute of Chicago, and was friends with many of the leading intellectuals of his time.[2] He had strong theories about art and its role in society and was an articulate spokesman for the importance of regional identity within national culture and the significance of rural life in America, ideas that were extremely influential in the early 1930s. These beliefs, coupled with his representational pictorial style and overtly Midwestern focus, catapulted him to national attention (*Time* proclaimed him one of the leading artists in America in 1934), but his Regionalist agenda and imagery increasingly placed Wood at odds with an art world that by the end of the decade was anxious to celebrate avant-garde trends emanating from cosmopolitan and international centers. More than esoteric quarrels over arcane aesthetics, these tensions took on a heightened political tenor as the country emerged from the Great Depression and entered World War II. Art was an acknowledged political tool, and Grant Wood and his fellow Regionalists, in concert with New Deal ideologies and aspirations, were attempting to shift the locus of authority away from those who traditionally determined its course towards a far more populist constituency. Shortly after Wood's premature death in 1942, as many were praising the evocative beauty and astute insight of his work, some critics were vilifying his art as "dangerous" and even "fascist."[3] The passionate intensity on both sides of the debate testifies to the power of Wood's art and ideas.

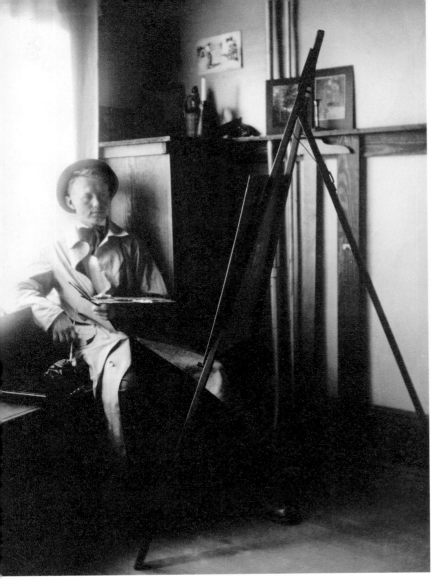

Fig. 2: Grant Wood as a young artist, 1910. Cedar Rapids Museum of Art Archives.

Although the Regionalist ideas that distinguished Wood were not unique to him—indeed, as Grant Wood scholar Wanda Corn has demonstrated, the 1920s and 1930s were characterized by a widespread "obsession with Americanness"—they were a natural outgrowth of his upbringing, artistic training, and personal identity.[4] He had been born in 1891 on a farm near the small town of Anamosa, Iowa, the second of four children. The first decade of his life was typical for its time and place, preoccupied with many of the same things he later painted: farming, the change of seasons, rural schools, and the people who lived, worked, and experienced those things. It was a life much as countless Iowans had lived since the state was founded in the 1840s, and those early experiences and Wood's memories of them provided the foundation of his mature imagery.[5]

His father died in 1901 when Grant was ten, and Mrs. Wood moved with her children to nearby Cedar Rapids, a city of about 45,000 that boasted, among other things, one of the largest cereal factories in the United States (now Quaker Oats).[6] Wood's life changed significantly there; he had new responsibilities to help the family, he attended city schools, and was surrounded by more people than he had been on the farm. But at the same time Cedar Rapids, like many medium-sized Midwestern communities of the time still had backyard gardens, barns with chickens, horses, and cows (figs. 3, 4). These elements of small-town life would also become important subjects for Wood's later art such as *Spring in Town* and *Spring in the Country* (pls. 21, 22).

His interest in drawing and painting began early, encouraged by Emma Grattan, the art supervisor for the Cedar Rapids public schools, and he began submitting his work to competitions as early as 1905. A drawing of oak leaves won him third prize in a national contest that year, instilling in the fourteen-year-old artist the resolve to make art his profession (fig. 2).[7] Entering Washington High School in 1906, Wood met Marvin Cone (1891–1965), a classmate also interested in art, and the two became lifelong friends. Almost immediately they began working together, designing stage sets for local theater productions and serving as volunteers for the Cedar Rapids Art Association (which later became the Cedar Rapids Museum of Art) where they did everything from exhibition installation to guard duty.[8] Wood also drew for the school's yearbook and magazine (figs. 36, 106) and began doing interior decorating, a trade he continued until the early 1930s. Wood and Cone later traveled to Europe together, created joint exhibitions of their work, and cooperated in establishing an art colony in Stone City, Iowa. Cone never became as nationally known as Wood, but the two artists were kindred spirits in their early "bohemian" years and were allied in their enduring interest in the power of Iowa's landscape.[9]

Wood's subsequent aesthetic development combined a smattering of courses in Arts and Crafts design, episodic training in several art schools, independent study in Europe, and professional work as an artisan, designer, and decorator. Immediately upon graduating from high school in 1910 he traveled to Minnesota, accepting a scholarship for a summer course at the Minneapolis School of Design and Handicraft, taught by Ernest A. Batchelder, a prominent proponent of the Arts and Crafts Movement and the author of an influential book, *The Principles of Design* (1904). Wood had been independently doing a correspondence course from *The Craftsman*, a leading Arts and Crafts magazine, and from Batchelder he learned directly about that branch of modern design which emphasized pattern and contour and hand-crafted wood, metal, and organic

materials.[10] At the school he took courses in jewelry and copper work, and his interest in the decorative potential of metal can still be seen in the unique grills, fireplace hood, and light fixtures he fashioned for his studio at 5 Turner Alley (fig. 54).

Wood returned to the Minneapolis school the following summer, but in the intervening months took a life-drawing course from Charles A. Cumming at the University of Iowa, Iowa City (then called the State University of Iowa). Cumming was an academic painter trained in France and his teaching emphasized classic rendering and formal clarity that proved important to Wood throughout his life. In 1913 the student painter moved to Chicago and took night classes in life drawing at the Art Institute. To support himself he worked at Kalo Silversmithing fabricating jewelry, and the next year he joined co-worker Kristoffer Haga to start a small metal studio, the Volund Crafts Shop. The business failed in 1916, however, and he returned to Cedar Rapids to help his mother, whose dwindling financial reserves had forced the sale of her home. Wood assumed financial responsibility for her and his sister, supporting them as a home-builder and decorator. During World War I he served a brief stint as an army camouflage designer while stationed in Washington, returning to Cedar Rapids after the armistice to take a position teaching art in the public schools.

At Jackson and later McKinley Junior High Schools, Wood honed the teaching skills he would later employ as a professor of painting at the University of Iowa. He was an inventive and popular teacher who devised a great range of assignments for his students,

Fig. 4: Grant Wood, *Old Stone Barn*, 1919. Oil on composition board, 14 ³/₄ × 17 ³/₄ in. Gift of Harriet Y. and John B. Turner II. 72.12.50

including murals that in some ways anticipated those he would later direct through the PWAP. One example was *Imagination Isle Frieze*, an 18-inch-by-150-foot-long landscape painting designed by boys in his ninth-grade art class (fig. 5). The scroll was presented to the school as a theatrical performance, much as moving panoramas were in the 19th-century, with dimmed lights, musical accompaniment, and a spoken narrative. Throughout his teaching Wood emphasized such cooperative endeavors as well as independent work; the relationship of community and creative activity was central to his belief that authentic art can be achieved by "a group of people painting harmoniously together, each contributing his own images to the forming of an accumulated vision."[11]

Wood had long hoped to visit Europe. Finally in 1920 he took a loan that paid for his summer trip and his mother and sister's living expenses at home, and traveled to Paris with Marvin Cone who had served there during the war. In France he freely adopted what he called "bohemianism," growing a beard, spending time at Left Bank cafés, and painting scenes of Paris and the surrounding countryside in an Impressionistic style (fig. 8). In 1923–24 he took a sabbatical from teaching to return to Paris to take courses at the Académie Julian and travel in France and Italy. He seems to have been little influenced by the modern movements in contemporary European art, but instead continued to paint, impressionistically, many of the same types of subjects that he would later portray in his home region—plowed fields and gardens, picturesque homes and

Fig. 3: Grant Wood, *Feeding the Chickens*, 1917–18. Oil on composition board, 11 × 14 in. Gift of Harriet Y. and John B. Turner II. 72.12.20

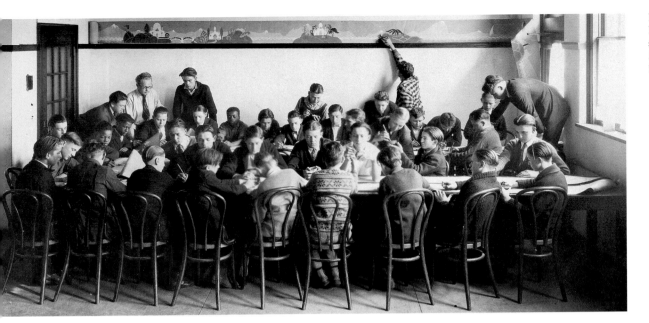

Fig. 5: Grant Wood with his McKinley Junior High School art students working on *Imagination Isle Frieze*, 1924. Cedar Rapids Museum of Art Archives.

distinctive structures, and decorative patterns of foliage and light (fig. 8).

He returned to Europe twice more, to Paris in 1926 and Munich in 1928. Each of these trips was formative, allowing Wood to experience a different culture and experiment with his own artistic direction, but although he dabbled with adopted styles for a time these explorations ultimately reinforced his dedication to his native roots. Like a prodigal son, time away from home helped him see and appreciate Iowa anew. Recognizing this influence on his personal and artistic identity, Wood later entitled his unfinished biography (written by his friend Park Rinard) "Return from Bohemia," and sketched a self-portrait for its cover (pl. 16). Behind him in the

scene, eyes downcast or even closed, are the almost ghostly figures to whom he returned, waiting it seems for the artist to complete their resurrection. Wood would become increasingly critical of the "bohemian" who defined himself through foreign cultivation, yet he acknowledged the personal importance of his own wandering and experimentation before he settled, both literally and figuratively, back home.[12]

In between his first and second European trips Wood taught at McKinley Junior High, but prompted by a curriculum dispute and the encouragement of David Turner he resigned in 1925 to devote himself to his own art.[13] He worked on decorating projects, portraits, commercial commissions, and other images (figs. 15–17),

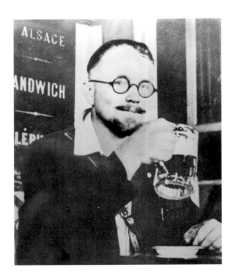

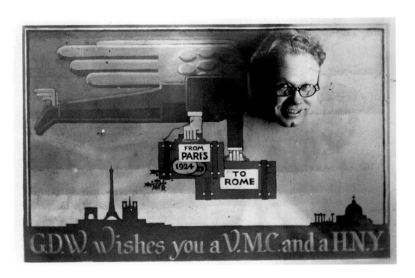

Fig. 6: Grant Wood in Paris, 1920. Gift of John B. Turner II in memory of Happy Young Turner. S7.7. Photo: Marvin Cone.

Fig. 7: Grant Wood's Christmas Card "From Paris to Rome," 1923. Courtesy of Figge Art Museum, Grant Wood Archives.

Fig. 8: Grant Wood, *At Ville d'Avray, Paris*, 1920. Oil on canvas, 193 ³/₄ × 24 in. Gift of Harriet Y. and John B. Turner II. 76.2.4

and with his new, centrally located studio apartment at 5 Turner Alley, the support of Turner and other local patrons, he became a central figure in Cedar Rapids' growing artistic community. He became a founding member of the Garlic Club, for example, a group of intellectuals, activists, and prominent Cedar Rapidians that gathered for meals, often with notable guests invited from around the country; and he was also a charter member of the Fine Arts Studio Group, a coalition of artists, art lovers, and musicians that began in 1926. Hoping to develop an art colony in town, Wood encouraged his friends to create studios in other carriage houses along Turner Alley, and when this proved impractical several of them established a "Studio House" in the nearby Mansfield mansion (Turner Mortuary's earlier location). Complete with three artisan residents, a gift shop, space for a theater and art classes, and a tearoom, Studio House became the center of artistic life in Cedar Rapids for a brief period. Wood was a regular visitor there and he also hosted frequent gatherings at his own studio, sometimes even turning it into a theater for amateur performances.[14] He and Marvin

Cone had been involved with the Cedar Rapids Art Association and the Community Theater (Cedar Rapids Theatre Guild), since they were fifteen, and they continued to create stage sets for theatrical productions throughout the 1920s.

Throughout the 1920s and early 1930s Wood exhibited his canvases in local department stores, the Carnegie Library's art gallery, and The Little Gallery, a public exhibition space opened in 1928 with funding from the Carnegie Foundation and the American Federation of Arts.[15] He also executed murals for such places as the Hotel Chieftain in Council Bluffs and Cedar Rapids' Hotel Montrose (figs. 87–89). In their monumental scale and focus on Midwestern subjects these works were important precedents for the Regionalist murals he would create in the 1930s. His easel paintings too, increasingly focused on scenes and individuals that shaped the community's character. His series for the J.G. Cherry dairy equipment factory in 1925 (figs. 24, 25), celebrates the creativity of labor as well as industry's contribution to the local economy. The portrait, *John B. Turner, Pioneer* (1928–30, fig. 22), juxtaposing an 1869 Linn

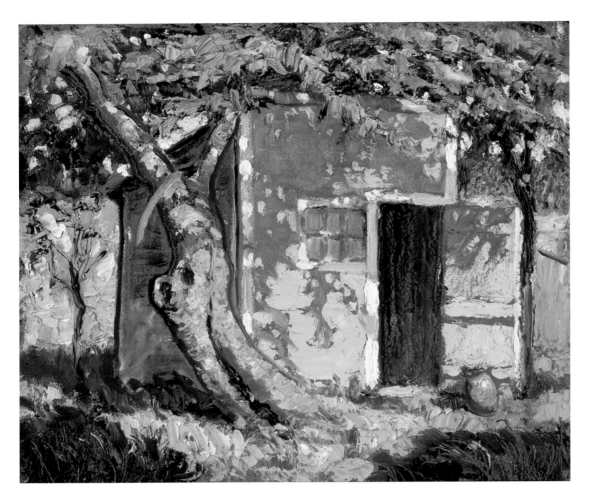

Fig. 9: Grant Wood, *Van Antwerp Place*, 1922–23. Oil on composition board, 12 $^7/_8$ × 14 $^7/_8$ in. Gift of Harriet Y. and John B. Turner II. 72.12.78

Fig. 10: Grant Wood, *New Plaster, Paris*, 1924. Oil on composition board, 13 × 5 in. Gift of John Reid Cooper and Lee Cooper van de Velde in honor of their grandparents John C. and Sophie S. Reid and their parents James L. and Catherine Reid Cooper. 89.5.1

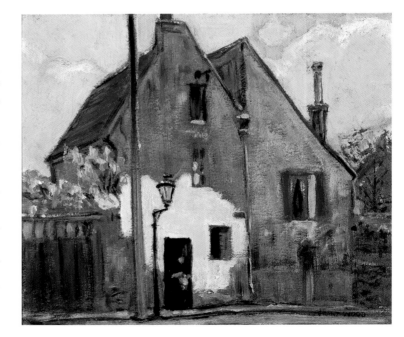

County map with the distinguished businessman (the father of his patron David Turner), is an overt reference to the interrelationship of place and identity that Wood would explore more widely in subsequent years. Indeed, the sitter himself called the painting "two old maps."[16] During this period Wood completed a number of other commissioned portraits, such as *Frances Fiske Marshall* (1929), for which he often made the frames (fig. 21).

The lively artistic and social community in Cedar Rapids refuted clichéd conceptions that Midwestern life is devoid of cultural value, and it profoundly enriched Wood's growing appreciation of the region. Artistic cultivation, he and others began to realize, really could be achieved in an area known primarily for agricultural cultivation, and both were rendered more authentic and compelling by their alliance. But their growing enthusiasm for indigenous culture was hardly unique to Wood and his friends. They were part of a much larger movement between the two world wars that emphasized national identity through regional representation and achievement, something that would become a hallmark of the

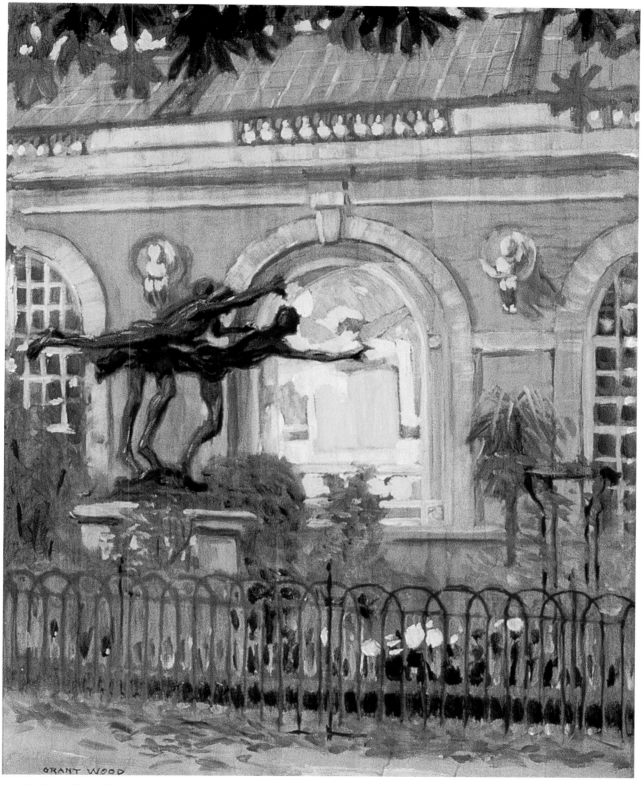

Fig. 11: Grant Wood, *The Runners, Luxembourg Gardens, Paris*, 1924. Oil on composition board, 15 $\frac{1}{2}$ × 12 $\frac{1}{2}$ in. Bequest of Miss Nell Cherry. 69.4.1

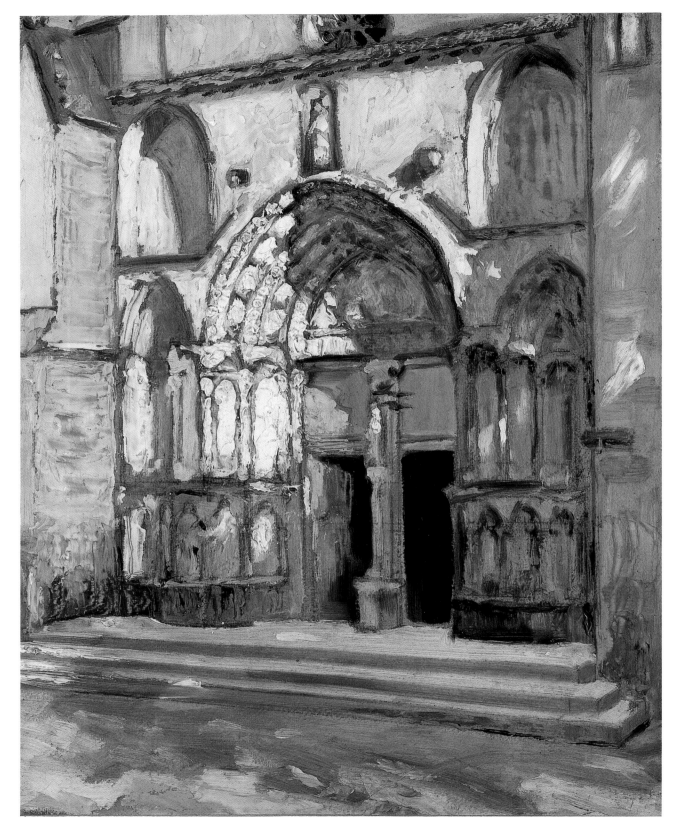

Fig. 12: Grant Wood, *Yellow Doorway, St. Emilion (Porte des Cloitres de l'Eglise Collegiale,* 1924. Oil on composition board, 16 $\frac{1}{2}$ × 13 in. Gift of Harriet Y. and John B. Turner II. 72.12.8

Fig. 13: Grant Wood, *Porte du Clocher, St. Emilion* [Cathedral], 1926. Oil on composition board, 16 ³/₈ × 13 ³/₈ in. Gift of Janet Coquillette Wray. 87.3.2

Fig. 14: Grant Wood, *Italian Farmyard*, 1924. Oil on composition board, 10 × 8 in. Gift of Harriet Y. and John B. Turner II. 72.12.22

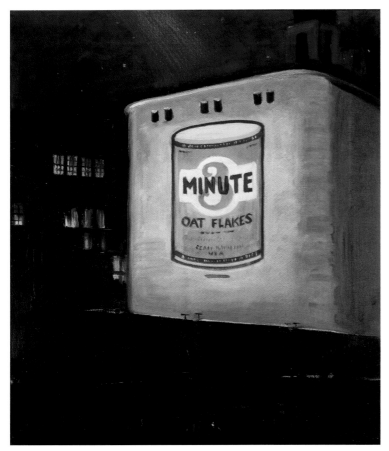

Fig. 15: Grant Wood, *Night Scene, National Oats*, c. 1928. Oil on canvas, 22 ¹/₈ × 18 in. Gift of John Reid Cooper and Lee Cooper van de Velde in honor of their grandparents John C. and Sophie S. Reid and their parents James L. and Catherine Cooper. 89.5.5

rectly was an important context for Grant Wood's developing interest in regional issues and their ability to reveal significant aspects of American character. Like President Roosevelt, Wood understood this work as essential to national recovery and growth. Aware of books and articles exploring the terrain, such as those by Iowan Ruth Suckow and Wisconsin native Hamlin Garland, Wood also had direct contact with people engaged in the cause, in particular Paul Engle, a poet who would later become director of the University of Iowa Writer's Workshop; Edward Rowan, director of The Little Gallery; and Jay Sigmund, a Cedar Rapids businessman, poet, and ardent proponent of Iowa and its evocation of American values. Interest in celebrating Iowa, the Midwest, and regional issues generally was widely and fervently discussed, and Wood enthusiastically joined the debate.

The process that transformed Wood from a "bohemian" who experimented with a variety of styles and subject matter to an avowed Iowa Regionalist was, of course, gradual in some ways, but the real turning point came in the course of a specific project, a 24-foot-tall, stained-glass window for the Veterans Memorial Building in Cedar Rapids (pl. 1), a prominent civic structure being constructed just south of downtown on May's Island. Wood received the commission, the most prestigious he had received, early in 1927, and he spent the next two years creating full-scale drawings (figs. 92, 93) and supervising the window's construction and installation. The glass itself was produced and assembled in Munich

psychological (and economic) recovery represented by the New Deal. Expressed in everything from the visual arts, literature, and music to political rhetoric, federal patronage, and advertising, the emphasis on things American reached a fever pitch in the United States in the 1920s and 1930s, encouraged by a growing self-consciousness that resulted from a devastating world war and introspection generated by economic depression.[17] Comparable trends were underway in other countries as well, most notably in Germany where cultural nationalism was taken to disastrous extremes. But at their best these inclinations resulted in widespread efforts to identify and celebrate unique expressions of cultural character, and they validated individual identity and invigorated people toward greater creativity and self-expression. Although the results of this in the United States would be most dramatically evident in projects financed by the federal government during the Depression, the process was already underway in the 1920s, and directly or indi-

Fig. 16: Grant Wood, *The Old J.G. Cherry Plant*, 1925. Oil on composition board, 13 ¹/₄ × 41 ¹/₄ in. On permanent loan from the Cherry Burrell Charitable Foundation. 74.5.4

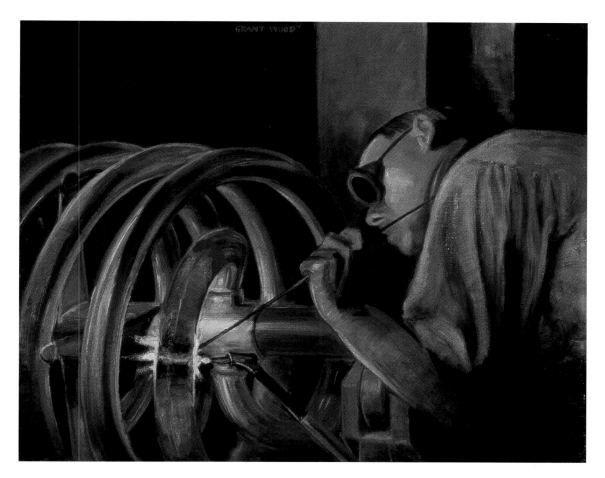

Fig. 17: Grant Wood, *The Coil Welder*, 1925. Oil on canvas, 18 1/8 × 22 in. On permanent loan from the Cherry Burrell Charitable Foundation. 74.5.2

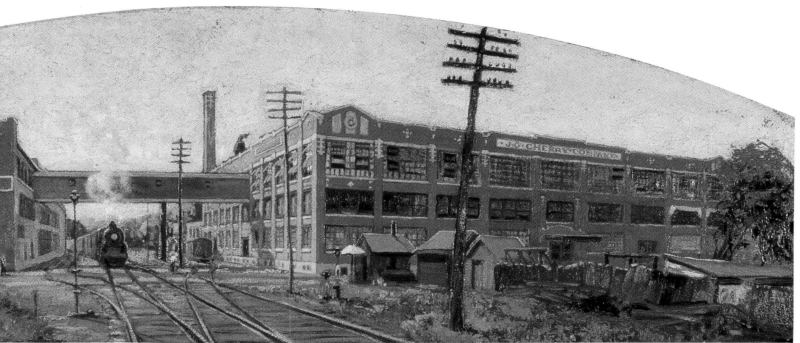

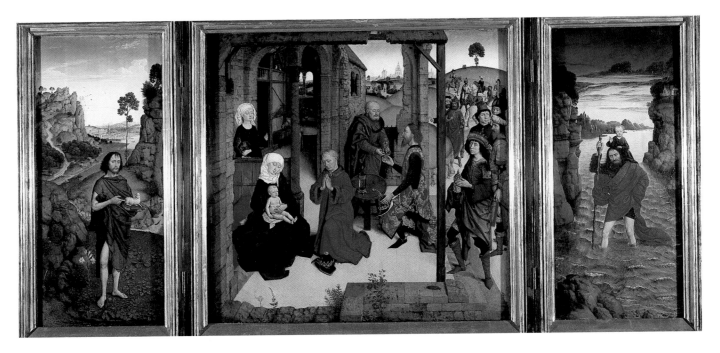

Fig. 18: Dieric Bouts, *Hinged altarpiece ("The Pearl of Brabant"),* c. 1465. Acquired in 1827 from the Boisserée Collection. Panel, 62.6 × 117.6 cm (overall), inv. nos. WAF 76, WAF 77, WAF 78.

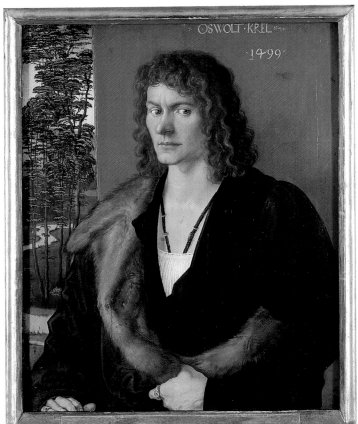

Fig. 19: Albrecht Dürer, Center panel of *Portrait triptych of Oswolt Krel,* 1499. Acquired in 1828 from the Oettingen-Wallerstein Collection. Panel, 49.7 × 71 cm (overall), inv. no. WAF 230a.

through the Emil Frei Art Glass Company of St. Louis, and Wood traveled to Germany in the fall of 1928 to oversee the work, his last trip abroad (fig. 91).[18] There he worked closely with the highly skilled glaziers who fabricated the window, and took time to visit the Alte Pinakothek Museum where he was drawn to the Flemish and German Renaissance paintings of Hans Memling, Hans Holbein, Lucas Cranach, Albrecht Dürer, and others (figs. 18, 19). Admiring the clarity, expressive contours, decorative details, smooth surfaces, and rich coloristic effects of these works, along with their vivid evocation of a historical moment and particular place, Wood recognized an authenticity he was seeking for his own art. Scholars have debated whether he might have also been influenced by contemporary German painting, especially the movement known as Neue Sachlichkeit [New Objectivity], a consciously representational style characterized by careful delineated rendering. But although the paintings of that group have similarities to some of Wood's post-Munich work, their direct influence on his art remains uncertain.[19] What is clear, however, is that upon his return to the

Fig. 20: Grant Wood, *The Blue House, Munich,* 1928. 23 1/2 × 20 1/4 in. Private Collection. Photo: George T. Henry.

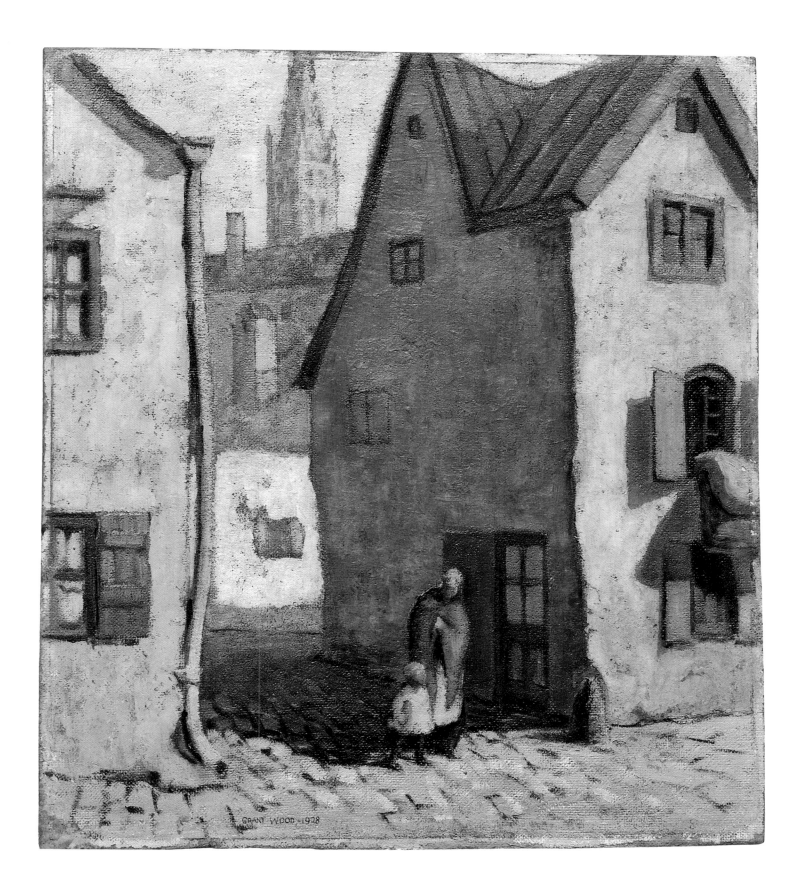

Fig. 21: Grant Wood, *Portrait of Frances Fiske Marshall*, 1929. Oil on canvas, 40 1/2 × 28 1/2 in. Gift of Frances Marshall Lash, Patricia Marshall Sheehy, Barbara Marshall Hoffman and Jeanne Marshall Byers. 81.11

United States Wood began experimenting with a new style and subject matter that consciously drew from his immediate surroundings with more detail, clarity, and smoothly executed decorative effects than had characterized his previous work. His first major effort in the new direction was a portrait of his mother, *Woman with Plants* (pl. 2), followed quickly by others, most notably *American Gothic* (pl. 3) and *Stone City, Iowa* (fig. 23), that revealed a new intensity of purpose and distinctive individuality.

The response was dramatic. Wood won first prize for portraiture for *John B. Turner, Pioneer* at the Iowa State Fair in 1929, *Woman with Plants* was shown at the Art Institute of Chicago's (AIC) annual exhibition that year, and *American Gothic* won a medal at the AIC in 1930. The museum promptly purchased the work, elevating the artist to national attention. *American Gothic* was understandably controversial, especially among Midwesterners who felt themselves the object of satire in the dour couple, but other viewers then and

since have found in the stoic representation the epitome of staunch American character, especially in the difficult era of the early Depression.[20]

This success confirmed Wood as an ardent Regionalist. In 1932, convinced that Midwestern artist coalitions could power aesthetic development in Iowa and its neighboring states, he spearheaded the creation of an art colony in Stone City, near his boyhood home of Anamosa (fig. 26). With courses accredited through Coe College and taught by Wood and several of his friends, the colony attracted participants from all over the Midwest, as well as such notable visitors as John Steuart Curry (fig. 27), the Kansas painter whose work would come to stand with Wood's and their Missouri colleague Thomas Hart Benton's, as the preeminent representations of Regionalism. While the Stone City colony lasted only two summers, it demonstrated the viability of regional art, the energizing potential of creative communities, and the cultivating influence of landscape (fig. 28).

Wood became an activist for Regionalism, lecturing and promoting the formation of regional art centers that could develop unique aspects of their locales into significant national art. He sought allies in Benton and Curry and encouraged them, successfully, to return to the Midwest from the eastern cities where they had migrated during their own "bohemian" periods.[21] The three became known as the leaders of Regionalism, in part through an important December 1934 cover story in *Time* magazine that celebrated their "opposition" to "outlandish" European modernism as a "turn in the tide of artistic taste in the U.S."[22] As evidence of his growing influence Wood himself was appointed head of the Midwest division of the Public Works of Art Project (PWAP) in 1933, helped no doubt by Edward Rowan who had left Cedar Rapids to become Assistant Director of the PWAP in Washington. Part of Roosevelt's New Deal programs, the PWAP was a collaborative project well suited to Wood's experience, interests, and talents since it employed artists to create public art, mostly painting American Scene murals in public buildings. Then, in early 1934, in an effort to align itself simultaneously with the important national initiative and Iowa's most famous artist, the University of Iowa arranged to have Wood's federal program administered in its art department. Wood joined the faculty through a special, short-term appointment (which was soon converted to a more conventional professorship), and the muralists who worked with him received course credit along with their government paychecks. Among their creations were Post Office

Fig. 22: Grant Wood, *Portrait of John B. Turner, Pioneer*, 1928–30. Oil on canvas, 30 1/4 × 25 1/2 in. Gift of Harriet Y. and John B. Turner II. 76.2.2

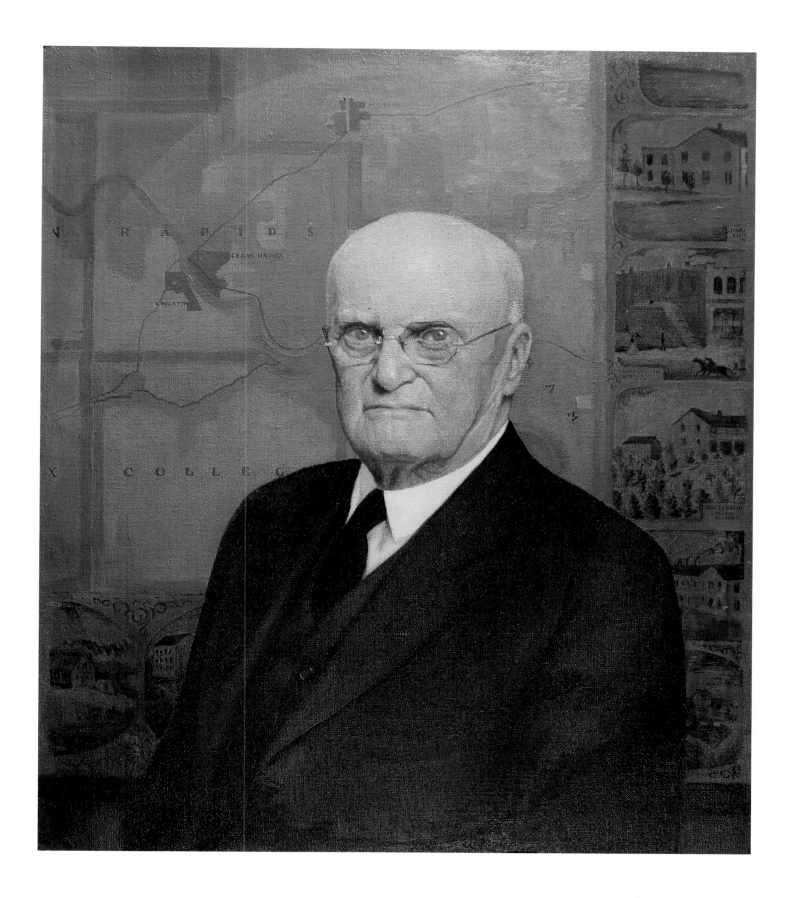

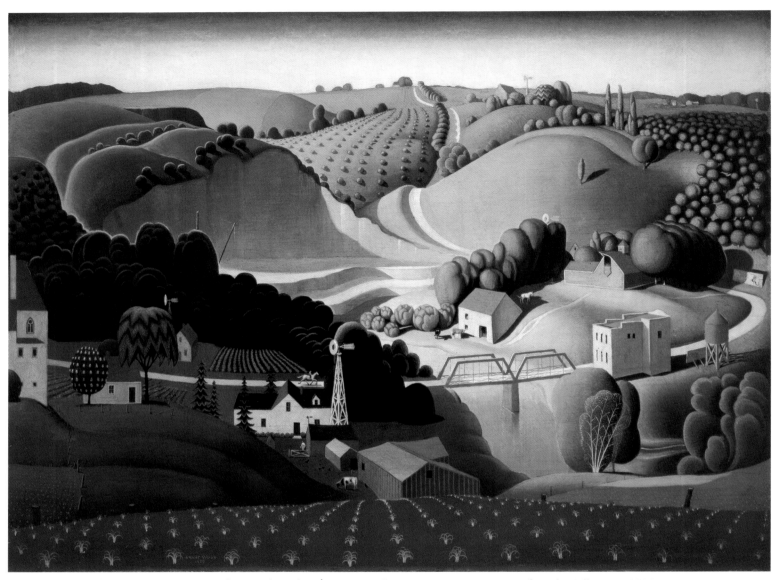

Fig. 23: Grant Wood, *Stone City, Iowa*, 1930. Oil on wood panel, 30 ¹/₄ × 40 in. Joslyn Art Museum, Art Institute of Omaha Collection. 1930.35.

murals throughout Iowa and others at the Iowa State University library in Ames (fig. 32).[23]

After 1933 Wood's life focused increasingly on his new community in Iowa City. He joined the Times Club, a group of like-minded intellectuals who brought notable individuals to campus, hosting them through the S.P.C.S.—the "Society for the Prevention of Cruelty to Speakers." Wood delighted in decorating the clubrooms in "the worst style of the Victorian period," and he and his friends mugged for photographs in period costumes, spoofing the very Regionalism they were helping to shape. He was himself a sought-after speaker, his work was now routinely exhibited in major national exhibitions and bought by prominent collectors, and he was mentioned frequently in the national press. In 1935, with his friend and University of Iowa journalism professor Frank Luther Mott, he published *Revolt Against the City*, a manifesto of Regionalism that summarized the ideas he had been exploring since 1930.[24]

Despite his considerable success and growing prominence, the late 1930s were a difficult time for Wood. His move to Iowa City and abrupt marriage in 1935 to Sara Maxon, a former singer from Cedar Rapids who was four years his senior, alienated him from many long-time friends. The marriage proved unhappy and ended in divorce after only three years. His beloved mother died during the same

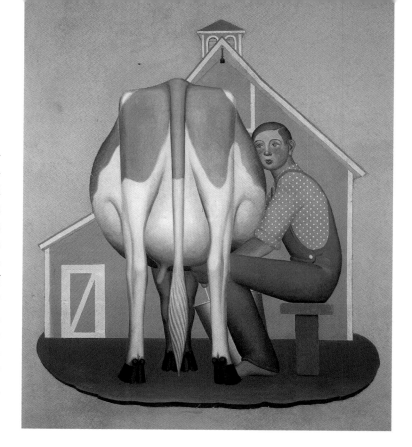

Fig. 24: Grant Wood, *Boy Milking Cow*, Fruits of Iowa mural for Hotel Montrose, 1932. Oil on canvas, 71 1/4 × 63 1/4 in. Collection of Coe College, Cedar Rapids, Iowa, Gift from the Eugene C. Eppley Foundation.

period. His busy lecture schedule, university teaching, and increasingly difficult domestic life slowed his own painting, prompting critics to question whether his best years were past. He did paint several notable works, *Parson Weems' Fable, Spring in the Country, Spring in Town* (pls. 20, 21, 22), and *Adolescence* (fig. 118) which rivaled his earlier work in importance, but the majority of his art after 1937 was devoted to smaller projects such as book illustrations and lithographs (figs. 30, 31). He sold the latter through the Association of American Artists, a New York company that marketed modestly priced prints to a wide audience. Although these commercial ventures were financially rewarding for Wood, and helped compensate for his wife's extravagant spending and several tax problems he encountered during the period, they also provided ammunition for detractors who already believed his work was too "illustrational" and his reputation too dependent upon media attention.

Most disturbing to Wood was an ongoing controversy at the University of Iowa that threatened to discredit him, his work, and the Regionalist movement more generally. The disputes were a source of continual distress to the artist in his final years, and after his unexpected death in 1942 it played an important and unfortunate role in diminishing his legacy within the art world. When Wood arrived on campus in January 1934, the Department of Plastic and Graphic Arts, as it was then called, was still dominated by the academic tradition begun by Charles Cumming, and Wood was considered a "liberal" painter, a modernist whose methods and ideas contrasted with those favored by his colleagues. By June tensions were significant enough that a document describing them was included in the cornerstone of the new art building.[25]

With a change in the department's administration, however, in 1936, Wood was cast as a reactionary, positioned against the new chairman's preference for "internationalist" avant-garde modernism. Lester Longman (1905–87) was a 30-year-old historian of Spanish medieval art with a new Ph.D. from Princeton. Intent on fashioning the University of Iowa's program into a model of progressive art education, he implemented curricular reforms that clashed with what he called Grant Wood's "atelier" method, but even more significantly the artist's celebration of local culture and landscape,

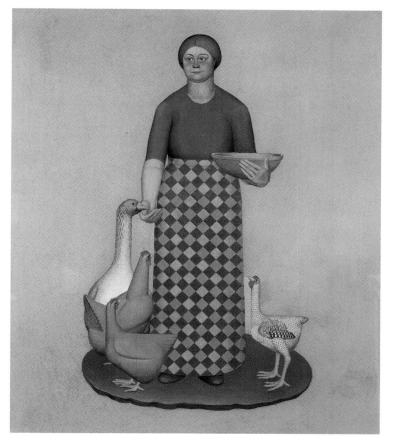

Fig. 25: Grant Wood, *Farmer's Wife With Chickens*, Fruits of Iowa mural for Hotel Montrose, 1932. Oil on canvas, 71 1/4 × 49 in. Collection of Coe College, Cedar Rapids, Iowa, Gift from the Eugene C. Eppley Foundation.

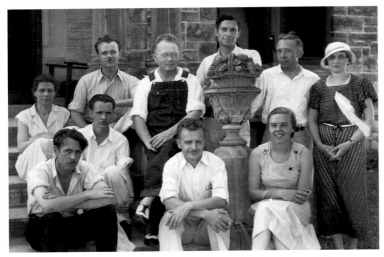

Fig. 26: Stone City Art Colony Faculty, Stone City, Iowa, summer 1932. Cedar Rapids Museum of Art Archives. Photo: John W. Barry.

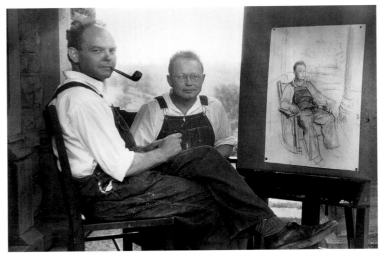

Fig. 27: John Steuart Curry and Grant Wood at Store City, Iowa, 1932. Cedar Rapids Museum of Art Archives. Photo: John W. Barry.

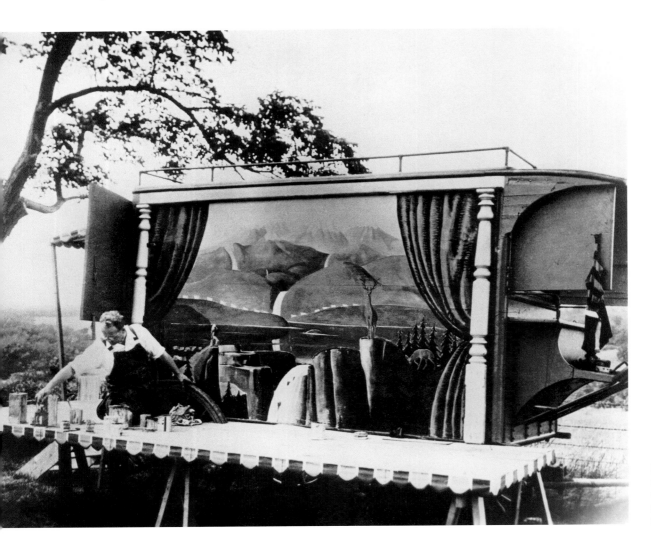

Fig. 28: Grant Wood with his decorated ice wagon at Stone City Art Colony, Stone City, Iowa, 1932. Courtesy of Figge Art Museum, Grant Wood Archives.

and probably the honorary doctorates Wood received in 1936–37 (fig. 50), were abhorrent to the refined Longman whose notion of "cultivation" had nothing to do with the soil. Tensions between the two men escalated into a zealous personal dispute, with Wood writing in early 1940 to Earl Harper, Director of the School of Fine Arts (Longman's immediate supervisor), complaining bitterly of the chairman's "general disparagement of my work and what I am working for," and asking to be appointed director of a new "creative art" program separate from art history.[26] Although anxious to retain their most famous faculty member, the university administrators nevertheless denied the request, and when Wood threatened to resign they granted him a sabbatical for the 1940–41 academic year, hoping time would solve the problem.[27]

Sensing an opportunity to be rid of his nemesis, Longman launched a campaign in the fall of 1940 to discredit Wood, both locally and nationally. In October at the Western Arts Conference he publicly criticized Wood's paintings, showing slides to demonstrate they were drawn from photographs and praising by contrast the work of Fletcher Martin (1904–79), his own hand-picked sabbatical replacement for Wood.[28] Less than a month later a *Time* magazine reporter came to Iowa City to investigate some unflattering rumors about Wood. Martin, who made no effort to disguise his disdain for Wood's work, was accused of being the source because he had just returned from New York, but he had only been in Iowa since September so most of his knowledge of Wood probably originated with Longman.[29]

Time's inquiry caused a furor even though the story was never published. The reporter's notes included a list of "charges:" that Wood had been fired from the university; that he relied on photographs because he could not draw; that students painted much of his work; and that they had vehemently protested his insistence that they use his methods in their own art.[30] While such accusations would garner little attention today (especially regarding the use of photographs), almost anything about Grant Wood was newsworthy in 1940. *Time*'s interest in the story, however, seems to have been driven by something infinitely more serious than was publicly admitted, a personal dimension that went largely undocumented in the voluminous university records about the episode. Only a few hints of the damning implications survive, the first appearing in a letter from an outraged Grant Wood to the dean, asking for an official investigation into the origins of the *Time* inquiry, "The charges are false," he wrote, "but they are so serious that they indicate a deliberate campaign to destroy my reputation as an artist and a teacher and to impugn my personal integrity."[31] This personal element was also a part of Lester Longman's carefully worded

official statement to *Time*. It denied the "charges" (although demurred on the issue of photography), insisting that Wood was a valued faculty member, but concluded with the implied aspersion, "You see, therefore, that Mr. Wood's personal persuasions have nothing whatever to do with our granting his leave of absence…"[32] Those "persuasions," of course, were something other than the artist's regionalist ideas or his pedagogical methods.

The charge of homosexuality was specifically recorded, if only in passing, in a much later meeting in University President Virgil Hancher's office: "It was also reported that comment had been made on the 'strange relationship between Mr. Wood and his publicity agent,' the inference and intimation indicating that Grant Wood was a homosexual and that Park Rinard was involved."[33] Rinard, the author of Wood's unpublished biography, was also the artist's assistant and had lived in his home for a time, including during Wood's brief marriage. Rinard was present at the meeting in Hancher's office, but his response to the comment went unrecorded.

Homosexuality, of course, was the one accusation in 1940 that could have ruined Wood's reputation merely by implication. Its virtual absence from the university documents, even though it was obviously an element in the controversy, is an indication of its delicacy at the time. Beyond these brief references there is no mention of the issue (although it has been a subject of considerable speculation in more recent years), even though the discussion about Wood and the problems in the art department lasted for months and was otherwise carefully documented.

Although Lester Longman was usually guarded in his public comments about Wood, the artist nevertheless believed him to be "at the heart of the most serious charges" and considered the university investigation (which relied on the chairman's involvement) "more of an attack…than a defense."[34] He was correct; Longman *was* intent on undermining Wood's reputation. He was already writing articles that called for the "defenders" of "true art…to attack" what he described as "reactionary" and "communazi" art, including Regionalism.[35] And in November 1941 he talked with the *Time* reporter in his office for two hours, inviting in faculty members Martin, Carl Okerbloom, and Horst W. Janson (who would later become famous in the discipline for his *History of Art* textbook), even though the Director of the School of Fine Arts had specifically warned Longman not to speak to *Time*.[36] A week later, in the name of the university's investigation, Longman gleefully solicited written opinions about Wood's artistic abilities from nearly twenty art historians and critics throughout the country, all carefully chosen for their dislike of Wood's work. Many of these were prominent, including editors of *The Art Bulletin, Art Digest,* and *The Magazine of*

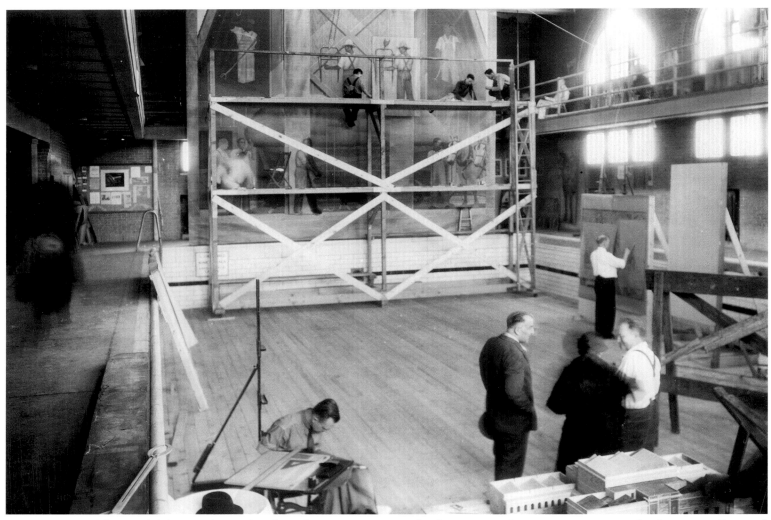

Fig. 29: Grant Wood (lower right) directing the Mural Studio in the empty swimming pool at the University of Iowa, Iowa City, 1934. Frederick W. Kent Collection of Photographs, Dept. of Special Collections, University Archives, University of Iowa.

Art, the president of the College Art Association, and curators and directors at several major museums, including Alfred Barr, Director of the Museum of Modern Art and Lloyd Goodrich, Curator at the Whitney Museum of Art.[37] Longman dutifully forwarded their critical letters to his director, deans, and the president of the university, saying that they were "evidence to show that as an artist he [Wood] is not so important as his publicity would lead one to believe …"[38] The critiques were varied but they all agreed that Wood's "sensationalist" and "provincial" popularity was without "enduring worth," his art was illustrational and dependent on photographs, and his pedagogy was self-serving.

Longman used the letters to discredit Wood and reinforce his own standing with the university administration, but his preoccupation with the artist went beyond these concerns, becoming almost pathological. Insisting in a bizarre letter to the dean in 1941 that the artist was "'out to get' me by hook or crook," he revealed the extent of his compulsion:

I must say, however, that I have been on the defensive in this for nearly five years, and if all this time I have misjudged him in this matter and have *for no good reason,* acquired an "obsession" about him (as charged), and never having had an "obsession" about anyone or anything else before, and generally speaking being a philosopher and man of reason, and usually rather tolerant and easy to get along with, it would be quite a strange thing. I quite freely grant I have this on my mind most of the time (and am terribly anxious to get rid of the problem), and don't mind its being called an "obsession" provided it

Fig. 30: Grant Wood, *February*, 1937. Lithograph, 8 $^7/_8$ × 11 $^7/_8$ in. Gift of Harriet Y. and John B. Turner II. 72.12.19.

Fig. 31: Grant Wood, *March*, 1941. Lithograph, 8 $^{15}/_{16}$ × 11 $^7/_8$ in. Gift of Harriet Y. and John B. Turner II. 72.12.41

is recognized that there *is indeed a good reason* for it and not something rather abnormal. It must be observed that one doesn't usually acquire an "obsession" about anything unless he is on the defensive in respect to it over a long period of time, and has no means of controlling the problem directly. And if this is true the first business in solving the problem would be to remove the causes of the so-called "obsession." And I want this done more than does anyone else.[39]

While this rather irrational statement says more about Longman than about Wood, it demonstrates the depth of the chairman's anxiety and the passion behind his efforts to diminish the artist's influence.

The official university investigation into the "Wood problem" finally concluded in June 1941 when the artist was given a new title and studio and was removed from Longman's supervision. Wood began, finally, to move beyond the controversy, spending the summer painting productively at Clear Lake, Iowa and returning to Iowa City with new optimism. His terminal illness was discovered by October, however, and only a few short months later, on the eve of his fifty-first birthday in February 1942, he died of pancreatic cancer (not liver cancer as has sometimes been reported).[40]

Although Wood himself was gone, the controversy that had surrounded him did not die with him.[41] Longman continued to forward articles that disparaged his buried foe to university administrators, persisting until Earl Harper had had enough. He wrote to the dean of the College: "Somehow there comes to my mind an old scriptural command, 'Let the dead bury their dead.'"[42] Insistent that

Wood's work represented not just a threat to his program but to the direction of modern art generally, Longman nevertheless went on to write articles that called Wood's art and Regionalism more generally "isolationist, tribalistic, chauvinistic illustration."[43] Saying that this type of art "constituted no grave danger to the arts so long as its exponents had little political power, . . . as the doctrine of American

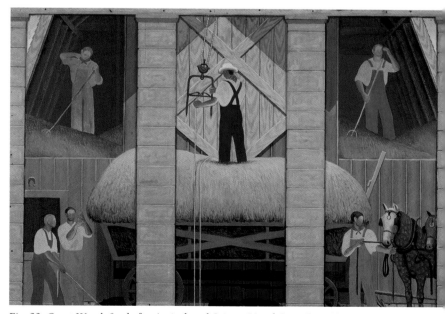

Fig. 32: Grant Wood, Study for *Agricultural Science Mural*, Iowa State University, Ames, Iowa, 1934. Oil on composition board, 32 $^3/_4$ × 47 $^3/_4$ in. Museum purchase, Mrs. G. F. Van Vechten Fund and Gift of Peter M. Turner. 90.7

Fig. 33: Grant Wood in his summer studio in Clear Lake, Iowa, next to unfinished *Spring in Town*, 1941. Cedar Rapids Museum of Art Archives.

prominent in the profession). An ardent proponent of modernism, Janson began his teaching career at the University of Iowa in 1938, but was abruptly fired in 1940 for taking a group of students to a Picasso exhibition in Chicago, an action he blamed on Wood's influence with the university administration. He was reinstated with Longman's help, but only after arguing that the chairman would never have power in his position if he did not intervene.[45] Janson left Iowa in 1942, and subsequently wrote several important articles that characterized Wood and Regionalism as fascist.[46] More significantly, he institutionalized a negative characterization of the movement (albeit without the pointed political aspersions) through his survey textbook, *History of Art,* which has sold millions of copies and remains in print today. Not surprisingly Grant Wood is not mentioned in the text and Regionalism receives one scant and rather negative paragraph that has gone unrevised through six editions.

Many others would add their voices to the overtly political climate of art history of the early 1940s, contributing to Regionalism's relegation in art history to the status of a provincial, virtually irrelevant art form until the late 1970s, even though its public popularity continued unabated. The prejudices that marginalized it were the consequence of an ideologically driven era that too often denied the significance of artistic plurality and regarded cultivation as an exclusive attribute. Although Grant Wood's own ideas could also be dogmatic, he devoted his life to reconciling the two notions of *cultivation*: one that reveals human character through hard work with the soil; and the other that aspires to create it through intellectual and artistic refinement. He believed both could coexist in American art and that together they might help remedy many of the cultural conflicts of his era. He was enormously popular with those who appreciated his efforts—often people who were themselves cultivators—but, as we have seen, his work was vehemently opposed, ironically by individuals who considered themselves *cultivated.*[47] For Wood, in contrast to those who saw culture as something to be brought *to* the provinces, cultivating Iowa was a lifelong endeavor that sought to be true to the place itself, and he realized more of its possibilities than he ever imagined.

isolationism acquired startling strength through the Depression years the seriousness of the danger became apparent."[44] Convinced that celebrating local character translated to National Socialism or that merely tolerating Wood's fame would forever associate himself with a region that he seems to have considered hopelessly provincial, Longman felt compelled to vilify Wood and the ideals he espoused.

Longman remained at the University of Iowa until 1958, leaving to spend the last few years of his career at UCLA. Despite his passionate publications his most enduring legacy was in the countless artists and art historians he mentored. Among these, Horst W. Janson (1913–82), the young art history professor who had attended the 1941 meeting with the *Time* reporter about Grant Wood's reputation, may have been the most influential since he went on to write the most important art history textbook of his generation and to teach at New York University's Institute of Fine Arts where he mentored countless students (many of whom, in turn became

Fig. 34: Grant Wood, Study for *Spring in the Country*, 1941. Charcoal, pencil, and chalk on paper, 23 ¹/₂ × 21 ¹/₂ in. Private collection.

Fig. 35: Grant Wood, *Sketch for American Gothic*, 1930. Pencil on paper, 4 ³/₄ × 3 ¹/₂ in. Private Collection.
Photo: D. James Dee.

Grant Wood Works on Paper: Cartooning One Way or The Other

James M. Dennis

Grant Wood is widely recognized for his mildly derisive sense of humor. This is due in large part to the enormous audience enjoyed by *American Gothic* (pl. 3), America's most reproduced painting. It began with a roughly three-by-two-inch pencil sketch that Wood drew and squared off on the back of an envelope (fig. 35). That the miniature sketch includes the main ingredients of the finished painting, save the three-tined pitchfork, the steel-framed eyeglasses, and the incessant stares, hints at a basic aspect of his mature creative process after 1930. Preparatory drawings became increasingly detailed compositions. A penultimate version of a given work, that is, a cartoon on paper, would undergo little editing as he converted its images into their final form and medium as a painting, illustration, or lithograph. This manner of cartooning a picture into existence increasingly merged with his cartooning as pictorial humor during the final decade of his relatively brief life.

In an entertaining variety of works throughout his career, Wood consistently followed Mark Twain's initial avoidance of overt social or political criticism. In a letter to Cyril Clemens of the Mark Twain Society, Wood credited the subtle wit fundamental to the two classic "Adventures" of Tom Sawyer and Huckleberry Finn as having cured him of emotional excesses, sentimental or otherwise.[1] His restrained sense of humor is exemplified at an early age when he executed pen-and-ink illustrations for his high-school yearbook. In the spring of 1908 the graduating senior, that is, *Man of the Class*, was drawn for the Senior Class section of the yearbook (fig. 36). He stands outside the school door, nervously toeing the edge of its threshold. He is dressed in a wrinkled, oversized suit, perhaps lent to him by his father, a floppy, broad-brimmed hat pushed back on his head, and brand new shoes. He self-consciously jams his hands into his coat pockets, his newly received diploma rolled up under his left arm. Squinting anxiously to his left into the future, he seems to be in a quandary as to what his first step toward adulthood should be.

This apparently was not the case for the young Grant Wood who, two years later, on the very night of his graduation from Washington High School in Cedar Rapids, Iowa, skipped the prom and took a train to Minneapolis to attend The School of Design,

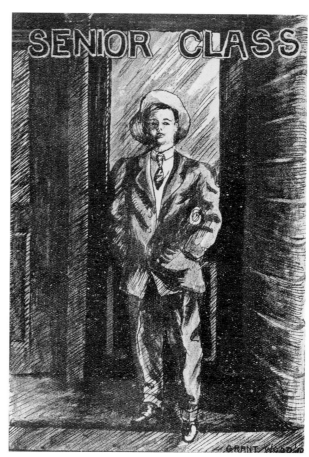

Fig. 36: Grant Wood, Yearbook Illustration, Senior Class, 1908. Cedar Rapids High School Reveille, Washington. Cedar Rapids Museum of Art Archives.

Handicraft, and Normal Art. There he enrolled in a summer design course taught by California-based Ernest A. Batchelder, a leading American advocate of the English Arts and Crafts Movement with which Wood had become acquainted through reading Gustav Stickley's *The Craftsman* magazine. From Batchelder, who had published a series of lessons in basic design in the magazine, he not only learned the rudiments of metalwork and furniture-making but also the principles of pictorial composition. He was eventually to combine these rules with what he learned and later taught to junior-

Fig. 37: Grant Wood, *House with Blue Pole*, 1924. Watercolor on paper, 8 ⁷/₈ × 10 ⁷/₈ in. Gift of Harriet Y. and John B. Turner II. 72.12.29

high and high-school art classes from Arthur W. Dow's widely distributed *Composition: A Series of Exercises in Art Structure for the Use of Students and Teachers*. This combination benefited his breakthrough paintings of the late 1920s and all his post-*American Gothic* works throughout the 1930s.

Both Batchelder and Dow stressed flat-patterned composition which Wood began to employ in scores of early, otherwise painterly, close-up landscapes alive with trees; in an assortment of local townscapes featuring homely, backyard structures; and in cityscapes of houses, fountains, and doorways painted during four visits to Europe. In at least one of the latter he included a touch of art-historical humor. In *House with Blue Pole, Paris*, (fig. 37) a watercolor of 1924, a jaunty young couple in summer frocks walk by the dark doorway of a stone house. In front of the house, to their right, stands a highly abstracted woman with a black, broad-brimmed hat and walking cane, painted exactly in the style of the little yarn-doll figures occupying Maurice Utrillo's street scenes of the same time. Too close to be a mere coincidence, this visual quote was obviously intended as a quip.

A year earlier, Wood's comic sense surfaced more explicitly in three horizontal pencil drawings which lampoon, as the general title of the works indicates, *Savage Iowa* (or *East Coast View of the West*; figs. 38–40). *Buffalo Stampede* (fig. 38) turns a herd of buffaloes charging down a Wild West Main Street into a rollicking ballet act. The stray beasts of the plains pass in front of The Parlor City Saloon, knocking down power poles, a barber pole, and a lamppost, all objects of civilization. At the same time they rear on slender, femi-

Fig. 38: Grant Wood, *Untitled*, from suite "Savage Iowa" (*Buffalo Stampede*), 1923. Pencil and wash on paper, 12 × 31 ¹/₂ in. Smithsonian American Art Museum, Gift of Park Rinard. 1995.86.2

Fig. 39: Grant Wood, *Untitled*, from suite "Savage Iowa" (*Indian and Cowboy*), 1923. Pencil and wash on paper, 10 × 27 in. Smithsonian American Art Museum, Gift of Park Rinard. 1995.86.1

Fig. 40: Grant Wood, *Untitled*, from suite "Savage Iowa" (*Clothesline*), 1923. Pencil and wash on paper, 13 × 31 ¹/₂ in. Smithsonian American Art Museum, Gift of Park Rinard. 1995.86.3

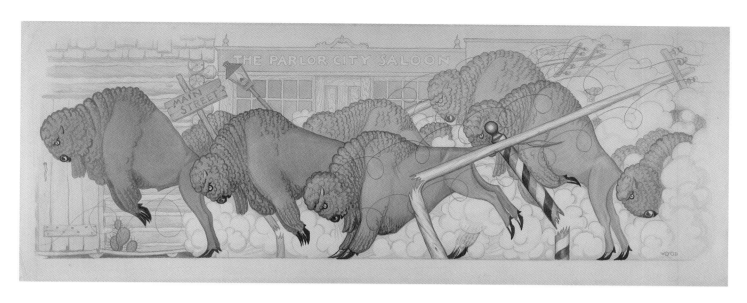

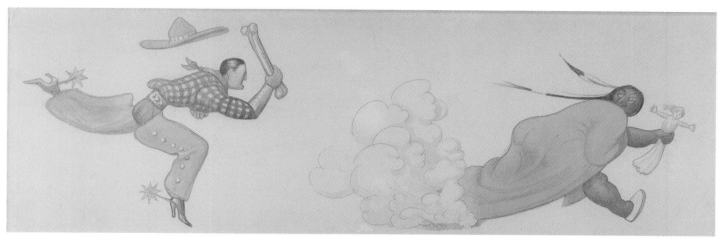

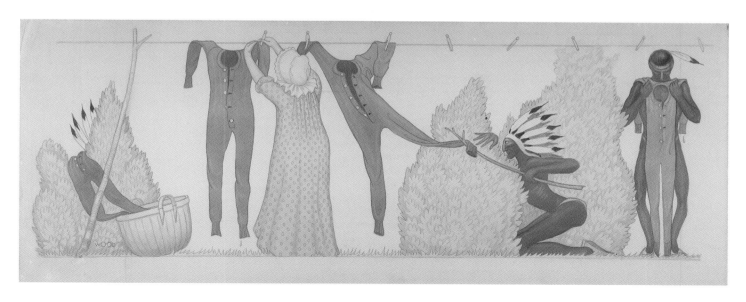

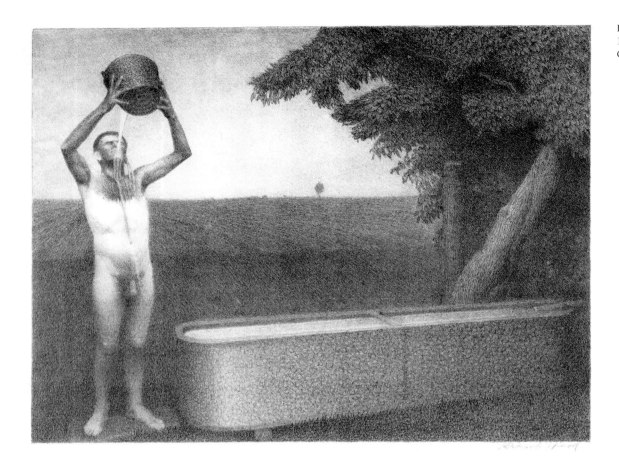

Fig. 41: Grant Wood, *Sultry Night*, 1937. Lithograph, 9 × 11 ³/₄ in. Gift of Peter O. Stamats. 85.3.7

nized hind legs and kick up high-heel hooves that look more like patent-leather, pointed pumps, in keeping with the marcelled fur of their heads and humps. Thus stylized, the stage-front foursome could very well be a comment on the extremes of a post-World War I "flapper" fashion parade.

The obsession with stereotyped cowboys and Indians in silent films also caught the amused attention of movie-goer Wood. In *Indian and Cowboy* (fig. 39) a Hollywood cowboy with slicked-back hair, a strong, he-man jaw, protruding chin, plaid shirt, narrow, wide-belted waist, leather chaps, extremely high-heeled boots, and huge spurs loses his ten-gallon hat as he chases a plump, robed Indian. Intent on saving the rag-doll maiden kidnapped by the Indian, he races after a cloud of dust, brandishing, curiously enough, a phallic leg bone instead of a six-shooter. In *Clothesline* (fig. 40) an unsuspecting pioneer woman, busy hanging up her washing of long underwear, is visited by three stealthful warriors hiding behind conveniently placed bushes. One pair of long johns is seen slipping out of the laundry basket, while a second pair is the desired goal of an essentially naked tribesman who attempts to fish it from the clothesline with a long stick. A third, more successful,

bow-legged thief holds his newly acquired pair in front of him to see how they might fit. Hardly what one would ordinarily imagine as the aim of a typical attack against frontier settlers, long underwear appealed to Wood's sometimes rustic playfulness as an amusing motif. Some ten or so years later he went so far as to send out a want ad for a suit of red long underwear to use in a painting he envisioned of a wintertime, Saturday-night bath in a 19th-century rural kitchen. This idea was finally abandoned and the long underwear ended up in a lithograph, *Midnight Alarm*, depicting a man holding a kerosene lamp to light his way down a staircase.

With the exception of a small, very comical female nude that he painted one night inside the liquor cabinet of his friend Dr. Welwood Nesbit of Madison, Wisconsin, Wood's unclothed figures were exclusively naked men. The most famous—once infamous— of these is his 1937 lithograph, *Sultry Night*, (fig. 41) in which a farmer has stripped down after a hot summer day in the field to take an impromptu shower. Facing forward at the end of a watering trough into which he has dipped his bucket, he pours sun-warmed water over his chin, neck, and chest. Only the "farmer's suntan" might be considered the least bit funny. Otherwise, the image has

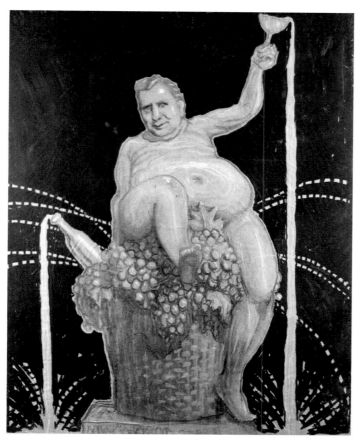

Fig. 42: Grant Wood, *Charles Manson as Silenus*, 1928. Chalk and paint on paper, 36×29 in. Private Collection.

been ultimately accepted as a straightforward, natural interpretation of the man of the soil, as an iconic, noble yeoman.

Such ennoblement was impossible for Wood's earlier, equally controversial nude, *Charles Manson as Silenus* (fig. 42). Preceded by an assortment of male nudes in the early 1920s, including a class-room life study, a teenage bather, and eight allegorical figures, the 1928 Silenus portrait was intended to be a joke. Manson, the executive secretary of the Cedar Rapids Chamber of Commerce was to be toasted, and perhaps "roasted" at a dinner to commemorate his devoted service. A committee of leading local businessmen approached Wood to come up with a humorous portrait of the guest of honor, one that could be presented to him at the end of the meal. The resulting yard-high chalk-and-paint drawing was done in a basic cartoon style shared by numerous contemporaneous American painters, including William Gropper, Peter Blume, Ben Shahn, Reginald Marsh, and fellow "Regionalist" Thomas Hart Benton. It caricatures the head, face, and overweight body of his friend as the over-indulgent foster father of Bacchus. Accordingly, he is dressed only in a strategically placed grape leaf. Perched in foreshortened view on top of a pedestaled basket overflowing with freshly picked grapes, he stares drunkenly down at us as champagne pours from a bottle and spills out of an uplifted glass. Tracers fly out from behind like fireworks against a black sky, adding to the bright vertical streams and their respective splashes in a decorative, ceremonial composition. All this frivolity unfortunately backfired when the

Fig. 43: Grant Wood, Study for *Draft Horse*, 1932. Charcoal and pencil on paper, 16×22 in. Gift of Happy Young and John B. Turner II. 72.12.16

Fig. 44: Grant Wood, Study for *Race Horse*, 1932. Charcoal and pencil on paper, 16 1/2 × 21 1/4 in. Gift of Happy Young and John B. Turner II. 72.12.55

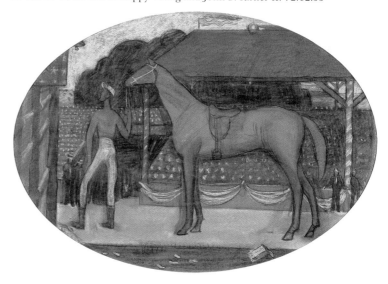

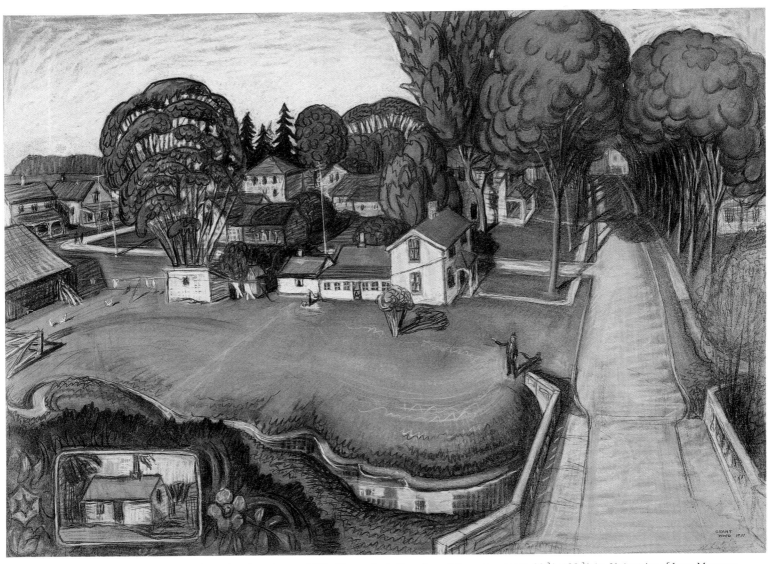

Fig. 45: Grant Wood, Study for *The Birthplace of Herbert Hoover*, 1931. Charcoal, chalk and graphite on tan paper, 29 ³/₈ × 39 ³/₈ in. University of Iowa Museum of Art, Gift of Edwin B. Green. 1985.92

highly embarrassed Manson bolted from the party, resigned his position, and immediately left town never to be seen in Cedar Rapids again.[2]

Cartooning as a means of poking fun at a subject, and cartooning as the last step in drafting a work into final form, jelled for Grant Wood as he enjoyed the initial success of *American Gothic*. Its affectionate projection of Midwestern provincialism, extending from farm and field to Main Street and national identity, continued throughout much of his work during the Depression years of his final decade. Like his amusing 1931 painting *Appraisal* (pl. 8), his drawings *Draft Horse* and *Race Horse* of 1932–33 spoof outward

appearances of taste and value separating urbanity from the barnyard (figs. 43, 44). Their contours and decorative patterns, already well detailed as charcoal, pencil, and white chalk sketches on cinnamon-colored butcher's paper are to reappear more refined and pronounced with the use of the same materials on white Bristol board. The bulky draft horse, sniffing an apple offered by a thick-limbed farmer in front of a big red barn, has little in common with the extremely lean racehorse held by a beanpole jockey in front of a grandstand of uniformly packaged people and two groups of horse owners. In place of a luxurious, Grant Wood landscape, the Stars and Stripes identifies more appropriately with a spilled box of

peanuts than it would with the patch of dandelions infesting the otherwise pristine barnyard.

Upward mobility as the idealized aim of the American way of life underlies the ornately detailed, full-scale, chalk-and-pencil cartoon drawing for *The Birthplace of Herbert Hoover*, (fig. 45). In order to underline the theme Wood inserted a picture inside the picture near its lower left corner, depicting the original cabin home of the much vilified president. As a "visual aid" to the distant, diagonally pointing guide, the inset helps locate the specific site of birth obscured by two later, much larger farmhouse additions on the edge of tiny West Branch, Iowa. That the orphaned son of a poor Quaker family from "way out there" could graduate from Stanford, become a wealthy world-class civil engineer, and eventually the president of the United States, lived up to the log-cabin myth that originated with the election campaign of the first "common-man" president, Andrew Jackson. But in Hoover's case, the aura of humble beginnings must have lost much of its symbolic appeal as the economy bottomed out at the height of the Great Depression.

The paradox of Wood's playful painting of a lush little community (fig. 46, also pl. 12) would increase over the months following its completion, as Hoover, until the very end of his term, rejected all proposals of federal relief for the unemployed and thereby precipitated the loss of homes for thousands of working-class families. Victims of neglectful policies most surely would have looked upon a cute little tucked-in, white cabin home with envy if not contempt in view of the ramshackle "Hoovervilles" being thrown together from scrap on dump sites of America's industrial cities. Such a social crisis allows for an edge of criticism in the content of an otherwise

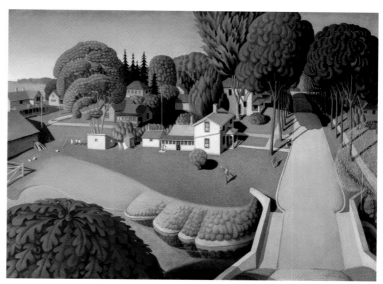

Fig. 46: Grant Wood, *The Birthplace of Herbert Hoover*, 1931. Oil on Masonite, 29 5/8 × 39 3/4 in. Des Moines Art Center Permanent Collections; Purchased jointly by the Des Moines Art Center and The Minneapolis Institute of Fine Arts, with funds from the Edmundson Art Foundation, Inc., Mrs. Howard H. Frank, and the John R. Van Derlip Fund. 1982.2

commemorative painting, and may have contributed to its rejection by none other than Hoover himself.

The subject of the painting, innocuous at best, had been suggested to the now renowned Wood by a group of Iowa businessmen who wished to present the work to the president as a gesture of appreciation. As with Charles Manson, however, the intended recipient was not pleased with whimsy. In spite of his problematic administration, Hoover wished to be remembered as a rag-to-riches

Fig. 47: Grant Wood, Study for *Daughters of Revolution*, 1932. Charcoal, pencil, and pastel on paper, 22 × 41 3/4 in. Collection of Coe College, Cedar Rapids, Iowa.

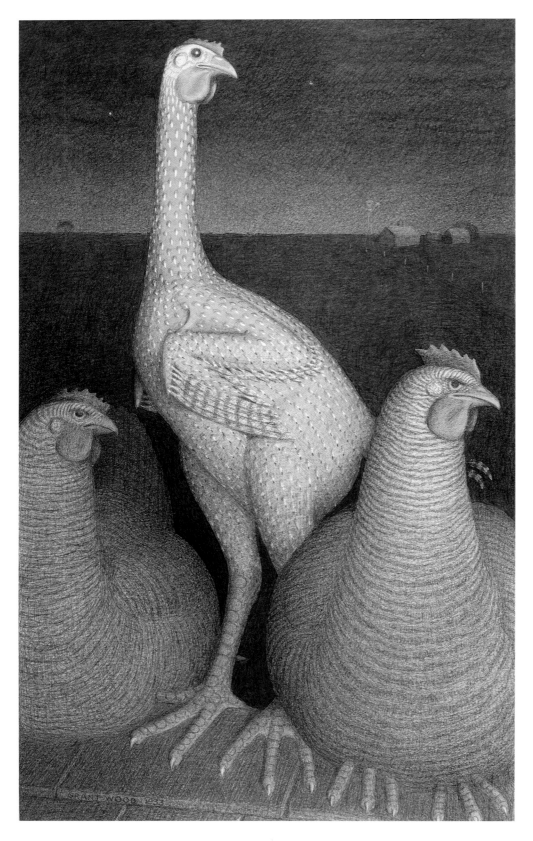

Fig. 48: Grant Wood, Study for *Adolescence*, 1933. Brush and black ink wash, pencil, and white chalk on brown paper, 24 $^1/_2$ × 14 $^5/_8$ in. Private Collection.

success story, and would have preferred a painting of his family's cabin standing alone, unencumbered by any later additions that obscure it. Consequently the group of Republican admirers from back home were forced to back off and return the painting unpurchased.[3] The painting's omission of the drawing's charming little picture within the picture, which focusses one's attention on the actual historical landmark, cost Wood the opportunity of being represented in the collection of an ex-president of the United States.

As demonstrated by *American Gothic*, *Victorian Survival*, and *Appraisal* Wood preferred to concentrate on close-up studies of individuals as a means of spoofing foibles and fables. During the Depression-bound election year of 1932 he laid out and composed his second best known, and perhaps funniest painting, *Daughters of Revolution,* in a detailed pencil, charcoal, and chalk drawing on butcher's paper (fig. 47). An act of revenge, this cartoon and the painting which followed directly on its heels (pl. 10) made fun of the local chapter of the overly nationalistic Daughters of The American Revolution (D.A.R.), which, three years earlier, publicly denounced the fabrication in Munich, Germany of Wood's large stained-glass window for the Cedar Rapids Veterans Memorial Building. The campaign waged by the ladies against Wood, a World War I veteran who had the audacity to go to the land of the enemy to work on the window's allegorical figures of the Republic and six servicemen of America's major wars, delayed its commemoration until many years after his death.

Not one to brawl over anything, even a personal affront, the mild-mannered Wood softened his counter-attack by eliminating "the American" from the title of his most satirical picture. Nevertheless, his target was obvious. By studying membership photographs in D.A.R. yearbooks he arrived at three stereotypical caricatures complete with pulled-back hairdos, thin-lipped, steady-eyed expressionlessness, flower print dresses, and tatted lace collars. The drawing's ordinary teacup and unresolved hand evolved effectively into willow-pattern china extended from the end of extremely elongated fingers, an example of Wood's final editing in the painted version. His success in striking home was expressed in a letter to the editor of the *Cedar Rapids Gazette and Republican* in the spring of 1933. An irate D.A.R. member demanded that "this hideous monstrosity" be removed from The Little Gallery, a local experiment in community art patronage, sponsored by the American Federation of Arts and financed by the Carnegie Foundation. She claimed to be speaking for all of her friends "who glory in the fact that their ancestors fought for American freedom."[4]

It was exactly this ancestor worship that Wood was aiming at. He was repelled by its built-in class snobbery and racism seven years before Eleanor Roosevelt renounced the D.A.R. for preventing the great African–American contralto, Marian Anderson, from singing at Constitution Hall in Washington, D.C. Since his patriotism was brought into question by his work with German craftsmen in Germany, Wood retaliated by including in his picture a reproduction of what remains the most beloved, patriotic American battle painting, *Washington Crossing the Delaware*, which, ironically enough, was painted on the River Rhine in Düsseldorf. In choosing it for the background of his *Daughters of Revolution* he was more than likely aware of this irony. He may also have known that the German–American artist, Emmanuel Leutze, who painted this masterpiece in 1848, actively participated in the revolution of that year and intended to inspire further struggle for a democratic German republic through his depiction of the undaunted heroism of Washington and his men. These facts would most likely be unknown to jingoistic ladies standing in front of a steel-engraved reproduction of the painting. Nevertheless its presence underscores the incongruity of their repudiation of Wood's memorial window which was merely fabricated, not designed, in a defeated country that was about to be tragically sidetracked from its struggle toward democracy.[5]

In the fateful year of 1933, Wood repeated the theme of naive matronly protectiveness in his initial close-up drawing of two fat hens flanking a fledgling plucked down to mere pinfeathers in *Adolescence* (fig. 48). The painting, which duplicated the ink wash,

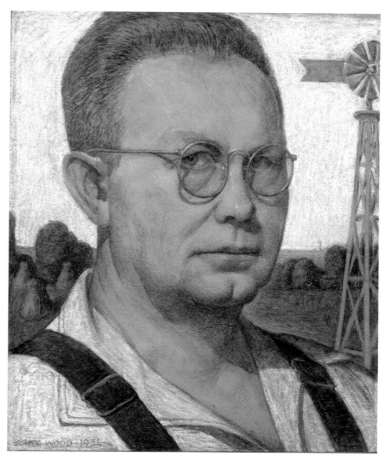

Fig. 49: Grant Wood, Study for *Self-Portrait*, 1932. Charcoal and pastel on paper, 14 $^1/_2$ × 12 in. Museum purchase. 93.11

pencil, and chalk cartoon on butcher's paper, did not occur until 1940. Roosting on top of a henhouse in the dead of night, the three stage-lit chickens remain wide awake, staring out at us with monocular vision, beaks pointed in one direction. While this in itself might strike us as funny, the speckled nakedness of the rigidly erect center of attention, topped by a head held ridiculously high on an extremely elongated neck, comically dramatizes the cocksure vulnerability of puberty.[6] Just such a figure could very well have appeared in a Looney Tunes animated cartoon, with which Wood was well acquainted by the time he went to Hollywood in 1940, the same year he painted *Adolescence* (fig. 118). The purpose of the trip was to concoct a publicity painting for the Walter Wanger–John Ford movie of Eugene O'Neill's *The Long Voyage Home* from a scene featuring John Wayne, Thomas Mitchell, and Barry Fitzgerald.

The technique of working from photographs developed as a trademark of Wood's detailed cartoons for his figurative paintings, with the possible exception of what appear to be direct,

mirror-image renderings of himself. No matter how humorous, the severity of his emotionless faces—perhaps a testimony to what he might have considered an overall flatness of the Midwestern personality—infiltrates his self-portraits. In 1932, the same year he provided the Hotel Montrose dining room in Cedar Rapids with five iconic images of a rosy-cheeked farm family (figs. 24, 25), he saw himself out of the corner of his eye as the reflection of a farmer wearing steel-rimmed glasses. The charcoal-and-pastel cartoon on butcher's paper of *Self-Portrait* (fig. 49) aligns the inner contour of Wood's lips with the perfectly horizontal horizon line. It also allows the cleft of his chin to act as a vertical accent parallel to the foremost leg of a middle-ground windmill whose vane encloses the open side of the composition. The corn has been harvested and overall straps press down on the wide-open collar of a fresh white shirt. This manner of wearing his favorite piece of apparel is recorded in various photographs going back to the summer of 1920, when he was snapped at a café somewhere in France, maybe Strasbourg, downing a liter of beer and sporting a peculiar-looking moustache and beard.[7] When the painted version of *Self-Portrait* (pl. 16) remained unfinished at the end of 1941, the overall straps as well as the white of the shirt had disappeared under a heavy layer of blue pigment. A gloomy premonition of Wood's cancer-ridden demise, this dark shade lowered the mood of the picture and obliterated a pronounced sign of his rural origin.

A deliberately staged cast of seemingly provincial characters in front of a red-barn backdrop stand behind the self portrayed artist, hard at work in the two almost identical versions of *Return from Bohemia*, one a pastel and charcoal (pl. 17) and the other a crayon, gouache, and pencil, both done in 1935 on butcher's paper. Slightly more finished in technique, the latter was intended to serve as the jacket for a projected, but never completed, autobiography of the same title. Its vaguely prodigal-son theme of regionalist reconfirmation relates to Wood's professed conversion experience following his extensive painting trips abroad in the 1920s. As the story goes, the adventurous artist had wandered away from his homeland, nearly lost himself to a modernist bohemian lifestyle in the European, especially Parisian, art world, and ultimately realized that in order to achieve his true artistic identity needed to return home and respond to the subject matter with which he had grown up and knew best. Although Wood's initial painterly techniques, compositional devices, and color schemes did not noticeably change in his European paintings of primarily urban subjects, the reformed style of his Regionalist works, announced by *American Gothic* and *Stone City, Iowa*, adopted linear techniques from the Late Gothic and Neue Sachlichkeit paintings he viewed in Germany in 1928. The former

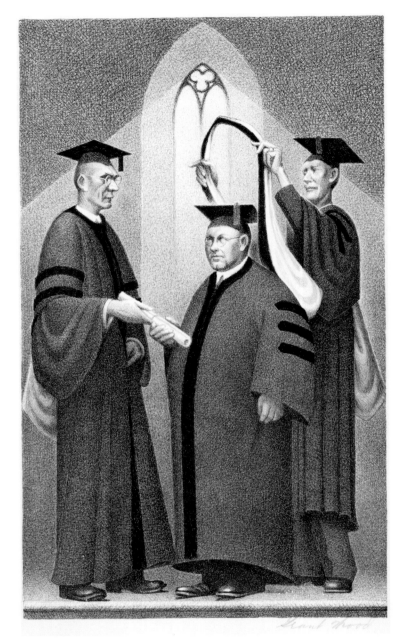

Fig. 50: Grant Wood, *Honorary Degree*, 1937. Lithograph, 11 7/8 × 7 in. Gift of Harriet Young and John B. Turner II. 72.12.27

related to the handicraft discipline of Batchelder and the latter in some instances maintained the spirit of pictorial design taught by Dow. Cubism too, although he never came out and said so, probably "added a lot of valuable tools to the kit of the artist," as he admitted Modernism in general had done.[8]

In the act of returning from bohemia, the newly enlightened artist, brush at the ready, contemplates his next stroke—a relatively

large one judging from the size of the brush. His open-collared shirt glows between the foremost space definers, the immaculately fastened canvas on its easel and the round palette. Light falls from directly above, illuminating the contour of his head and causing his shoulders to shine incandescently. Highlights over his frowning brows contrast with the deeply cast shadows behind his heavily framed glasses. Further bright spots accompany the shaded undersurfaces of his nose and firmly set mouth, as the darkened center of his neck is accentuated by a counter-lit chin. Very similar to the close-up lighting of a film actor, applied time and again for dramatic effect in movies of this period, Wood's handling of his image separates him, the creative artist, from the middle-ground gathering. He occupies his own special space, essentially more interior than exterior, with a hiatus clearly separating him from the audience of "local folk." David Turner, his foremost Cedar Rapids patron, wears a common, 1930s' cap and coat sweater in the center. Minus his eyeglasses a tall Edward Rowan, the Chicago-born, Harvard-trained director of The Little Gallery and by this time an assistant director of the PWAP in Washington, D.C., towers above him.[9] A farm family of three squeezes in from the sides. Backs to the barn, all five ostensibly watch the great master at work. However, they do not appear to be looking at the artist, let alone at the work of art with which he is preoccupied. They seem more in a state of devotion, bowing their heads and closing their eyes in worship of genius. Foreground and middle-ground behavior combined, ego gratification might well be the target of the picture, a glorification of the artist so melodramatic as to be laughable, a cartoon caricaturing fame.

Such was certainly the case in Wood's final self-portrait. Thanks to his boyhood friend, Dr. Welwood Nesbit, a collector of his works and a member of the Eye, Ear, and Nose Department in the Medical School at the University of Wisconsin in Madison, Wood received an honorary degree there in 1936. A year later, one of the first of his 19 lithographs, *Honorary Degree* (fig. 50), ridicules the experience and simultaneously mimics his highly intense image of the self-glorified artist in *Return from Bohemia*. In a reversal of *Adolescence*, the chubby figure is now flanked by a gangly pair, as two impossibly tall and slender university officials, decked out in mortarboards and academic robes, tend to the stubby recipient dressed up in the same attire. One rather absent-mindedly hands over a diploma as the other raises the ceremonial hood. Suspended there, its neck-piece mysteriously assumes the outline of the Gothic arch and tracery through which a dramatic light streams. The pretense of solemnity paralyzes the upwardly staring "provincial" from the University of Iowa, and his amusing appearance is increased by the raised tilt of his robe's hem, which unveils a pair of large, brightly shined oxfords.

Caricaturing himself, friends, and associates (for example Dean Carl Seashore and Professor Norman Foerster of Iowa City in *Honorary Degree*) played a central role in Wood's personal iconography. His habit of doing this was not yet chronic in 1919 when he exaggerated the head, hair, and facial features of his dear friend Marvin Cone in his fun-loving oil portrait called *Malnutrition*. But by the time he unintentionally humiliated Charles Manson, embarrassed his dentist in *American Gothic*, attenuated the neck of his aunt Matilda in *Victorian Survival*, and stereotyped the Daughters of The American Revolution, he was well in the groove of exploiting portrait photographs for purposes of primarily light-hearted commentary. Six of his nine full-page illustrations for a Limited Editions version of Sinclair Lewis's celebrated novel *Main Street* are a perfect case in point. A 1936 cartoon and subsequently finished charcoal, pencil, and chalk drawing on butcher's paper lampoon a fleeting

Fig. 51: Grant Wood, *Booster*, 1936. Charcoal, pencil, and chalk on brown paper, 20 1/2 × 16 in. Collection of Figge Art Museum, Museum purchase with funds provided by Friends of Art Acquisition Fund and Mr. and Mrs. Morris Geifman. 93.3

but symbolically important character from near the end of the novel, "Honest" Jim Blausser (fig. 51). Entitled *Booster*, they constitute a photo-based caricature of Wood's close friend at the University of Iowa, journalism professor Frank Luther Mott, his anonymous collaborator in writing his personal manifesto *Revolt Against the City*. With snapshot spontaneity, the land speculator and real-estate developer Blausser is caught gripping the front of the lectern at The Commercial Club, pointing into the air, and staring us down. He is soliciting support through folksy salesmanship of his scheme to turn Gopher Prairie's Main Street into a "White Way" and bring still more industry into the town. True to Lewis's narrative, Wood described the bulky hustler in his "brilliant" clothes and then added a Masonic ring, a Moose pin, and the eagle-topped flag to signify his wartime, "growth-is-good" patriotism. As a caricature, Wood exaggerated Professor Mott's jowls, thickened his upper body, narrowed his eyes, extended his ear, removed his sideburn, and reparted his thickened hair to create what he considered the typical appearance of a provincial parvenu.

Lewis-like lampooning of Midwestern town life held Wood's attention at least one more time among his continuous farm-related paintings and prints during his final five years. That middle-class, white American males would don tasseled, truncated cone caps identified with the ancient religious center of Morocco, complete with pseudo-mystical emblems, was reason enough for an artist prone to light parody to go after them with tongue in cheek. And if four members of the Ancient Order of the Nobles of the Mystic Shrine, founded in the United States in 1872, performed in front of a desert backdrop of brand new pyramids they became irresistible targets for his good-hearted gibes. In the lithograph, *Shrine Quartet* of 1939 (fig. 52), locally identifiable individuals (presumably friends of the artist) wear identical white shirts and ties and lift their voices in barbershop harmony, eyes, ears, and mouths straining upward with the exception of those of the bass in the lower right corner. Punctuated by flat, black shadows, the obvious but essentially harmless artificiality of orientalizing the entertainment contingent of a once controversial secret society brings the performance back to mundane reality. Indeed it is this relaxed recognition of a make-believe world for what it is—an entertaining attempt to enrich an otherwise utilitarian existence—that activates Wood's climactic cartooning-cartoon and its duplicate painting, *Parson Weems' Fable* (fig. 53), also of 1939.

In defending mythmaking, even flim-flam fantasizing, against a restrictive insistence on historical fact, Wood positioned his image of Parson Macon L. Weems up front, practically in the viewer's space,

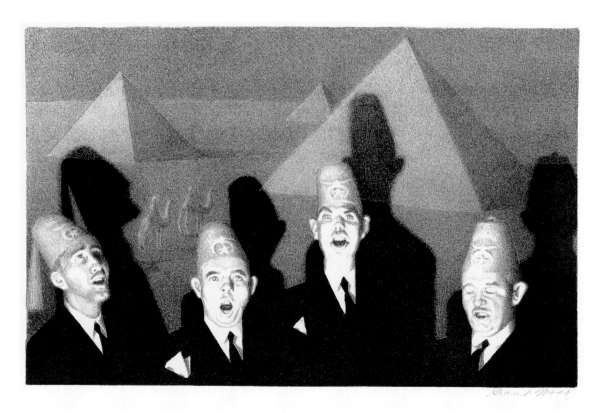

Fig. 52: Grant Wood, *Shrine Quartet*, 1939. Lithograph, 7 ¹/₂ × 12 in. Gift of Mr. Peter O. Stamats and Mr. Larry K. Zirbel. 85.6.1

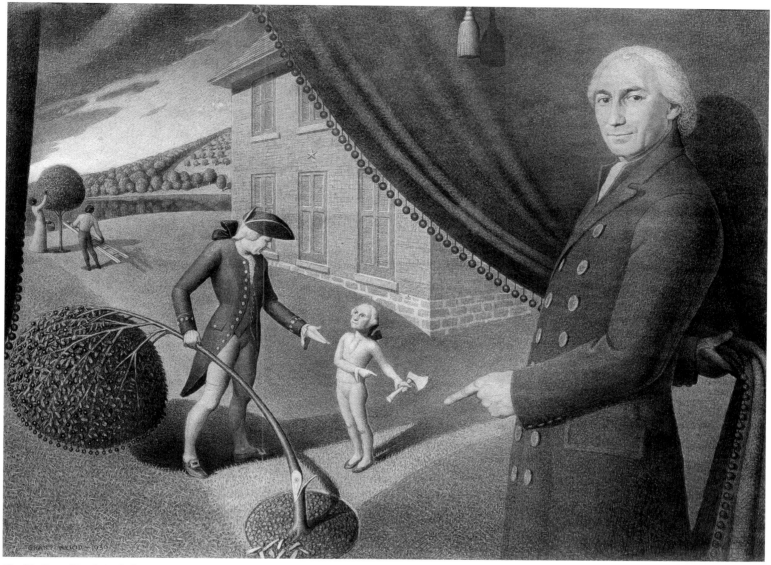

Fig. 53: Grant Wood, Study for *Parson Weems' Fable*, 1939. Charcoal, pencil, and chalk on paper, 38 ³/₈ × 50 in. Private Collection.

looming on the picture plane. The legendary preacher–teacher, caricatured from a photograph of Professor John E. Briggs of the State University of Iowa, holds open a cherry-trimmed curtain in a more subtle manner than Charles Willson Peale's hoist of heavy drapery in his *Artist in His Museum*. Nevertheless, he dramatically discloses the apocryphal tale of the once naughty but always honest George Washington. He points directly at the mortal slash in the trunk of the young cherry tree, while the miniaturized patriarch of the United States points at his hatchet, confessing his misdeed to a remonstrating father. In order to avoid any doubts as to the boy's identity, Wood performed what amounts to his most expressionistic stroke of whimsy. He plagiarized the iconic, "Athenaeum" head of the eld-

erly Washington painted by Gilbert Stuart in 1796, universally known to the American public through its engraved reproduction on the dollar bill. In doing so he altered only the eyes of the original, since the first president-in-the-making had to look upward at his parent. This distortion of Weems' reference to "the sweet face of youth brightened with the inexpressible charm of all conquering truth" provoked a *Chicago Tribune* writer who foolishly accused Wood of being "motivated by fiendish desire to belittle great men."[10] Pursuing this line of criticism one could include Wood's contrast of momentary but devastating bad behavior at stage center with the exemplary conduct in the background. There a young African–American slave dutifully assists a woman, perhaps his

mother, in picking ripe cherries. Storm clouds gather to threaten them, but not the future *pater patriae* who glows white, a lantern of privilege.

This culminating example of flirting with satire capped Wood's career-long experience in creating cartoon-like pictures, and repeated his mature process of preceding a finished painting or print with a cartoon. It also strengthened his credentials as a modernist. Although at odds with the "School of Paris," which probably meant the dominant influence of Picassoesque Cubism, he did consort with the enemy and adopt some of its "valuable tools." The abstract order of *Parson Weems' Fable* results largely from Wood's mechanical method of accommodating contemporary principles of pictorial design. Curving diagonals connect the pairs of evenly spaced points that divide each edge of the picture into three intervals. These points coincide with the two highly abstracted treetops, with the intersection of the curtain's edge and that of the storm cloud, with

the fold in the curtain behind Weems, and with the exactly round plot of soil at the base of the chopped trunk. Activated by what Batchelder termed a "play impulse," Wood's fanciful farmscapes, including the segment of one in *Parson Weems' Fable*, move rhythmically in and out "like successive layers of theater scenery," an analogy used by critic Leo Stein, Gertrude's brother, to describe a cohesively composed abstraction.[11] In such a dynamic complex of transverse planes, illusions of volumes, for example, the house, trees, and hill tend to flatten out, floating to the picture's surface as figures stand out in relief. The subject matter they enact, rather odd in its own right, became increasingly eccentric through Wood's personal fancy and inventiveness. It is this freedom from academic norms or from any specific school or tradition that qualify a majority of his mature works, a good number of them droll comments on American matters and manners, as independently modern.

The Plates

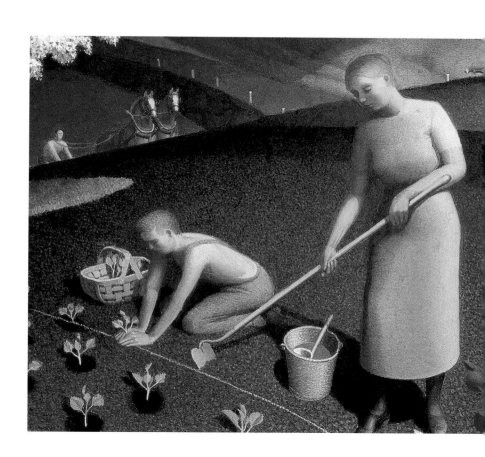

Plate 1: Grant Wood (designer), *Memorial Window*, 1928–29. Emil Frei Art Glass Company, Munich, Germany (fabricator). Stained glass, 24 × 20 ft. Veterans Memorial Building, Cedar Rapids.

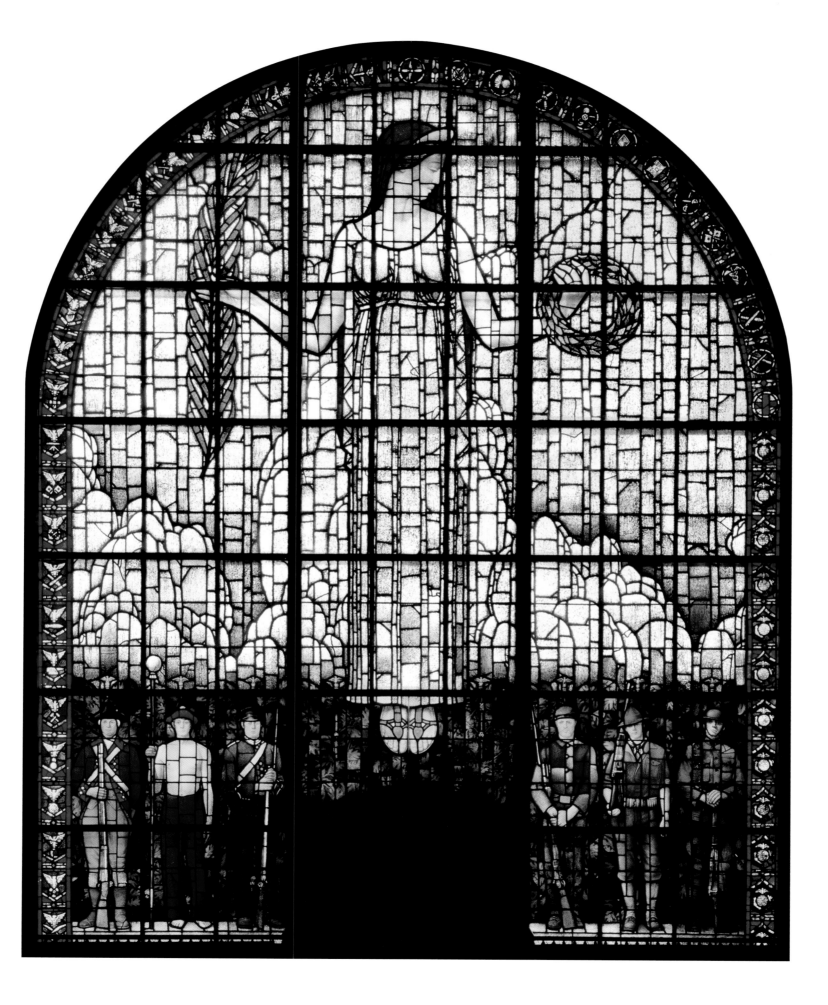

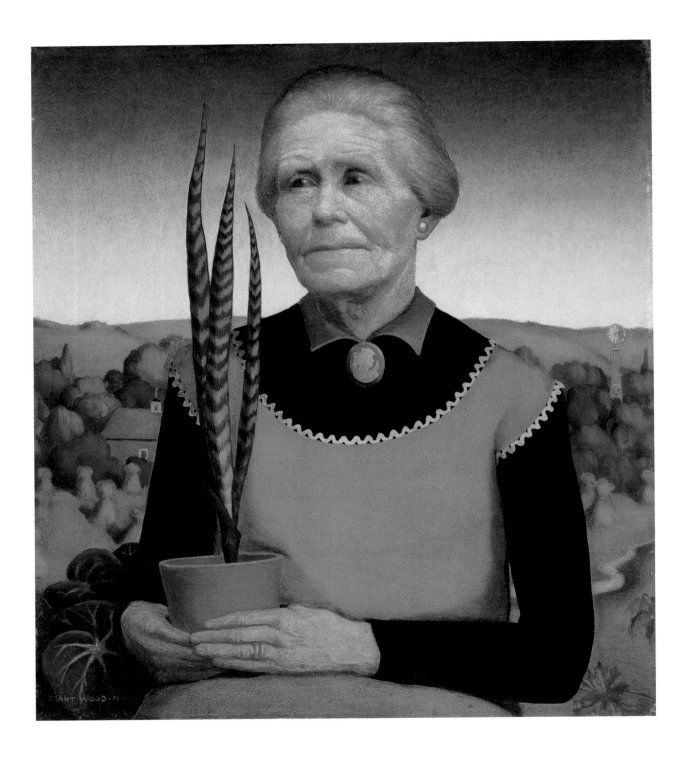

Plate 2: Grant Wood, *Woman with Plants*, 1929. Oil on upsom board, 20 $^1/_2$ × 17 $^7/_8$ in. Cedar Rapids Museum of Art, Museum purchase. 31.1

Plate 3: Grant Wood, *American Gothic*, 1930. Oil on beaverboard, 29 $^1/_4$ × 24 $^5/_8$ in. Friends of American Art Collection, All rights reserved by the Art Institute of Chicago and VAGA, New York, NY. 1930.934. Reproduction, The Art Institute of Chicago.

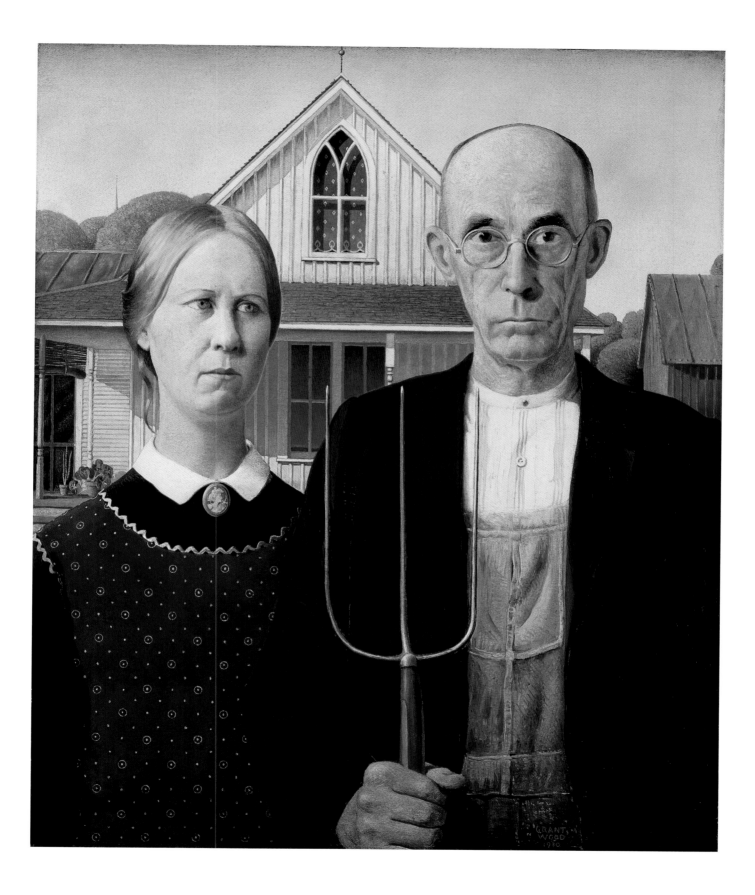

Plate 4: Grant Wood, *Stone City, Iowa*, 1930. Oil on wood panel, 30 $1/4$ × 40 in.
Joslyn Art Museum, Gift of the Art Institute of Omaha. 1930.35

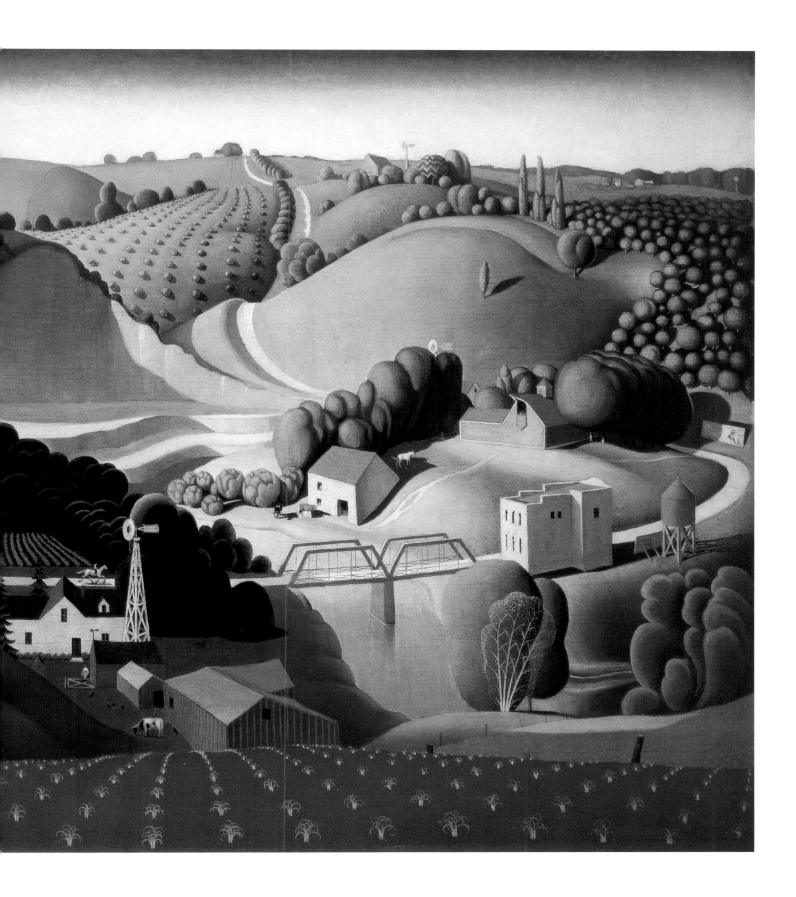

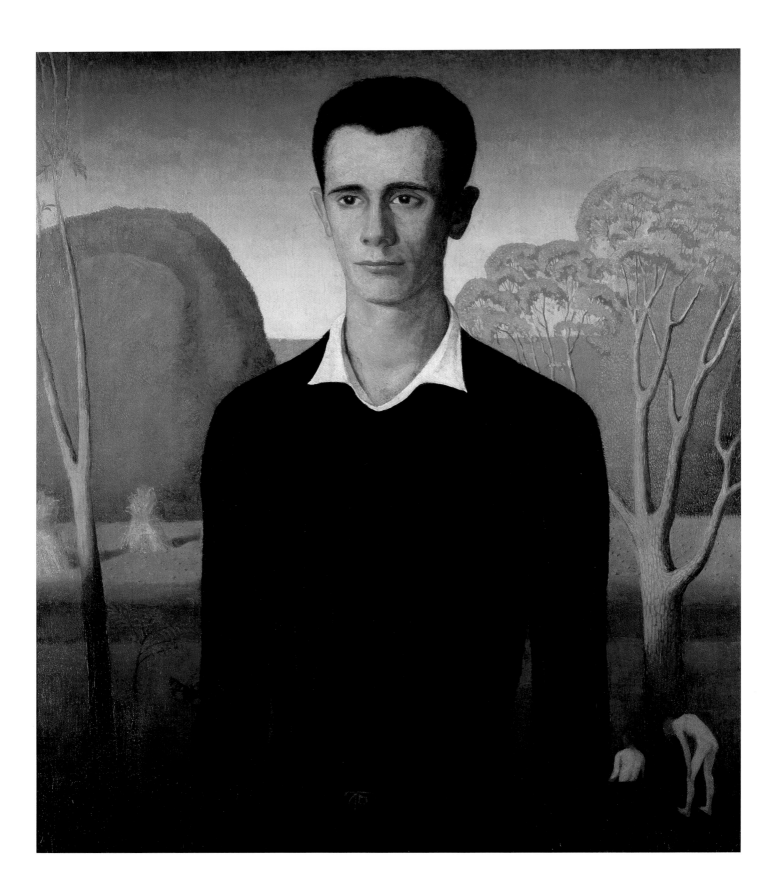

Plate 5: Grant Wood, *Arnold Comes of Age* (Portrait of Arnold Pyle), 1930. Oil on board, 26 3/4 × 23 in. Sheldon Memorial Art Gallery and Sculpture Garden, University of Nebraska-Lincoln, NAA-Nebraska Art Association Collection.

Plate 6: Grant Wood, *Autumn Oaks*, 1933. Oil on Masonite, 20 × 40 in. Cedar Rapids Museum of Art, Community School District Collection.

Plate 7: Grant Wood, *Overmantel Decoration*, 1930. Oil on upsom board, 41 × 63 ¹/₂ in. Cedar Rapids Museum of Art, Gift of Isabel R. Stamats in memory of Herbert S. Stamats. 73.3

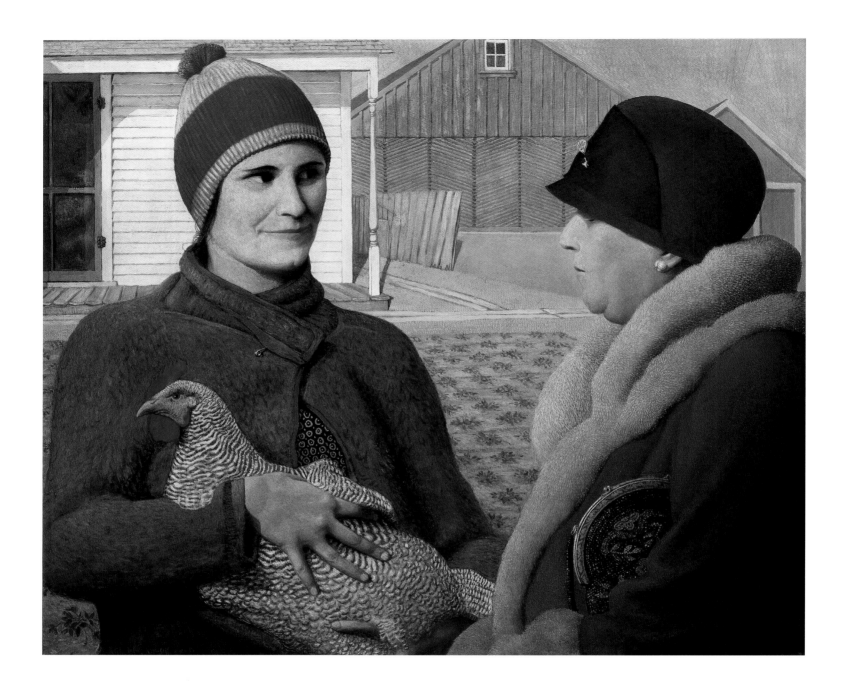

Plate 8: Grant Wood, *Appraisal*, 1931. Oil on composition board, 29 $^1/_2$ × 35 $^1/_4$ in. Dubuque Museum of Art, On long-term loan from the Carnegie-Stout Public Library, acquired through the Lull Art Fund. LTL.99.08

Plate 9: Grant Wood, *Victorian Survival*, 1931. Oil on composition board, 32 $^1/_2$ × 26 $^1/_4$ in. Dubuque Museum of Art, On long-term loan from the Carnegie-Stout Public Library, acquired through the Lull Art Fund. LTL.99.09

VICTORIAN
SURVIVAL

Plate 10: Grant Wood, *Daughters of Revolution*, 1932. Oil on Masonite panel, 20 × 40 in. Cincinnati Art Museum, The Edwin and Virginia Irwin Memorial.
Photo: Walsch; © VAGA.

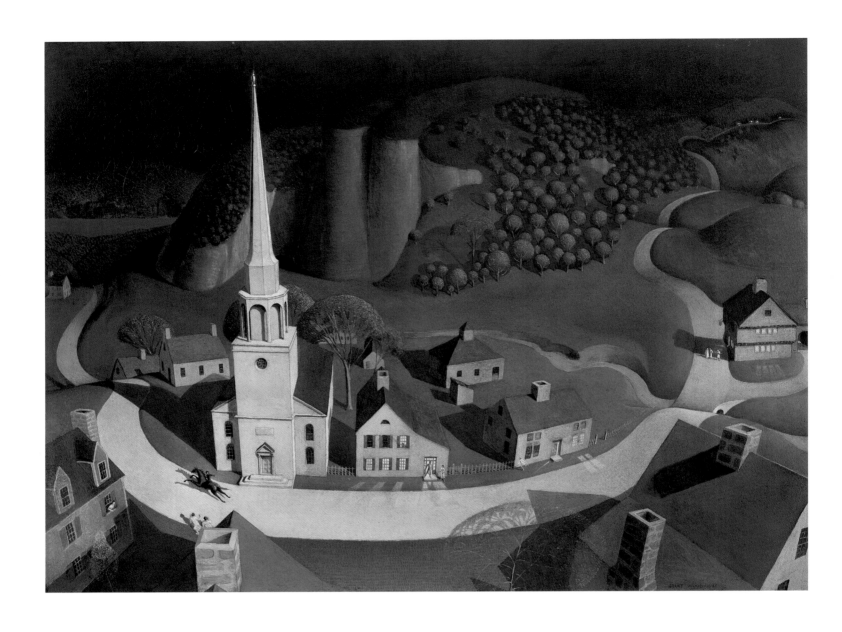

Plate 11: Grant Wood, *Midnight Ride of Paul Revere*, 1931. Oil on composition board, 30 × 40 in. The Metropolitan Museum of Art, Arthur Hoppock Hearn Fund, 1950. 50.117. Photograph © 1988 The Metropolitan Museum of Art.

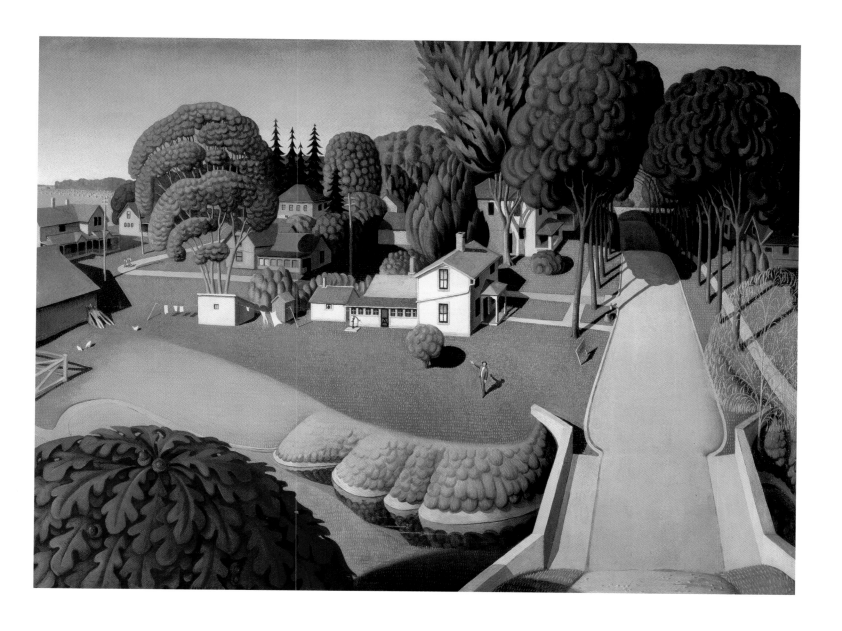

Plate 12: Grant Wood, *The Birthplace of Herbert Hoover*, 1931. Oil on Masonite,
29 ⁵/₈ × 39 ³/₄ in. Des Moines Art Center Permanent Collections; Purchased jointly
by the Des Moines Art Center and The Minneapolis Institute of Fine Arts,
with funds from the Edmundson Art Foundation, Inc., Mrs. Howard H. Frank,
and the John R. Van Derlip Fund. 1982.2

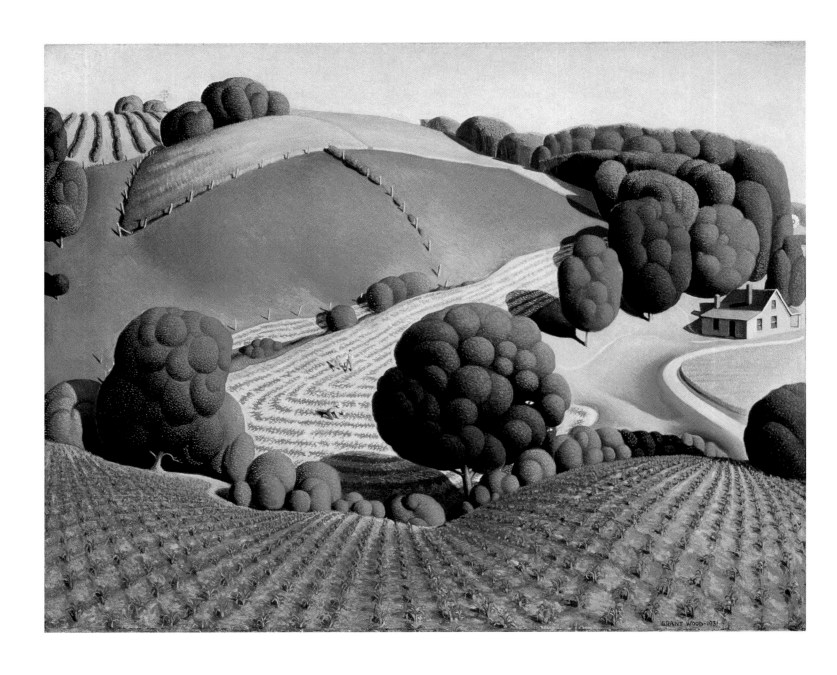

Plate 13: Grant Wood, *Young Corn*, 1931. Oil on Masonite panel, 24 × 29 $^7/_8$ in.
Cedar Rapids Museum of Art, Community School District Collection.

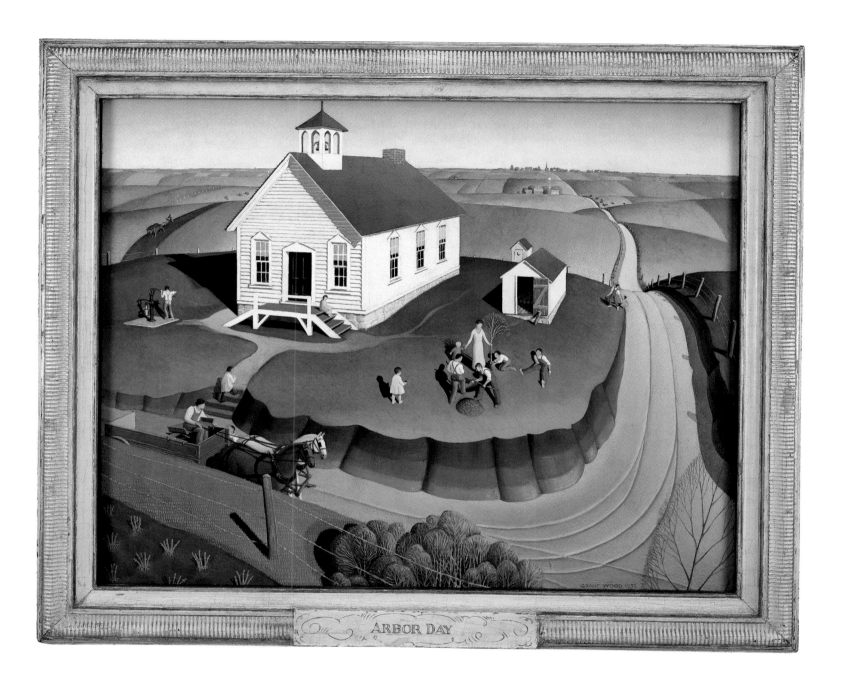

Plate 14: Grant Wood, *Arbor Day*, 1932. Oil on Masonite panel, 24 × 30 in.
William I. Koch Collection.

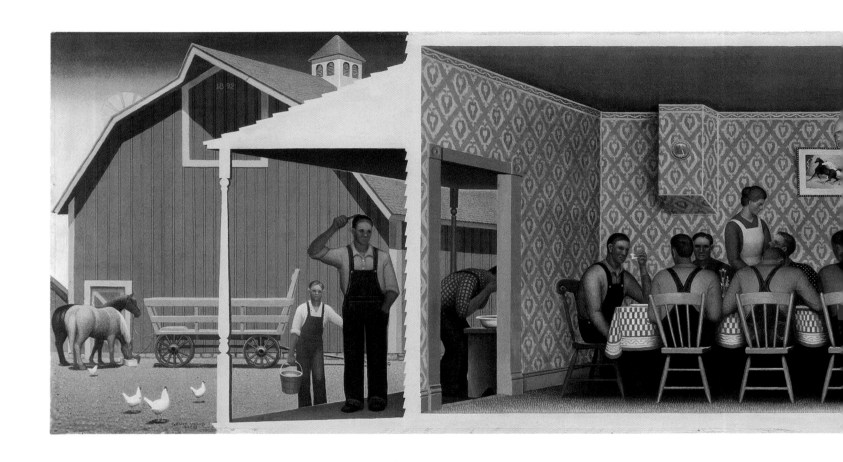

Plate 15: Grant Wood, *Dinner for Threshers*, 1934. Oil on hardboard, 19 $\frac{1}{2}$ × 79 $\frac{1}{2}$ in. Fine Arts Museums of San Francisco, Gift of Mr. and Mrs. John D. Rockefeller 3rd. 1979.7.105

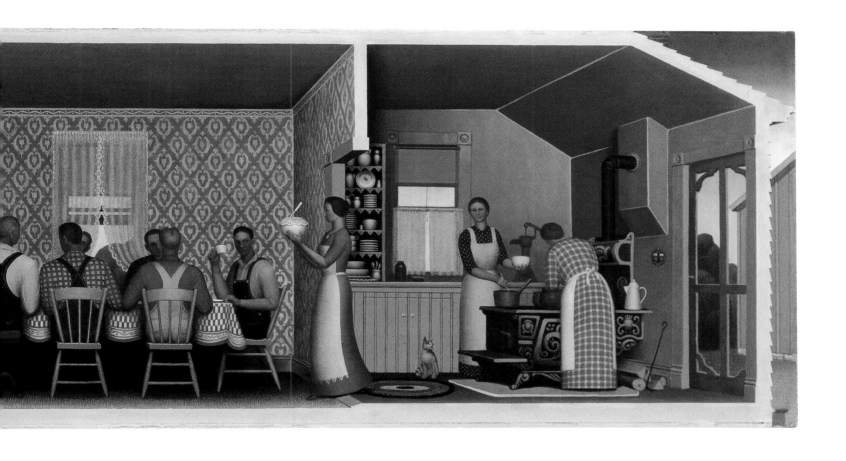

Plate 16: Grant Wood, *Self-Portrait*, 1932/41. Oil on Masonite panel, 14 3/4 × 12 3/8 in. Collection of Figge Art Museum, Acquisition Fund. 65.1

Plate 17: Grant Wood, *Return from Bohemia*, 1935. Pastel on paper, 23 3/4 × 20 in. Collection of Figge Art Museum, Museum purchase with funds provided by the Friends of Art Acquisition Fund. 96.1

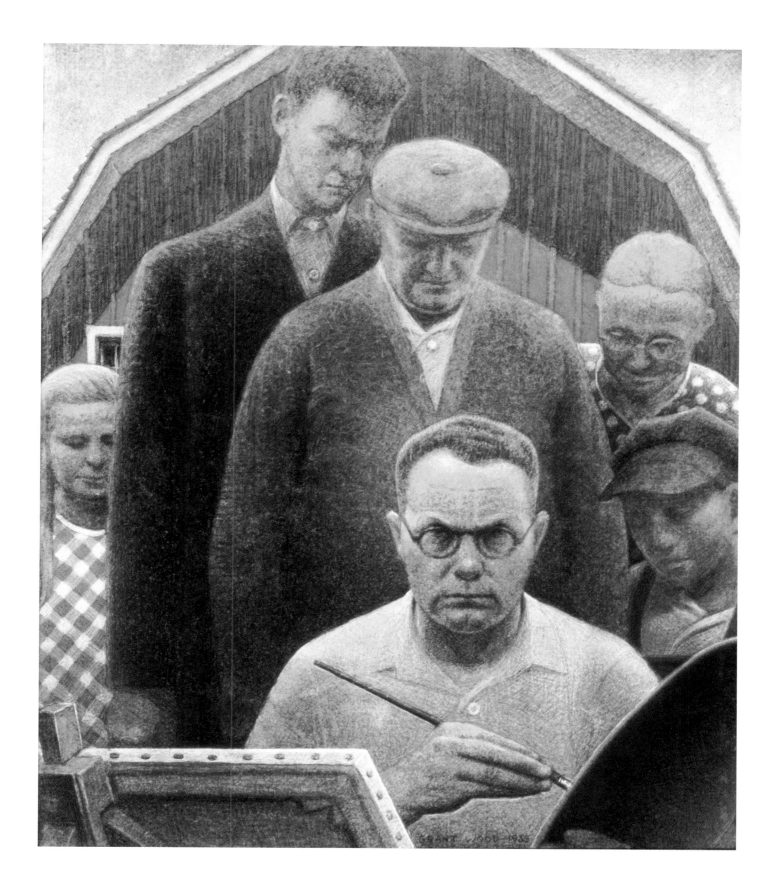

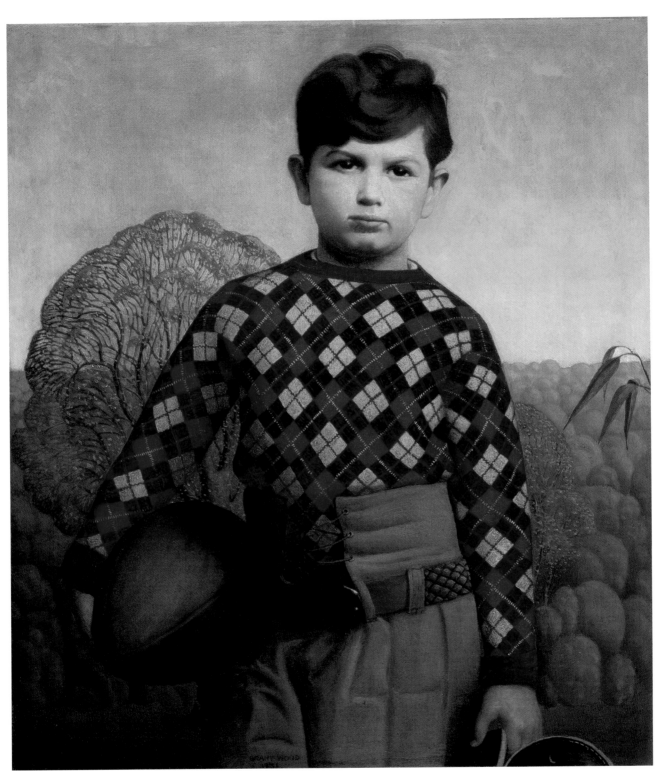

Plate 18: Grant Wood, *Plaid Sweater*, 1931. Oil on Masonite, 29 $\frac{1}{2}$ × 24 $\frac{1}{8}$ in. The University of Iowa Museum of Art, Gift of Melvin and Carole Blumberg and Edwin B. Green through the University of Iowa Foundation. 1984.56

Plate 19: Grant Wood, *Portrait of Nan*, 1933. Oil on Masonite, 34 $\frac{1}{2}$ × 28 $\frac{1}{2}$ in. (oval). Chazen Museum of Art, University of Wisconsin-Madison, Collection of William Benton. 1.1981

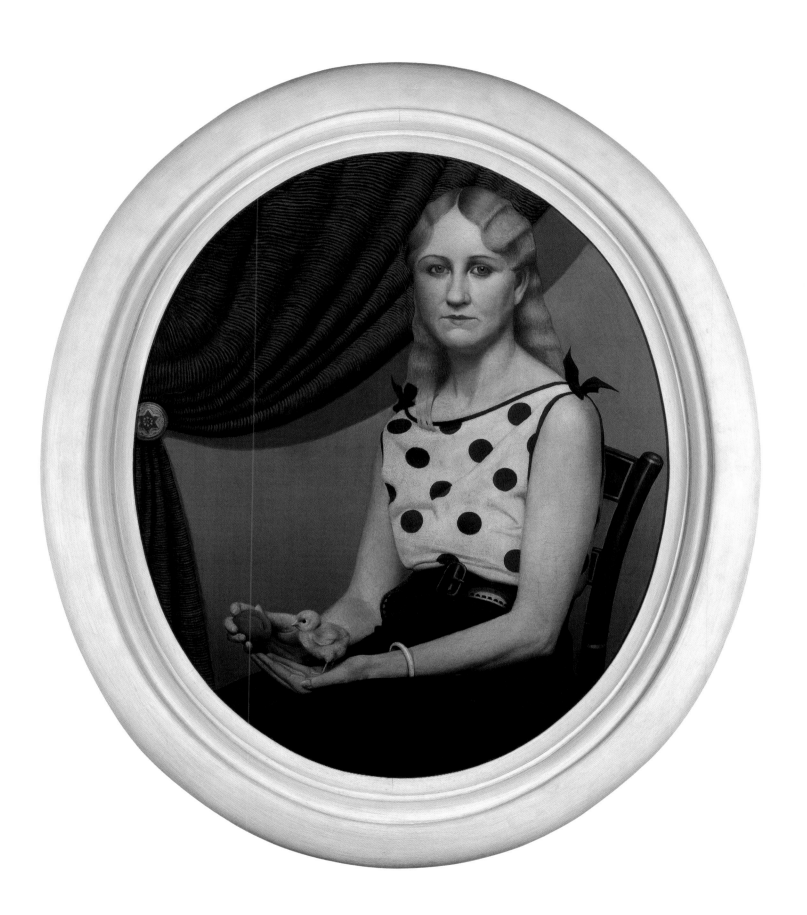

Plate 20: Grant Wood, *Parson Weems' Fable*, 1939. Oil on canvas, 38 $^3/_8$ × 50 $^1/_8$ in.
Amon Carter Museum, Fort Worth, Texas. 1970.43

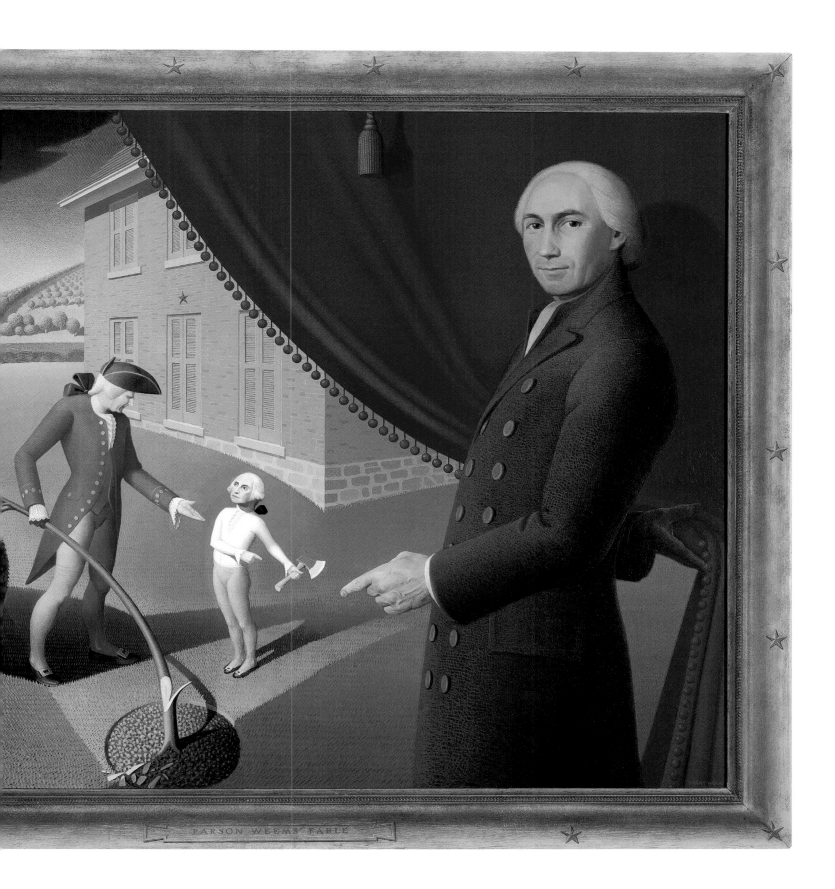

PARSON WEEMS FABLE

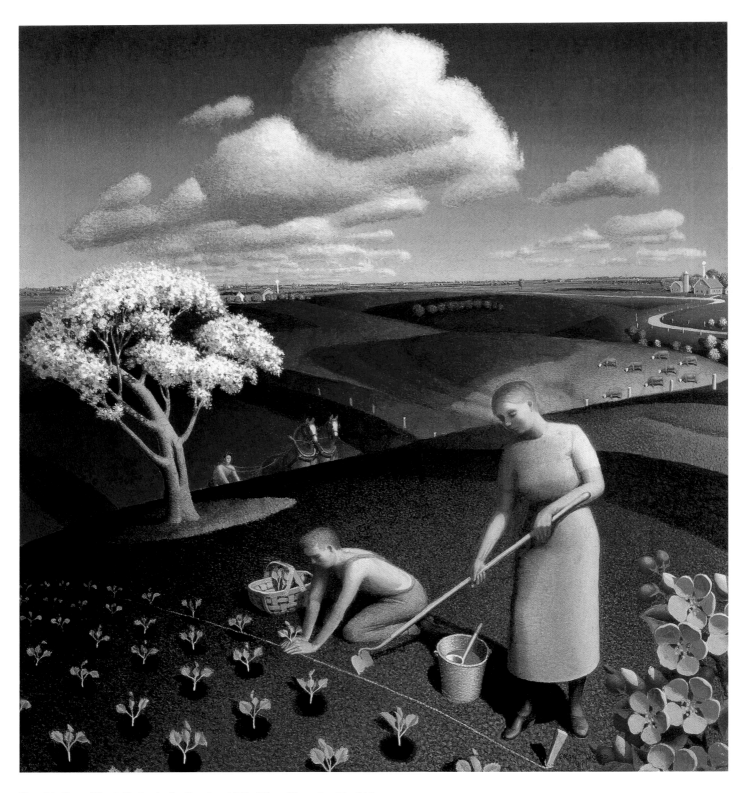

Plate 21: Grant Wood, *Spring in the Country*, 1941. Oil on Masonite, 24 × 24 in.
Cedar Rapids Museum of Art, Museum purchase. 93.12

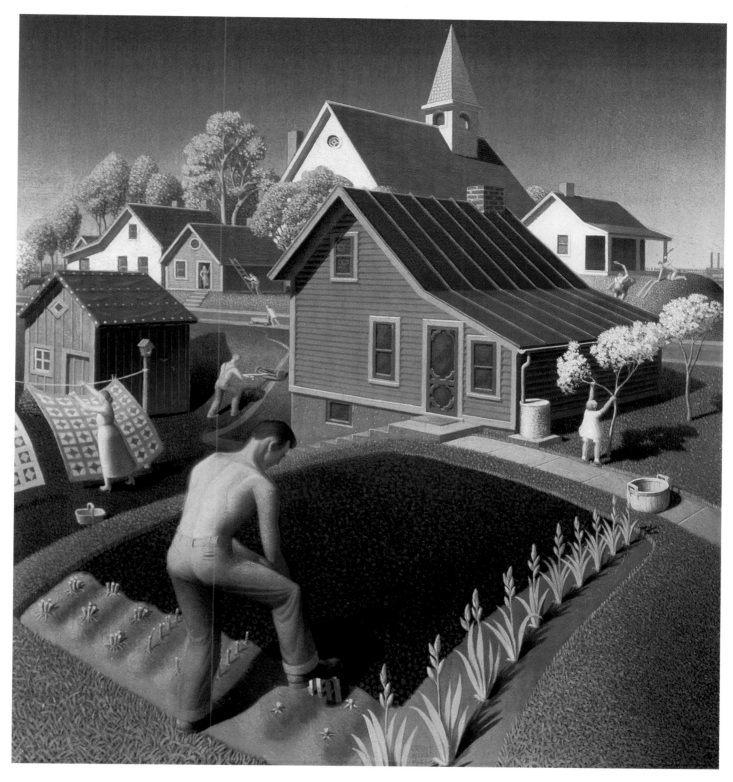

Plate 22: Grant Wood, *Spring in Town*, 1942. Oil on Masonite, 26 × 24 $^1/_2$ in.
Swope Art Museum, Terre Haute, Indiana. 1941.30. © Estate of Grant
Wood/Licensed by VAGA.

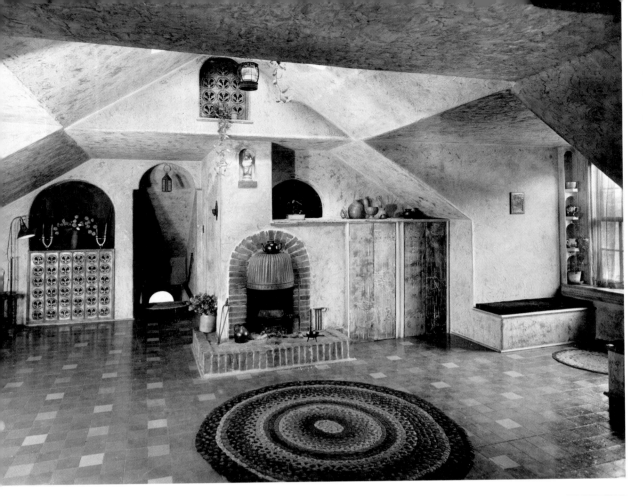

Fig. 54: Interior view of 5 Turner Alley, looking east, *c.* 1925. Courtesy of Figge Art Museum, Grant Wood Archives. Photo: John W. Barry.

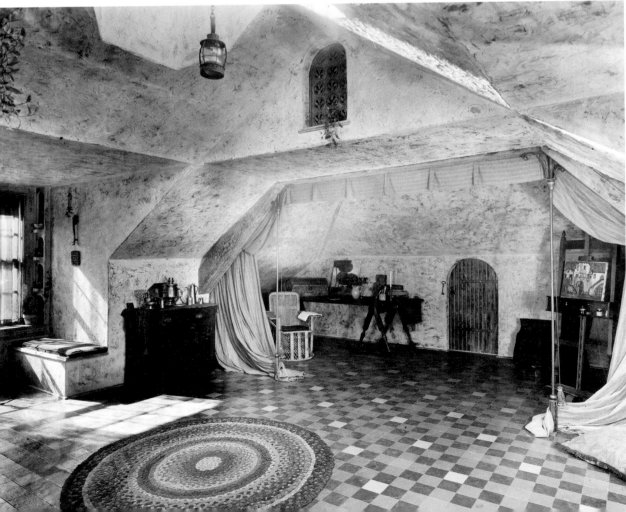

Fig. 55: Interior view of 5 Turner Alley, looking west, *c.* 1925. Courtesy of Figge Art Museum, Grant Wood Archives. Photo: John W. Barry.

Grant Wood's Studio: A Decorative Adventure

Jane C. Milosch

Within a few blocks from the heart of the modern city of Cedar Rapids is the quaint studio of Grant Wood, artist. It is a far cry from the old hayloft of another day to the studio as the visitor sees it now. Aided by friends and students, Grant Wood converted the musty and dusty attic of Turner's garage into a charming room, preparing it after the fashion of early periods in European craftsmanship. The artist took the rawest of materials and produced the artistic, fashioning beauty from ugliness.[1]

Cedar Rapids Republican, October 18, 1925

Number 5 Turner Alley is more than an address in Cedar Rapids, Iowa.[2] It is the name Grant Wood gave to his studio-home—and the place of conception, incubation, and birth of an American cultural icon. Stepping into this remarkable place is like stepping back in time and entering Grant Wood's world, or even like stepping into one of his paintings. Many of the ideas, themes, and images that occupied his artistic imagination and that were later used in *American Gothic*, and other famous paintings, can be seen in the architectural alterations and the many decorative details in various media that he used to finish the studio. In short it is not too much to say that Wood used 5 Turner Alley as a kind of laboratory for his artistic ideas, and the result was an artist's atelier that was also a powerful work of art.

As with most notable artists' studios, Wood's studio-home was a complete expression of his personal style and taste. It reflected his inventive nature and love of efficiency, as well as his theatrical and humorous sensibility. Everything he made for the studio was both functional and aesthetic. He designed and executed all of the decorative and utilitarian elements of his studio-home, which even included a stage for use both as a theater and as a salon for the artistic and social set of Cedar Rapids. He designed hideaway tables, cupboards, and beds so that by day he had an open, clutter-free studio, and by night cozy living quarters. Early in his career, inspired by the Arts and Crafts Movement, Wood learned to make things in a variety of media. In the creation of 5 Turner Alley, he utilized his metalsmithing, woodworking, and decorating skills to create a living and working environment that reflected his interest in materials and his knowledge of their distinct, expressive potential.

Wood lived and worked at 5 Turner Alley for eleven years, the years when he produced his greatest work and ultimately achieved critical acclaim for his painting. Many things came together for him in these years: he benefited from the assistance of his major patron, enjoyed the freedom to pursue his own artistic ideas in a rent-free studio, traveled twice to Europe, and participated in the artistic and social scenes of Cedar Rapids, which led to many residential and commercial commissions. In 1935, when he moved out of 5 Turner Alley and transferred his residence to Iowa City, he was a major national artist. But in 1924, when Wood moved into 5 Turner Alley, his reputation as an artisan and artist barely extended beyond Cedar Rapids.

Cedar Rapids and the Influence of Arts and Crafts

During the early 1900s Cedar Rapids had an unusually rich cultural life for a medium-sized Midwestern city. The home of Quaker Oats, National Oats, and other grain-processing plants, and a hub for trains traveling between Chicago and Omaha, Minneapolis and St. Louis, this prosperous city saw a constant flow of travelers—including writers, performers, and artists. Cedar Rapids even had its own opera house, which drew, if for only one-night runs, some of the best talent in the country. Early on the affluent families of Cedar Rapids were in the habit of promoting the arts. The city had its own liberal arts institution, Coe College, and a small circle of artists and writers, all of whom had an impact on Cedar Rapids through the 1920s. Already in 1905 the city enjoyed a Carnegie-funded library, which included an art gallery on the second floor, and the Cedar Rapids Art Association was formed to bring in small exhibitions from Chicago and the East Coast. In 1928 the American Federation of Arts selected Cedar Rapids to be the first city in the country to receive funds for an experimental art gallery, The Little Gallery, and appointed Edward Rowan (1898–1946) as the founding director. One of America's foremost art critics of the time, Forbes Watson, visited the gallery in 1929 and wrote that the gallery was more than a "pleasant ornament" in the life of Cedar Rapids and "thoroughly

awake to the advantages to the artists and the community to be derived through the purchase of paintings, sculpture and prints...in keeping with the optimism with which Middle Westerners' attitude toward art is imbued."[3]

Grant Wood participated in the city's cultural life. As a youth he assisted with the installation of exhibitions at the Cedar Rapids Art Association, and even at times slept in the gallery at night to save the fledgling group insurance costs when valuable paintings were on display. Wood attended Washington High School, located on the same square as the Carnegie Library with its gallery, and both nurtured his artistic talent. He painted scenery for school plays and illustrated school publications together with his good friend Marvin Cone (1891–1965), who would also become a talented Regionalist painter. In the 1920s, when Wood was an adult living in Cedar Rapids, a small circle of Cedar Rapids' artists and writers became his friends and supporters, including poet Jay Sigmund (1885–1937) and authors MacKinlay Kantor (1904–1977) and William Shirer (1904–1993); and the latter two wrote about Wood in their memoirs.[4] In the late 1920s and early 1930s, Rowan often wrote about and exhibited Wood's work at The Little Gallery.

It was in this Cedar Rapids, where Wood's family moved when he was ten, that Grant developed his artistic aspirations. As a young boy he was acknowledged for his ability to draw and paint, as well as for the handsome things he made out of wood, metal, and other materials. As a high-school student, Wood began reading *The Craftsman*, the magazine of Gustav Stickley, the leading representative in America of the Arts and Crafts Movement. He paid particular attention to articles by Ernest A. Batchelder (1875–1957), an artist–craftsman, arts educator, and another important proponent in the United States of the Arts and Crafts Movement.[5] Through a series of design lessons by Batchelder that were first published in *The Craftsman*, Wood taught himself how to make jewelry, copperware, ornamental light fixtures, and furniture.[6] He was so talented in this regard that even at the time many assumed he would become a professional designer or craftsman.[7] Years later, at a reception held in his honor at The Little Gallery in Cedar Rapids, one of his early supporters recalled:

It was in 1906 that I first heard of Grant Wood and his art work. He, with some of the young Barry boys, fixed up the basement of the John W. Barry home on B Avenue where they experimented with copper and other craftwork. One of the first orders Grant had was from James W. Good, who had just built his home on B Avenue at Nineteenth Street. The order was for a hood for the living room fireplace which insisted upon smoking. The fireplace was a large one and the problem presented was difficult, but Grant proved entirely equal to it

and pounded out of one large piece of copper a beautifully shaped and colored hood which remedied the defect and was a decorative addition to the room. This proved his ability even at that early age to plan and execute artistically a difficult thing. I have taken pleasure in watching Grant's progress from that time on. All the early years were spent at craftwork, in which he was exceptionally good, both in original ideas and execution, so good in fact that most of his friends felt that he should stick to that line of art work, but all the time he wanted to paint and paint he did at every opportunity, and without much instruction.[8]

Though Wood spent almost his entire life in Cedar Rapids, the years of Wood's peregrinations beyond Iowa began as soon as he finished high school. Following his high school graduation in June 1910, Wood boarded a train for Minneapolis, where he studied with Batchelder, who was teaching that summer at The School of Design, Handicraft, and Normal Art (now Minneapolis College of Art and Design). After Wood had studied his first summer in Minneapolis, he returned to Cedar Rapids to establish himself as a metalsmith and jeweler. He worked in the small metalsmithing studio of Kate Loomis, a prominent figure in the Cedar Rapids art scene, and he helped to decorate her new home, creating light fixtures, fireplace hood, and an overmantel painting. Between 1911 and 1912 they worked together to produce different kinds of Arts-and-Crafts-influenced designs, including this hammered copper calendar stand (fig. 56), and exhibited their work at the Art Institute of Chicago. In 1913 Wood moved to Chicago planning to study at the School of the Art Institute. While in Chicago he worked at the well-known Kalo Silversmiths Shop in Park Ridge, but after a year left with another craftsman, Kristoffer Haga, to establish their own jewelry and small metalwork shop, Volund Crafts Shop, also in Park Ridge. Their work was exhibited in the *Thirteenth Annual Exhibition of Industrial Art and Original Designs for Decorations* at the Art Institute of Chicago in 1914. The onset of World War I and increasing

Fig. 56: Grant Wood and Kate Loomis, *Calendar Stand, c.* 1911–12. Copper, 4 3/8 × 4 5/8 × 1 1/2 in. Gift of Mrs. Arthur Salzman. 94.25

Fig. 57: Grant Wood, *Necklace*, 1915. Copper and mother-of-pearl, 12 × 1 ³/₄ × ³/₄ in. Gift of John B. Turner II. 82.1.5

something was made from wood, plaster, metal, or fabric it was desirable to leave evidence of the material and the fabrication process, such as hammer, chisel, or tool marks. These revealed that the work was indeed hand-made and therefore unique. This was seen as a morally superior approach to that of "one-size-fits-all" designed homes filled with machine-made products. Wood both embraced and contradicted this "honest" aesthetic, since he often used unorthodox methods and materials. Given the opportunity to design his ideal studio, Wood took advantage of much useful information gleaned from *The Craftsman* magazine, and he applied those aspects of the Craftsman aesthetic which fit his practical nature and his talent for producing handcrafted, functional objects. Although Wood was drawn to the Craftsman aesthetic in many ways, he was never a follower of any one style—he chose freely what best suited his task at hand, taking into account the effect he wanted to create.

Wood's range of craftsman's skills were tested out and developed long before he converted 5 Turner Alley into a studio-home. Wood acquired his home-building skills, such as masonry and other construction techniques, when he built homes together with his friend Paul Hanson. In 1916 they first built rustic cottages as temporary homes for their families. A year later, on the northern edge of Cedar Rapids, Wood and Hanson helped each other design and build permanent homes. Together they studied books on carpentry and home-construction techniques. Because Wood had read *The*

financial hardships caused their studio to close after only a year and a half, and Wood cut short his studies at the School of the Art Institute.[9] A beautiful example of Wood's jewelry from this period is an Art Nouveau pendant necklace made of copper filigree and mother-of-pearl (fig. 57). It would be more than a decade before Wood returned to Chicago with his painting *American Gothic*; but in 1916 he returned penniless to Cedar Rapids, where he would continue to develop his skills as an artist and craftsman.

Before Wood embarked on his career as a metalsmith and painter, his artistic sensibility was shaped by the aesthetics and ideas of the American Arts and Crafts Movement. This artistic movement set the predominant style in home design in the early 1900s and strongly influenced Wood's early work and his development as an artist. *The Craftsman*, published between 1901 and 1916, featured Stickley's Mission-style furniture, and offered sample plans for designing and building Craftsman-style homes, from the basic structure to the interior furnishings (fig. 58). It also disseminated the reform philosophy of the British Arts and Crafts Movement to the American public: to re-establish harmony between architect, craftsman and designer and to promote handcraftsmanship in the production of well-designed, affordable everyday objects. If

Fig. 58: Craftsman fireplace corner with built-in seat and bookshelves, from *Craftsman Magazine*, March 1913, p. 27. L. and J.G. Stickley.

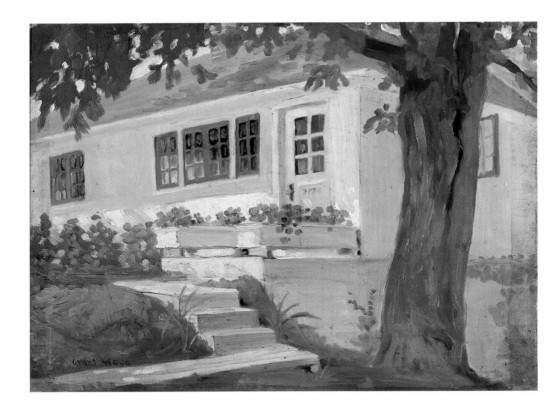

Fig. 59: Grant Wood, *Thirty-One Seventy-Eight*, 1918. Oil on panel, 14 ⅞ × 20 in. Gift of Gordon Fennell. 80.2

Craftsman magazine as a youth, it seems likely that he would have consulted Stickley's book, *Craftsman Homes*, which included advice to homebuilders on material and techniques as well as complete house plans. Some of the architectural features and the layout of Wood's second home resemble that of a simple Arts and Crafts bungalow. A hip roof, red-trimmed windows, and creamy white stuccoed walls ornamented the exterior, while the interior featured hardwood floors, built-in cabinetry and decorative wall painting—all identifiable features of a Craftsman home.[10] Wood's sister Nan recalled that for the interior decoration Wood "painted the walls a mellow orange, stained the ceiling beams light brown and stenciled a design of seed pods between them, picking up the colors in the room."[11] Wood's painting, *Thirty-One Seventy-Eight*, is a depiction of this second home (fig. 59).

While Wood's first experience in home design was for his own gratification, his first decorative landscape painting was for the US government. In 1918 Wood enlisted in the Army, and because of his artistic skills was assigned to Washington DC to paint camouflage onto artillery. He worked from aerial photographs—probably his first bird's-eye view of landscape—for his army job and, in his spare time, drew portraits of his fellow soldiers for extra money. By fall 1919, Wood was back in Cedar Rapids. The young artist secured a position as a junior-high-school art teacher, which finally provided

him with a steady income. To better provide for himself and his mother he continued to augment his income with a few local commissions—mostly for design work, but for some paintings, too—and he began to acquire a local reputation as a talented artist and designer–craftsman.

Patronage and the Acquisition of the Studio

One of Wood's first major commissions was to create a large "outdoor" mural painting for Henry Ely, a local home developer who was one of Wood's earliest supporters. Ely had commissioned Wood years earlier to create miniature models of homes complete with landscaping to help sell his homes, but this time Ely wanted a work that praised the benefits of home life in Cedar Rapids. Wood's *Adoration of the Home*, an unabashedly boosterish image of civic pride, was designed to be installed under a roof-like construction near Ely's downtown office (fig. 60). For this project, Wood closely based his composition and painting style on the work of Chicago artist Allen Philbrick (1879–1964), whose murals decorate the interior of the Peoples Savings Bank in Cedar Rapids.[12] Wood turned to his friends and acquaintances to serve as models—a practice he would continue in the 1930s at 5 Turner Alley—for the

painting's idealized figures.[13] Though painted in an imitative style, Wood's elaborate framework for *Adoration of the Home*—a triptych with side panels that featured calligraphic texts (no longer extant)—demonstrates his own imagination and craftsmanship (figs. 60, 61). The painting is placed like a jewel within a larger construct, as in a Renaissance altar painting, and thus conceived of as part of a larger construct and not just as a painting. The project captured the attention of the community and much was written about it in the local press, as it seemed forward-thinking and inventive to make an advertising sign artistic.[14] In terms of Wood's painting and decorative artwork, the work represents a synthesis of themes and ideas which he would return to in the years to come.

The success of Wood's *Adoration of the Home* mural must have caught the attention of another local businessman, David Turner, who was the owner of an expanding funeral home business—after all, if a real estate sign could be admired for its artistry, why couldn't a funeral home be perceived as a work of art? In 1924, when Wood had just returned from a 14-month stay in Europe, Turner commissioned him to convert a mansion into a state-of-the art mortuary and funeral home. This was Wood's largest commercial project to date. For the expansion of his business, Turner had acquired a late 19th-century mansion built in a Georgian Revival style, with the same stately attractive style lavished on the carriage house and wall surrounding the property. The original owner was George B. Douglas, a son of the co-founder of Quaker Oats and one of the wealthiest families in Cedar Rapids.[15] The task of converting the mansion into an inviting place of business involved remodeling, decorating, and furnishing the interior of the funeral home. If Turner wanted an artist as well as a craftsman for his project, Grant Wood was the perfect choice.

Fig. 60: Grant Wood, *Adoration of the Home*, 1921–22. Oil on canvas attached to a wood panel, 22 3/4 × 81 3/8 in. Gift of Mr. and Mrs. Peter F. Bezanson. 80.1

Fig. 61: *Adoration of the Home*, with original frame and side panels.

Fig. 62: Grant Wood, *Exterior view of Turner Mortuary from the Southwest,* 1924. Pencil on paper, 18 × 29 ¹/₂ in. Gift of Harriet Y. and John B. Turner II. 72.12.72

Throughout the fall of 1924, Wood and local builder Bruce McKay worked to remodel the mansion into an appealing and functional setting for Turner's mortuary (fig. 62). McKay, a self-taught architect, built an addition for a chapel, while Wood selected and even made some of the furnishings for the interior—from designing a Pullman chair to making wooden biers for holding caskets.[16] In carrying out the remodeling, Wood supervised the work of other craftsmen, but completed much of the detail work himself. He also planned the landscaping of the grounds, which included a design for a hand-wrought iron gate (fig. 63).[17] A variation of this gate design became the signature logo for the Turner Mortuary. Turner was extremely happy with the outcome of the project and, to promote the opening of the business, he commissioned Wood to create a series of pen-and-ink drawings of the interior and exterior of the mansion, which he then published in booklet form in December 1924 (figs. 62, 63, 64, 65).[18] These lively renderings of the interior scheme illustrate Wood's ability to sketch and envision his decorating projects for clients. The opening of the funeral home received acclaim from the local press, which announced on December 13, 1924: "New Turner Mortuary To Be Opened Next Week: Fine Establishment," and told of Grant Wood's contributions to the success of the project.[19]

As a result of this commission, Wood gained a friend and supporter in Turner. Wood also gained a studio and home—an old hayloft and coachman's quarters to the carriage house on Turner's property—5 Turner Alley (figs. 66, 67). Turner was greatly impressed by Wood's attention to detail and artistic abilities, but Turner had also observed that Wood lacked the business acumen to manage his financial affairs. Taking an active interest in Wood's career, for years he would function as Wood's unofficial personal advisor and promoter. Seeing that Wood needed a place where he could conduct business with clients, display his work and focus on his painting, in 1924 he offered him the use of the carriage house. According to Wood's sister Nan: "When Turner learned that Grant was intrigued with the fine brick colonial barn with an elegant cupola at the rear of the property, he offered the hayloft as a studio.

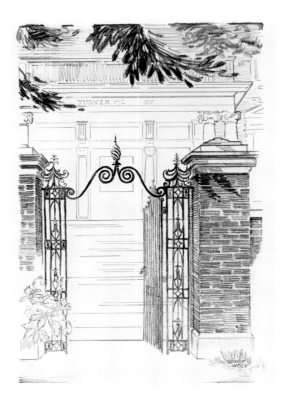

Fig. 63: Grant Wood, *Entrance to Turner Mortuary*, 1924. Ink on paper, 9 ¹/₄ × 13 ⁷/₈ in. Gift of Harriet Y. and John B. Turner II. 72.12.74

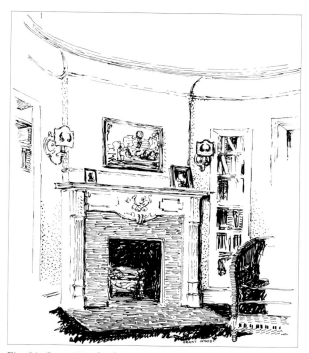

Fig. 64: Grant Wood, *The Turner Mortuary, Fireplace in the Round Room*, 1924. Pen and ink on board, 13 3/4 × 11 7/8 in. Gift of Harriet Y. and John B. Turner II. 72.12.71

Fig. 65: Grant Wood, *The Turner Mortuary, Table, Lamp, and Two Chairs*, 1924. Ink on paper, 10 3/4 × 13 1/2 in. Gift of Harriet Y. and John B. Turner II. 72.12.68

Grant could fix it up at his own expense, and he would pay no rent. Grant accepted immediately with no contract, no termination date, and probably not even a handshake."[20]

The chance to set up his own studio came at an opportune time in Wood's career. His reputation as a painter had changed little since his first exhibition at a department store in Cedar Rapids in 1919. He knew that artists' reputations were made in major cities, where their work could be seen by critics and *cognoscenti*, but he lacked the means and connections to propel things forward on that level.[21] He had already made two trips to Europe: the first to Paris in the summer of 1920 with his painter-friend Marvin Cone; and the second, from 1923 to 1924, to study at the Académie Julian in Paris. He traveled through France and spent the winter in Sorrento, Italy. In the summer of 1924, at the very end of his stay in Paris, he established contact with the Galerie Carmine, a reputable gallery that agreed to hold an exhibition of his work in the future. Wood must have felt that having his own studio would increase his chances of returning to Paris, because this would give him a place to paint and prepare. He would eventually have the exhibition in 1926, but it did not launch his painting career as he had hoped.

With Turner's encouragement, in June of 1925 Wood resigned from his teaching position at McKinley Junior High School to rely on freelance decorating and design projects as his major source of income which he planned to supplement with the sales of his paintings. It was Turner's patronage that made this possible. Turner encouraged Wood to exhibit and sell his works in the mortuary—it was an ever-changing sales gallery for Wood's paintings until Turner bought thirty of them for permanent display.[22] Turner organized exhibitions of Wood's works, published small catalogues, placed promotional ads in newspapers, and even convinced Wood to speak at national conferences for morticians about decorating their funeral homes. With Turner's help, Wood's prominence as a local artist increased, and he began to receive major public and commercial commissions beyond Cedar Rapids. But best of all, he now had a studio home that gave free reign to his artistic imagination, and 5 Turner Alley became a unique showcase of his talents.

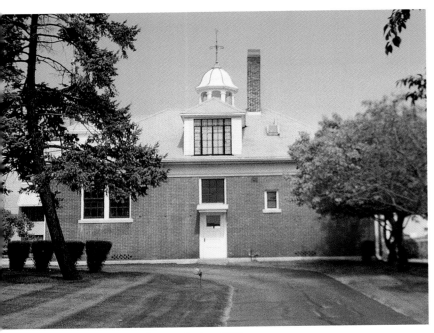

Fig. 66: 5 Turner Alley, north view, 2004.

Fig. 67: 5 Turner Alley, northwest view, 2004.

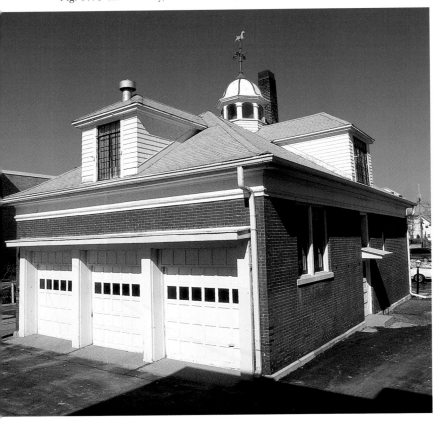

The Creation of the Studio

> Few painters are fortunate enough to have studios designed expressly for the purposes of creative art. Ideally, the modern studio should be located atop of a building in order to capture available light. A large angled skylight with blinds for increasing or reducing natural light is desirable. The French design of a single-room studio with living accommodations … is still one of the most compact and convenient arrangements for an artist with modest means. More often a studio is improvised from a room in a house, but one essential requirement remains—there must be sufficient light.[23]
>
> Francis Kelly, *The Studio and the Artist*, 1974

Few things can be more important to an artist's work than his studio. Besides providing a convenient place to live and work, it must be a haven that nurtures the creative process. Clarence Cook, art critic and spokesperson of late 19th-century interior design, wrote: "The artist who is really an artist, not merely one by profession, fits up his rooms instinctively in a way that at once feeds his artistic sense, and reflects his artistic character. He must have things about him that keep his artistic senses keyed-up and serve as a standard by which he can judge his own performance. Looked at with the eye of reason these things are really the tools of his trade—essential to his life as an artist."[24] Over the last two decades in America, many artists' homes and studios, including 5 Turner Alley, have been preserved and offer a new look at the artist and his work, from the perspective of his natural and adapted surroundings. Some of the most well-known studios are: Frederic Church's Olana overlooking the Hudson River, Charles Demuth's row house studio in Lancaster, Pennsylvania, and Georgia O'Keeffe's hacienda in New Mexico.[25] These visual, archival-like environments reveal the physical parameters in which the artist lived and worked and are themselves art-historical treasures. What is unique about Grant Wood's studio is the way in which it reveals the artist's talent as a craftsman as well as a painter. In some ways, his hayloft studio anticipates the open, multi-functional and modern-day artist's studio lofts converted from empty warehouse spaces in New York City's Soho district.

Adaptive Use of Space

Wood designed and fabricated almost every square inch of 5 Turner Alley. When he acquired the old hayloft it had no delineated layout or ornamentation beyond that of a large open space with exposed wooden support beams. Large dormer windows located directly opposite each other offered ample light, ideal for an artist's studio. One of the few structural changes Wood made was the addition of a new entrance, building internal and external staircases on the east side of the carriage house. When Wood began to re-design the

Fig. 68: Floor Plan, 5 Turner Alley, c. 1931 configuration. Plan drawn by Gilmore Franzen Architects, Inc.

interior of the loft, he kept the plan open, constructing as few walls as possible. The overall size of the studio was not much more than 1,000 square feet. Wood used all of that space to his advantage, dividing it into areas for various activities (fig. 68). The main part of the studio was multi-functional, with more than half of the large open room serving as a living area, and a smaller area—designed as a stage—serving as his studio by day and a sleeping area at night. He built cabinets under the eaves with enough space below for beds to be neatly stored away. The beds could be pulled out for use at night and the stage curtains closed for privacy. He built partitions with arched openings to separate off a storeroom, kitchenette, and bathroom. Where there had been an internal staircase to the garage below, Wood installed an efficient Pullman kitchen with pass-through window to the studio as well as a table that could be pulled out from a cupboard. Where there had been a grain shoot he put in a sunken bathtub. The tiny kitchenette and bathroom featured built-in storage in every conceivable spot, including a disappearing *armoire* on the inside of a closet door. Light was introduced into the kitchen and bathroom by the addition of skylights in those areas. In front of the south-facing dormer windows, Wood constructed window-seats, and designed a collapsible trestle-style table that could be placed there to create a dining nook. In order to store his paintings he designed large built-in rolling drawers with dividers and hooks for his wet paint brushes, which he even identified with little tags for each color. In keeping with the Arts and Crafts' practice of built-in furnishings, there was little free-standing furniture in the

studio. Wood's built-in features and disappearing furniture contributed to the overall impression of the studio as a vast uncluttered room.

During the eleven years Wood lived at 5 Turner Alley, he made few changes to his original layout. Around 1931 he added a west dormer window, which is visible in a photograph of Wood with his painting, *Daughters of Revolution* (fig. 127).[26] In this nook he created an office for himself, adding a desk and more built-in shelves for books (fig. 80). When his mother fell ill, he converted the storage room into a private bedroom for her.[27] Wood raised the ceiling in this room, added two windows, and created a decorative metal shade that could be raised or lowered to close off the bedroom for privacy.

Architectural Elements

Wood's adaptive use of the interior of 5 Turner Alley reveals his ability to combine formal considerations, such as line and shape, with "regional" flair. His architectural alterations exemplify Stickley's advice to his *Craftsman* readers: "The necessities of construction demand a sufficient variety of line to satisfy the aesthetic cravings of the eye for pure form; while the delights of color wait upon the use of our native and scarcely appreciated woods."[28] Also in keeping with the Arts and Crafts' aesthetic are Wood's many "marks"—chiseled, carved, drawn and painted surfaces—that emphasize the work of an artist's hand. Within a year, by June of 1925, Wood had completed all of the major renovations and the defining features of

the studio.[29] In a hand-colored print Christmas card of 1927, Wood depicts 5 Turner Alley in a cross-section view (fig. 69). In his remodeled hayloft Wood appears like a comic-strip character on a stage. Dressed in bibbed overalls, he stands next to his easel, brush in hand, surrounded by the architecturally defining elements of the studio: sloped ceilings, arches, fireplace, and the crowning cupola.

Sloped Ceilings. The interior space of the carriage house, with its sloped ceiling and large dormer windows, reflects the same architectural features found in many Parisian attic ateliers of the kind Wood must have seen in Europe. Wood used the marked configuration of the sloped roof and structural beams to create a series of diagonals that define the ceilings and walls. He plastered some of these beams into the walls while leaving others exposed. Geometric patterns and hard-edged lines emerge and recall Modernist interiors of the 1920s. Exposed timber beams were a common feature in Craftsman homes, providing an opportunity for function and ornament to be combined. Wood carved into the former hayloft's beams so they would appear hand-timbered, lending an antiquated appearance to the studio. The interior walls of 5 Turner Alley are not built from massive stone materials. The impression of stone walls covered with plaster is just that—an impression. Wood used fiberboard, a modern material of the time, to construct walls, parts of the cabinetry, and shelves in 5 Turner Alley. He used three basic types and thicknesses: insulation board, hardboard for the walls, and medium density fiberboard when he needed a flexible material to form the intrados of arches and the curved ceiling of the entry hall. His application of this material predated its extensive use in other American homes.[30] He used it not only for his home decorating projects but also for his paintings. Instead of oil on canvas, Wood preferred to paint on the smooth, hard side of this board as the support and ground for his paintings.[31] Hardboard manufactured by the Masonite Corporation became one of Wood's favored materials. His later use of Masonite was so extensive and inventive that the company created an advertisement with examples of how Grant Wood used its product when remodeling his Iowa City home.[32]

Stage. Wood and Turner had originally planned that the studio would also be used as a small community theater. To serve this purpose, Wood created a large open stage on the west side, opposite the kitchen and dining area. Here the attic beams allowed for the formation of a classic proscenium arch to dramatically define this area of the studio as a stage. Just behind the arch, Wood designed and installed two decorative iron poles to further define the stage within

a rectangle. He attached lights to these poles with adjustable brackets that could be moved around or up and down the pole. These may have served as stage lights or used as work lights above his easel, which is depicted in front of the stage in several photographs. Heavy curtains lining the arch of the stage added dramatic effect to the entire space. Wood's sister Nan recounts: "He had tracks for curtains made to order so he could close off one end of the studio, and I made enormous drapes out of heavy Baghdad curtain material he had brought from Spain—hand-woven and hand-embroidered wool…creating a lovely, soft harmony of tan, rust, old blues, and browns."[33]

The plan to use the studio for theater did not last long. After only a few performances the theater group and audience had outgrown the space, and there was concern that the structure might not be able to safely support so many visitors. It was probably at this time that Wood realized the practicality of living at the studio. Wood was the primary provider for his widowed mother, and he began to modify the studio to include living quarters for himself, his mother, and at times his sister Nan. An experienced set designer, Wood designed many multi-functional "quick-change" features in his living quarters, as if there were only a few moments between acts.

Arches. Arched openings are rhythmically placed throughout the studio. The entryway to 5 Turner Alley is framed by an arched portal. The fireplace, stage door, and two openings in the walls are also arches. Above the fireplace, an arched niche holds an Italian majolica statue of a Madonna, whose location recommends her as Wood's patron saint of the studio. High up in the peaked wall space, on either side of the main room, are two arched niches containing decorative metal screens and plants that snake down, introducing a natural, organic effect against the studio's stark diagonal lines and plain walls. At the highest point in the studio is the cupola, with its six arched windows. More arched niches with shelves, one above the other, frame a dormer window in which plants and pottery are displayed in a regimented order. Wood even created an arched wall niche to accommodate his candlestick phone, which humorously takes on the appearance of a side altar or shrine to technology (fig. 99).[34] Wood's design for his "Number 5 Turner Alley" studio stationery depicts a vignette of his studio interior and many arched forms are included in this stylized depiction (fig. 70).

Wood's affinity for the Roman arch came about during his travels in Europe. While in Paris and southern Italy he painted many compositions in which arched forms are a central motif (see figs. 11, 12, and 14). These paintings often focused on architectural

features such as arched portals, doors and windows, or the façade of a building. He carried this theme back with him to Iowa and used it extensively in his studio, combining Old World charm with an Arts and Crafts aesthetic. Even his most significant public commission was a stained glass window in the shape of an arch. The arched window for which Wood is famous, however, is not a Roman arch, but a Gothic one he discovered in Eldon, Iowa.[35]

Fireplace. A unique fireplace and hearth anchors the interior design of the studio. Stickley advocated that one of the focal points of every Craftsman Home should be the fireplace, as this was a way to bring together function and beauty. Wood's design, however, is not a typical, horizontally oriented Craftsman fireplace; instead it recalls a vaulted Romanesque arch. Red bricks line the opening, setting it apart from the stucco walls. The curve of the opening is mimicked in the fluted metal hood which, upon closer inspection, turns out to be an inverted metal bushel basket cemented into the top of the opening. Rather than fashioning a hood from metal, something he had often done for others, Wood ingeniously recycled the basket and painted it an antique bronze color to give it an ornamental effect, disguising its original function. The overall design of the fireplace is strengthened by a raised brick hearth which wraps around the fireplace and neighboring wall. This introduces a ledge which visually frames the fireplace, but is also utilitarian. Wood's use of red

brick and mortar in the arched opening—as rectangular forms and lines—is repeated in the laying of the bricks for the ledge. These bricks are positioned on their short end, emphasizing verticality and height. Even the bricks that make up the surface of the hearth are laid in a decorative manner, with the holes of the flat side of the brick facing up, creating a pattern of little dots filled with mortar. With so little Wood created a fireplace and hearth that is both simple and complex.

Fig. 70: Grant Wood, Design for Number Five Turner Alley stationery, c. 1924–25. Cedar Rapids Museum of Art Archives.

Cupola. The abundance of natural light in 5 Turner Alley suited it well as an artist's studio. The pre-existing dormer windows permitted adequate northern and southern light, but Wood capitalized on this light source even more by installing modern, steel casement windows.[36] Light also streamed in from above, through a cupola which Wood cleverly modified. While still a hayloft the cupola contained arched openings with metal vents to permit air circulation. Wood removed these vents and inserted panes of glass. The lighting effects from the cupola were dramatic, creating a well of sculpted light. Soft and crisp shadows together with strong tonal contrasts abound in the studio. The alteration to the cupola also added height to the interior, making the room seem larger, and created a cathedral-like ceiling in the studio, with the cupola windows functioning similarly to clerestory windows in a Gothic cathedral. The new lighting effects of the six-sided cupola became a defining feature of the interior as well as the exterior, a light source by day and a beacon by night.

Decorative Finishes

> Grant Wood converted an ugly appearing attic into one of the coziest and most attractive rooms in the city. On every side the visitor sees evidence of Wood's resourcefulness, originality and genius. Over the rough flooring Mr. Wood has placed different colored tile, and the window sills are finished in the same manner. With the assistance of his pupils at the junior high school, Mr. Wood plastered the walls of the room in antique fashion.[37]
>
> *Cedar Rapids Republican*, June 7, 1925

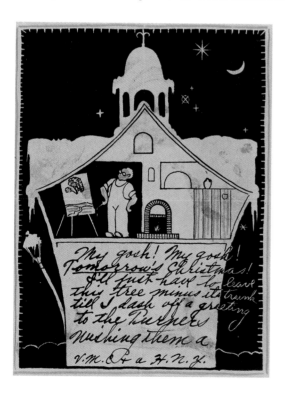

Fig. 69: Grant Wood, *5 Turner Alley Christmas Card*, 1927. Relief print with hand coloring, pen and ink, 10 × 7 ¼ in. Gift of John B. Turner II. 81.17.4

Wood employed his experience as a theatrical set designer, painter of backdrops, and maker of props masterfully in the staging of his studio. The walls, floors and other surfaces in 5 Turner Alley showcase Wood's paint handling skills and his craftsman's sensibility

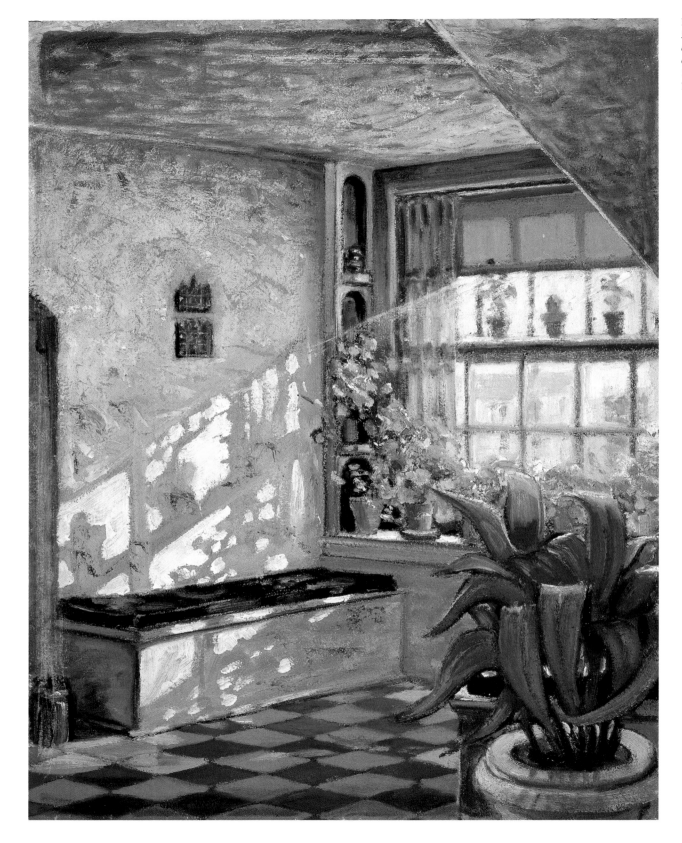

Fig. 71: Grant Wood,
Sunlit Studio,
c. 1925–26. Oil on
composition board,
15 $\frac{1}{8}$ × 19 $\frac{3}{4}$ in.
Private Collection.

towards surface and texture and, perhaps even more, his talent for decorative faux finishes. The mark of the artist's hand is evident throughout. Wood covered the walls and sloped ceilings in the main studio area with gypsum board, and gave them an antique look by first applying a textured "plastic" paint, and then glazing the surface with color. Using these inexpensive materials, he was able to create the illusion of tinted stuccoed walls. He applied layers of colored washes to the textured surfaces, so that they took on a mottled appearance. The ceiling and wall colors in 5 Turner Alley were changed at least twice. The surfaces in the large, open space were originally a blue-green color over a yellow-gray, but were later changed to creamy yellow-gray.[38] Wood's painting, *Sunlit Studio* suggests how these color effects may have looked in the studio (fig. 71). Painted in an Impressionist style, *Sunlit Studio* further captures the textured, mottled surface of the yellow-gray walls and the profusion of light that the studio enjoyed.

Wood's painterly wall and ceiling surfaces in 5 Turner Alley bears comparison to his Impressionist works. Like many American painters of this period, Wood was drawn to the painterly approach of the French Impressionists. In Europe and in Iowa he painted numerous works *en plein air*, capturing the changing effects of light and shadows. Wood's choice of subject matter and his application of color with Impressionist brush work, however, reflects more a study of surface and texture than of light. One of Wood's earliest paintings, *Old Stone Barn*, (fig. 4) is a study in surface and patterns as much as it is of light and shadow, while *New Plaster, Paris* (fig. 10), depicts the stark contrast of new and old plaster on the exterior of a house. The Gothic doorway and walls in *Porte du Clocher, St. Emilion*, share a resemblance to the mottled effects Wood achieved on his studio walls (fig. 13). As Grant Wood scholar Wanda M. Corn observed about this period of his work: "All of these early works are timid and self-conscious. Wood's temperament—that of a tidy and meticulous craftsman—kept him from ever being able to fully adopt (or even understand) the Impressionists' sensuous style, their elimination of drawing and modeling, and their innovation in painting the substance of light. … Even in the late 1920s, when his style loosened somewhat—he began to apply paint with a palette knife in an assortment of colors to build up surfaces of encrusted paint and then incise them with a sharp instrument—an academic crafting of the forms in terms of light and shadow works against the abandon and spontaneity he affects on the surface."[39] The walls of Wood's 5 Turner Alley are more convincing forms than those in some of his paintings.

Wood originally envisioned his studio with an abundance of ceramic tile. He acquired and lined a windowsill with blue-green glazed tiles that recall the kind produced by Batchelder's workshop in California.[40] He planned ceramic tile for his floor but this proved to be too costly and the old floors would have been unable to sustain the weight. So he created faux ceramic tiles. A labor-intensive project, Wood enlisted the help of his art students to cut grooves in the existing planks to mark up six-inch squares. He invented a tool that resembled his mother's cabbage chopper, a saw shaped like a half moon, to help cut the grooves. The squares were then painted different colors and sealed to resemble ceramic tile. The effect was so real that most visitors assumed that it was a real ceramic tile floor (fig. 71). Wood's faux-tile could be interpreted as a "dishonest" use of materials, because it tried to look like something it was not, or it could be praised as an inventive and decorative solution. Wood's sister reported that, though the parquet floor looked lovely, the floor was so thin that exhaust fumes from the hearses below often entered the studio. Sometime before January 1931 Wood replaced the original floor with an oak plank tongue-and-grove floor with wooden pegs that hid the nails.[41] The new floor contributes to the Arts and Crafts ambience of the studio.

Wood used a variety of moldings as trim throughout the studio. Just as he made unique frames for his paintings, he applied wood trim as a framing device to outline various shapes in the studio. He used painted trim as a decorative accent to face shelving units, cover joints in panels, case window and door openings, and to accentuate faux finishes on cupboard doors. The profile of most of this trim is similar to the battens on vertically sided buildings, such as the house depicted in the sketch for *American Gothic* (fig. 121).[42] He used a similar curved molding, though thicker, to frame many of his paintings and often incorporated painted fabric, carved into the frame, or lined it with a thin gold beading. Wood's mixing of unorthodox materials to achieve an antiquated or modern effect on his frames is best exemplified in his frame for *Victorian Survival* (pl. 9). In a not-so-different approach Wood "gilt" the walls of his bathroom with metallic silver wallpaper, while he scored and painted cement boards to simulate ceramic tile.[43] Whether framing one of his paintings, an object, or an architectural element in his studio, Wood's frames and embellished surfaces are always part of an overall design.[44]

Wood's transformation of 5 Turner Alley from hayloft to studio home took less than two years. By the end of 1926 or shortly thereafter, Wood's new studio home was widely admired for the ingenuity and craftsmanship that went into its design. Visitors were intrigued by the overall effect of the transformed space—it seemed both antiquated and modern, controlled but dynamic, and expansive yet cozy.

Fig. 73: Grant Wood, *Mailbox*, 1924. Wood and mixed media, 21 3/8 × 12 × 6 3/4 in. Cedar Rapids Museum of Art, Gift of John B. Turner II. 82.1.3

Fig. 72: Grant Wood, *Mourners' Bench* (details and total view), 1921–22. Oak, 37 × 49 × 16 in. Cedar Rapids Community School District Collection.

Studio Furnishings

His attic is crammed with quaint bits of pottery, bronzes, etchings and curios ... And an undertaker keeps his hearses downstairs ... Grant Wood is a bachelor, and lives with a quiet sweet faced woman who is his mother ... He has a disappearing cupboard, disappearing dining table, and disappearing bed. Everything but the bathtub is apt to disappear at a moments notice [...] and the front door of his apartment is made of glass ... a glass coffin lid. OOOOOOOoooooh... And our humble opinion is that Grant Wood's *American Gothic* is just the magnificent beginning.[45]

MacKinlay Kantor, 1930

From Mourners' Bench to Coffin-Lid Door. In addition to being recognized for his artistic abilities, Grant Wood was known among his friends and colleagues for his sense of humor. While teaching art at McKinley Junior High School, Wood designed and built a *Mourners' Bench* for the principal's outer office (fig. 72). The Mission-style bench looks like an uncomfortable church pew. Crudely carved into the top rail of the bench in raised letters is the inscription:

"The Way of the Transgressor is Hard," and atop the columns are carved faces of doleful and weeping children. Wood designed the bench and completed individual carvings, while his students helped him to build the bench. Students who misbehaved in class could expect to be sent to the principal's office to wait on the dreaded bench, for their meeting with a higher power. During his last year of teaching, Wood made sculpted bouquets that he called, *Lilies of the Alley* (fig. 76). Injecting humor into the Modernist aesthetic of found-object art, Wood made several of these bouquets from bits of things he found lying in the alley outside his door, and other recycled objects such as clothes-pins, shoehorns, bottle caps, old gears, etc. These whimsical flowers were given to friends as gifts and decorated his studio.

Wood had always amused himself and others with humorously unique creations. Number 5 Turner Alley opened a new arena for

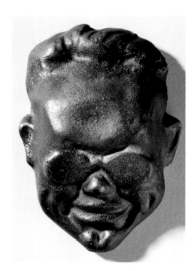

Fig. 74: Grant Wood, *Self-Portrait*, *c.* 1925. Brass, 3 × 2 × 1 in. Gift of Harriet Y. and John B. Turner II. 72.12.59

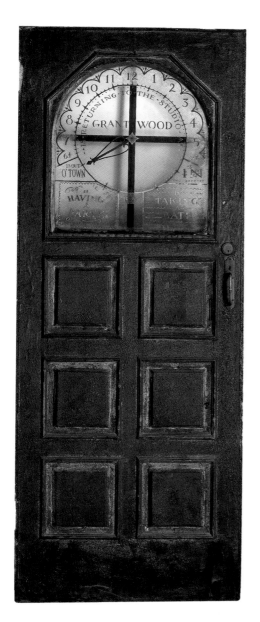

Fig. 75: Grant Wood, Door to 5 Turner Alley, 1924. Painted wood, fabric, glass, and wrought iron, 78 × 29 7/8 × 1 1/4 in. Gift of Harriet Y. and John B. Turner II. 72.12.15

box platform, the letters would fall out through the bottom (fig. 73). Little details such as these told guests to prepare themselves for an out-of-the-ordinary experience before entering the artist's studio.

Visitors entered Wood's studio through a front door he fashioned from a primitive coffin lid with a glass window—a humorous reminder of the mortuary next door and the hearses in the garage below (fig. 75).[46] Around the edge of clock-like construct painted on the window of the door was lettered: "Grant Wood Is Returning To The Studio At—" and a revolving metal arrow, like the hand of a clock, pointed either to the time of his return, or to "Is In," "Out Of Town," "Is Taking A Bath," "Is Having A Party," "Is At -" with a blank space for him to write in another location. The hand-painted red lettering is skillfully executed, as is the wrought-iron metal pointer. No less attention was lavished on the surface of the door which was covered with a linen fabric and textured paint, and then glazed an antique bronze-green color. The same wood molding used through out the studio, and as the liner for many of his picture frames, surrounds the door's arch-shaped window with a six-sided frame that mimics the outline of the proscenium stage inside—a window into "Wood's World."

Much of Wood's humor was connected with his involvement in theatrical production—he designed stage sets, costumes, and even tried his hand at writing plays. While in high school Wood made "death masks" of his two good friends, Lawrence Bartlett and Harland Zimmerman. He was so fond of these that years later he

his quirky and inventive imagination. His new studio home was located somewhat off the beaten track, on an alley with no street address until Wood invented one. He installed an antique lantern that had a tendency to lean, and he left it that way. It shows up on his 1927 Christmas card as a humorous characteristic of the studio. To direct visitors to his studio, Wood made a wooden dingbat (a pointing arm and hand) which pointed up a staircase toward the second floor and announced "Grant Wood's Studio." There was also a brass bell which Wood had brought back from Europe for visitors to announce their arrival. For his letters, he built an unusual wooden mailbox with a narrow slot at the top. By pressing down on the

Fig. 76: Grant Wood, *Lilies of the Alley*, 1925. Ceramic, paint, wire and found objects, 12 × 12 × 6 1/2 in. Gift of Harriet Y. and John B. Turner II. 72.12.38

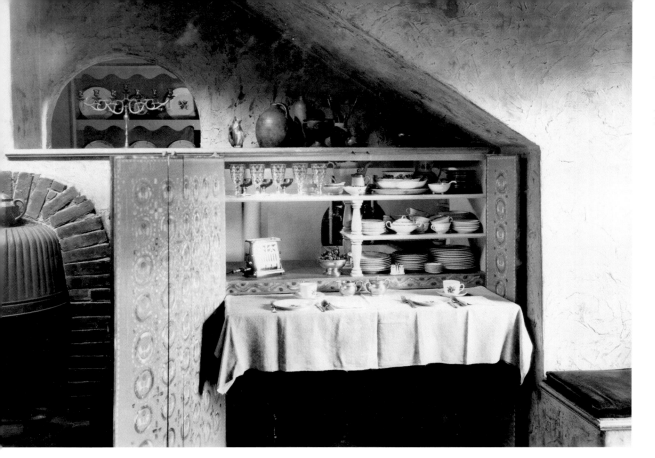

Fig. 77: Interior view of Grant Wood's "Mother's Hot-Dog Stand" at 5 Turner Alley, c. 1925. Courtesy of Figge Art Museum, Grant Wood Archives.

Fig. 78: Grant Wood, Bibbed Overalls Cupboard Door (front), *c.* 1925. Mixed media, 56 × 52 ¹/₄ in. Gift of Happy Young and John B. Turner II. 72.12.51

Fig. 79: Grant Wood, *Calendulas*, 1928–29. Oil on composition board, 17 ¹/₂ × 20 ¹/₄ in. Gift of John Reid Cooper and Lee Cooper van de Velde in honor of their grandparents, John C. and Sophie S. Reid, and their parents, James L. and Catherine Reid Cooper. 89.5.4

painted them to resemble antique bronze and installed them on either side of the front door at 5 Turner Alley. Perhaps the masks of Bart and Zim inspired Wood's later creation of a mini-self-portrait sculpted in plaster and cast in bronze (fig. 74).[47] His sister recalled that he made a hundred of these and gave them away as Christmas mementoes, so his friends could carry him around in the palm of their hand or in a pocket, or simply use him as a paper weight. This jolly self-portrait, which closely resembles a photograph of Wood taken in Paris in 1923, played up his protruding forehead with furrowed brow, a slightly receding hair line and cleft chin (fig. 7). These facial features are again exaggerated in Wood's self-portrait drawing, *Return from Bohemia* (pl. 17), which had been designed as the cover image for his uncompleted autobiography of the same title. Wood's sense of humor also found expression in the caricatures he drew of himself and others. These gently comic caricatures often found their way into his paintings. Many artists include images of themselves in their work, and Grant Wood was no exception. In some of Wood's works, certain facial features—forehead, chin, glasses, or eyes—curiously resemble his own; even in *Mourner's Bench* one detects the cherubic features of a young Grant Wood (fig. 72).

Bibbed Overalls and Mother's Hot-Dog Stand. Several pairs of Grant Wood's bibbed overalls were immortalized in the making of 5 Turner Alley. Wood wore denim overalls whether painting pictures or working on his decorating projects; he considered this unpretentious garb ideal for an artist. While plastering some of the walls of his studio they became so encrusted with plaster that he decided to use them like wallpaper. He cut them up and stretched them like canvas over a pair of cupboard doors and painted them to look weathered and rustic (fig. 78). He left one of the denim pockets on the door functional so that he could conveniently store his bottle opener and other bar utensils. He fabricated antique-looking metal hinges that curiously resemble a handle-bar moustache; though he did make beautiful hand-wrought hardware for his studio, Wood had no trepidation about mixing high and low craft, fine with fake materials. These "plastered" cupboard doors opened up to reveal a pass-through to the kitchenette, shelves for dishes and a pull-out table (fig. 77). Wood's sister Nan recalled that Wood jokingly referred to this set-up as "mother's hot-dog stand." The reverse side of the over-all cupboard doors is painted a brilliant green with an abstract flower motif. Visible only when the "hot-dog stand" was open for business, the color and pattern of the interior door decoration inspired the background for one of Wood's lush floral still lifes, *Calendulas* (fig. 78). The famous bibbed-overalls are also

camouflaged in another way. In the middle of the large open space is a circular rag rug which marks the center of the studio, a bull's-eye beneath the cupola. The rug softens the overall angular quality of the walls and ceiling, repeating the rotund shapes of the arches. Made by Grant Wood's mother Hattie Weaver Wood, the rug was made from Wood's old overalls. A humble product from resourceful hands it speaks to the pioneer spirit which Wood greatly admired and captured in his 1929 painting, *Woman with Plants*, for which his mother posed (pl. 2).

Decorative Metalwork. Wood's training as a metalsmith is evident throughout his studio, in what he created in metal, recycled in metal, and collected in metal. A decorative metal grille separates the studio from a store room (later bedroom), and a pair of metal screens with the same design decorate the arched openings in the triangular peaks of the highest walls (fig. 54). Wood designed and fabricated this grille with the help of his art students.[48] Painted to resemble antique copper, they are actually strips of punched tin joined together by wooden battens. The punched-tin design, a stylized flower motif within a medallion, recalls American folk art and Colonial patterns. Wood also used a modified, more abstract version of this design on painted cupboard doors, and a stenciled version for curtains (figs. 77, 99). Adaptation of the same basic design on three different materials helped to unify the look of his studio.

The hardware and light fixtures in the studio were other means to showcase Wood's metalwork and mixing of hand-made and found-objects in the studio. Aside from the recycled metal bushel basket used as a fireplace hood, two antique, Colonial-style lanterns are prominently displayed, one in the entryway, and the other hanging from a chain beneath the cupola. An antique iron chain was modified to serve as a handrail for the internal staircase, and a wrought-iron torchère hangs on the wall in the dining nook; both introduce a medieval look to the interior, as do the elaborate hinges on the backstage door.[49] Wood's use of Colonial motifs and medieval designs was consistent with the Arts and Crafts aesthetic. *The Craftsman* magazine contained articles on medieval crafts, folk arts from many countries, as well as American-Colonial arts and handicrafts. These earlier traditions were recommended to American Arts and Crafts enthusiasts as rich material to serve as inspiration in developing a new American style in interior design.

Wood's *Objets d'Art.* The orderly and stage-set appearance of Wood's studio can be compared to his post-1930 paintings in which everything is arranged in a fashion both dynamic and balanced. The

Fig. 80: Grant Wood at his desk with star design motif, 5 Turner Alley, c. 1931. Gift of Mrs. John W. Barry. 89.2.1. Photo: John W. Barry.

Fig. 81: Grant Wood, Folding Screen with Star Design, c. 1931. Wood, paint, pencil and metal, 71 3/4 × 100 3/4 in. Gift of Happy Y. and John B. Turner II. 72.12.64

eye moves from one place to another, never tiring of the pleasing arrangement of three-dimensional objects framed within or against the backdrop of the ceilings and walls. In his mature paintings, and when he taught art at the University of Iowa, Wood relied on a compositional technique he termed "principle of thirds."[50] This approach involved dividing each edge of the composition into thirds and then drawing diagonal lines through the intersections of the grid. The main parts of the composition are placed on diagonal axes, thus introducing "dynamic" movement to the otherwise rigid, symmetrical structure; and the eyes are always carried back to the center of interest rather than out of the picture. Strong diagonals are the defining feature in Wood's meticulously crafted works, but they are buried in his repetition of patterns and other shapes that offset the grid. Many of Wood's early paintings of European houses include strong diagonals as part of their composition as well as other strong, flat geometric patterns (figs. 10, 20). Regardless of the perspective from which one views 5 Turner Alley the slanted ceiling diagonals create the same effect of a stage on which objects are arranged. In the 1925 photographs of Wood's studio, all of the free-standing furnishings—wicker chair, chest, trestle table and easel—are arranged in a pleasing composition within the "stage" section of the studio. When Wood added the west dormer to his studio, he placed a desk in this alcove which he painted with a stippled star pattern (fig. 80). He repeated the pattern on a free-standing, folding screen painted a yellowish gray to match the walls and desk (fig. 81). The four wooden panels contain a star and diamond design created by a series of diagonal lines, neatly framed within squares to which Wood added a decorative silver border, imitative of gilt bookbinding decoration. This screen design, with its smooth, flat surface and crisp lines, is comparatively modern in appearance.

Displayed throughout the studio were Wood's objets d'art, arranged always with the artist's eye for composition. Ceramic and metal vessels are grouped together in still-life fashion on the table behind the stage, on the sideboard in front of the stage, on the hearth, and in the angular niche above the cupboards. Glass goblets, neatly stacked china and a pressed tablecloth are displayed in showroom fashion. Within all this order, there is a bit of mayhem—trailing plants, pillows on the floor, sweeping stage curtains, art work displayed on his easel, or casually leaning against the walls. These effects, together with a samovar which he ceremoniously used to serve tea, point to a somewhat bohemian and cosmopolitan lifestyle. Number 5 Turner Alley represents an eclectic style of decorating that was not yet common in America. Wood happily mixed antiques with modern furnishings. He visited flea markets in Europe as well as in Iowa, and collected antiques and other objects

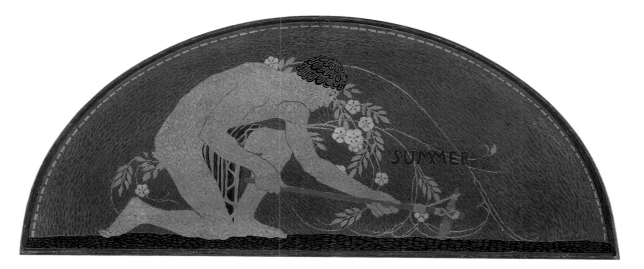

Fig. 82: Grant Wood, *Summer* (Lunette of *Four Seasons*), 1923. Oil on canvas mounted on panel, 16 ⅛ × 29 ⅛ in. Cedar Rapids Community School District.

that appealed to him simply because they were well designed and well made. Wood's collections included family heirlooms and travel memorabilia. On display in the studio were Haviland china, salt-fired stoneware, French, Italian, and Spanish majolica, metal vessels of all shapes and sizes, and candelabra; even a carved wooden putto from Spain hung in the apse of the cupola. The distinct forms and patterns of these objects stood out effectively as decoration against the blank walls. Some of them also served as inspiration for, or occasionally appeared in his paintings. Even when viewed as a stage set, the many personal objects and the great attention to detail make the atmosphere of Wood's studio enormously appealing. The display of belongings in a showroom-like fashion, almost as if merchandise, hearkens back to Wood's earlier experience as a window dresser.

The Studio Years

Residential Commissions

The years at 5 Turner Alley were the most productive and developmental of Grant Wood's career. As an interior decorator he completed many residential projects in Cedar Rapids that called on his artistic imagination as well as his craftsmanship. In 1925 he received a commission to decorate a sleeping porch for the Queen Anne style mansion of the George B. Douglas family, which was later named Brucemore (now a property of the National Trust for Historic Preservation). Wood's *bas-relief* design for the walls of the

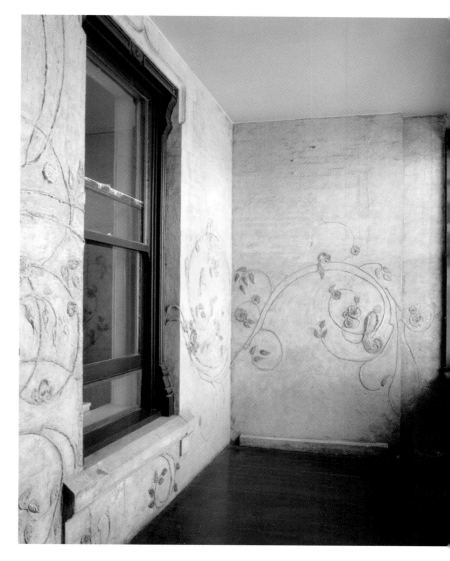

Fig. 83: Grant Wood, *Sleeping Porch* at Brucemore, A Historic National Trust Site, Cedar Rapids, Iowa, 1925. Plaster stucco.

Fig. 84: Designed by Grant Wood, forging attributed to George Wilhelm, *Fire Screen Ornament*, c. 1929–30. Wrought iron, 50 1/4 × 21 1/4 × 4 1/2 in. Gift of John T. Hamilton III. 69.12

porch, executed in plaster, features dreamy Art Nouveau-inspired morning glories, trailing vines, and nightingales (fig. 83). While the curvilinear patterns and graceful lines of the Douglas' frescoed walls recall Wood's earlier Art-Nouveau-style works, such as *Summer* (fig. 82) (one of his *Four Seasons* lunettes) and *Necklace* (fig. 57), they also anticipate the more abstract and stylized vegetation characteristic of his paintings and decorative art works of the late 1920s.

Between 1929 and 1930, Wood completed several sizeable residential decorating projects for families living on Linden Drive, in a picturesque neighborhood of homes in Cedar Rapids. In these he demonstrated an inclination to borrow from many artistic sources, ranging from Italian Renaissance painting to 19th-century American maps, and an ability to adapt them to carry out his ideas. For the George Hamilton home he executed floral designs in plaster relief, painted the ceiling in the front hallway with a star motif, and designed an elegant railing for a circular staircase, as well as *torchère*, gates, and a *Fire Screen* fabricated in hand-wrought iron (fig. 84).[51] The screen's elaborate design, with cranes and intermingling foliage, would animate any fireplace with or without a fire. A similar arabesque design appears, in two-dimensional form, on a pair of French doors designed for the Van Vechten-Shaffer home.

Wood painted these doors, which led into the library, with neoclassical imagery (fig. 86). The portrait busts within oval medallions, mythological vignettes, foliage, and putti pay homage to Raphael's 16th-century grotesque designs for the walls of the Vatican library, a flattering reference for a family that prided itself on its fine library.[52] Ornate stucco wall and ceiling decorations complete the Renaissance villa effect in the living and dining rooms, and the pair of wrought-iron gates that led into the sunroom were also in keeping with the Italianate look (fig. 85). The gates, though more reductive and modern in design than the doors, incorporate a touch of Iowa with the stylized, individual sheafs of wheat in the lower quadrant, while the mythological scenes on the doors include Ceres, the goddess of agriculture, another symbolic link to Iowa.

During Wood's time at 5 Turner Alley, he often teamed up with architect Bruce McKay on residential projects, following their successful collaboration on the Turner mortuary. Between 1929 and 1930, they designed and built a neo-colonial style home for the Herbert Stamats family. This project was a turning point for Wood in many ways, as he painted a picture of a home he helped to design. The same flat patterns and flowing lines that make up the floral motifs on the Van Vechten-Shaffer doors and in the Hamilton fire screen emerged in a more stylized and hard-edged fashion in his painting, *Overmantel Decoration*, for the Stamats' home (pl. 7). For this work, Wood again borrowed compositional and design elements from many sources, but instead of mining French Art Nouveau or Italian Renaissance art for inspiration, he looked closer to home. Wood's *Overmantel Decoration*, which includes a depiction of the Stamats' home, takes inspiration from illustrations of landmark estates featured on an antique map of Linn County, Iowa, published in 1869 (fig. 109).[53] Even the oval-shaped, faux-floral mat that frames each of the map's home illustrations is repeated in the picture's decorative border. While Wood's portrayal of the Stamats family, dwarfed by the landscape, is reminiscent of Currier and Ives prints, the fanciful vegetation and foliage are blown-up versions of shapes and patterns found on majolica and willowware china that he collected and displayed at 5 Turner Alley (fig. 111).

The crowning achievement of Wood and McKay's residential work was a home they designed and built for Robert C. and Esther Armstrong. Completed in 1933, well after *American Gothic* had secured his name as an artist, Wood worked tirelessly on this house. For this project they researched mid-19th century regional architecture and interiors. Wood followed every detail, from the choice of stone for the exterior to the design features and furnishings of the interior as well as the landscaping of the grounds. Wood's architectural and decorating projects, from 5 Turner Alley to the grand

Fig. 85: Designed by Grant Wood, forging attributed to George Keeler, *Pair of Gates*, designed for the Van Vechten-Shaffer Home, 1929–30. Wrought iron, 79 $^1/_2$ × 28 $^1/_4$ × 3 in. Museum Purchase. 2001.1

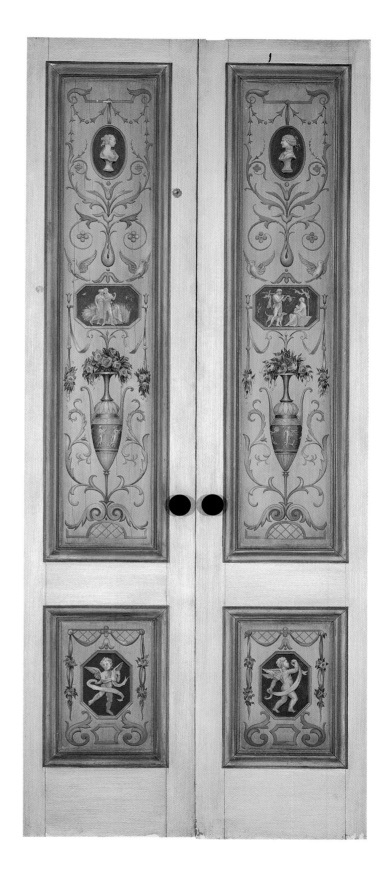

estates of Cedar Rapids, demonstrate his unique ability to create a holistic environment with an artistic flair, whether for the interior of a room or the exterior of a building.

Iowa Corn Rooms

The scope of Wood's commercial decorating projects, between 1925 and 1930, ranged from dining rooms for the Cedar Rapids Chamber of Commerce to wall paintings with aquatic and mermaid motifs for the Submarine Sweet Shop in Waterloo, Iowa, 1929.[54] One project

Fig. 86: Grant Wood, *Library Doors*, designed for the Van Vechten-Shaffer home, 1929. Oil on wood, 89 $^1/_2$ × 38 $^5/_{16}$ × 6 $^7/_{16}$ in. Dubuque Museum of Art, Gift of the Bob and Barbara Woodward Family. 00.12.51

Fig. 87: Grant Wood, Interior of the Iowa Corn Room, Hotel Montrose, dining room, Cedar Rapids, Iowa, 1925–26.

that stands out among them and eventually became known as the "Iowa Corn Room," came from Eppley Hotels. The commission was to design a dining room for their Hotel Montrose in Cedar Rapids (1926–27), and subsequently for their hotels in Sioux City (1927) and Council Bluffs, Iowa (1926–27).[55] Wood looked close to home for inspiration for this project—to the farmland near Anamosa, Iowa where he had grown up. The Iowa Corn Mural rooms, which bring Iowa's landscape indoors, pay homage to the expanse of the Iowa landscape and the agricultural staple of the state (fig. 87). The hotels that contained the murals are no longer extant but sections of these eight-foot-high canvases have been preserved at the Cedar Rapids Museum of Art and the Sioux City Art Center. The decorations for the Corn Room included large sectional paintings that depicted cornfields, evoking the perspective that one was dining in the middle of a cornfield. Painted in primarily golden hues, Wood used quick gestural strokes to define the corn stalks and landscape. He achieved a three-dimensional effect by adding a thin layer of a

translucent glaze over the entire canvas so that it shimmered, and then partially removed areas of the glaze to achieve a matt surface (fig. 88). Wood's surface treatment of these large murals recalls the techniques he employed for the faux surfaces in his studio, while the entire ensemble of canvases paired with corn-cob chandeliers and window treatments with corn motifs demonstrate his penchant for totally designed environments (fig. 89).[56] Wood's friend Hazel Brown recalled: "As you sat at a table eating, you were sure you were in the middle of a cornfield; you almost felt the crunchy corn-stalks under your feet. The men who used the room for meetings loved to tip their chairs back against the wall and make big business of picking off an ear of corn. The chandelier even had corn-colored bulbs glowing from the tops of upright ears of corn, with pendants of graceful corn leaves…"[57] There was also a frieze above the corn murals which included a stanza from the Iowa corn song: "We're from I-O-way, I-O-way State of all the Land, Joy on ev-'ry hand. We're from I-O-way, I-O-way. That's where the tall corn grows."

What could be cornier—and more apropos of Wood's sense of humor?

For the overall concept and design of the Iowa Corn Rooms, Wood again looked to the Peoples Savings Bank in Cedar Rapids for inspiration (fig. 90). Designed by architect Louis Sullivan in 1911, the bank's Prairie-style interior was a treasure trove of ideas and images for Wood.[58] The arrangement of Wood's Corn Room mural panels within an architectural construct, as well as the coordinating light fixtures and windows, recalls Sullivan's masterful design. A major feature of Sullivan's interior is a series of murals by Chicago artist Allen Philbrick, which surround the interior of the bank in a

Fig. 89: Designed by Grant Wood, forging attributed to George Keeler (1908–44), Corn Cob Chandelier for Iowa Corn Room, 1925–26. Formed brass sheet, cast and machined iron, and copper wiring, 94 × 32 × 34 in. Gift of John B. Turner II. 81.17.3. Photo: Charles Walbridge.

frieze-like manner. Philbrick's mural, *Industry—Banking—Commerce*, served as a compositional and thematic source for Wood's earlier painting, *Adoration of the Home* (figs. 60, 61), while the other three murals of agrarian scenes recall Wood's Regionalist-inspired work. Philbrick's *Summer Noon*, depicting threshers picnicking in a cornfield, probably served as inspiration for Wood's Corn Room murals as well as his famous work, *Dinner for Threshers* (pl. 15). Sullivan's interior design is brought to a crescendo in the stunning art-glass windows, installed in clerestory fashion, above the murals. The impact of this unified, artistic, and functional space bears comparison to 5 Turner Alley and Wood's next major commission—a stained glass window for a building only two blocks from the bank in Cedar Rapids.[59]

Fig. 88: Grant Wood and Edgar Britton (1901-82), Hotel Montrose, Iowa Corn Room Mural, Unit 1, 1926-27. Oil on canvas, 50 1/8 × 38 3/4 in. Gift of John B. Turner II. 81.17.1

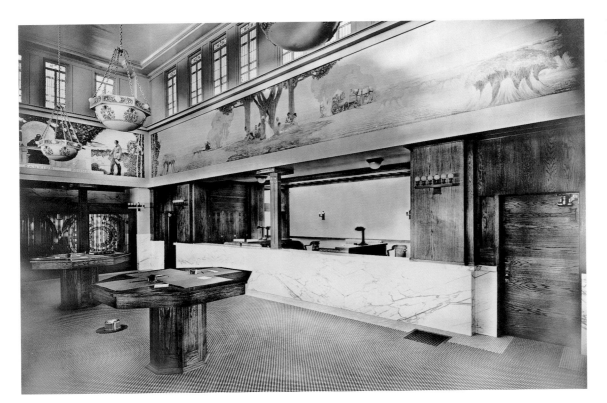

Fig. 90: Louis Sullivan (1856–1924), Peoples Savings Bank, Cedar Rapids, Iowa, interior view, 1911. Murals painted by Allen Philbrick (1879–1964) "Industry-Banking-Commerce" (left) and "Summer Noon" (right). Courtesy of the Library of Congress.

From Stained Glass to *American Gothic*

During his first five years at 5 Turner Alley, Wood's commercial reputation as a local decorator grew faster than his critical reputation as a painter. However, between 1929 and 1930, his painting style underwent a dramatic shift away from Impressionist influence, to meticulously crafted compositions that were bold and direct. Instead of quick, expressive brush strokes, in an attempt to capture light and color on canvas, he began to paint carefully drawn and delineated compositions. This shift in style was partially precipitated by Wood's work on a major stained-glass window commission for the Veterans Memorial building, a project that took him to Munich, Germany (pl. 1). He had limited experience in this medium and had never before undertaken a project of this scale and complexity. Recorded as the largest stained-glass window in the United States, it depicts six soldiers one from each of America's wars and a female figure symbolizing victory. The project required Wood to carefully work out a design to scale, and in great detail, before it could be fabricated in stained glass. His cartoons for this project are decorative and monumental, and in them it is possible to see the beginning of a new stylistic direction (figs. 92, 93).

After Wood's design for the window was complete, he selected the Emil Frei Art Glass Company in Saint Louis to carry out the stained-glass fabrication of the window. However, because of the size and complexity of the project, it had to be made in Emil Frei's studio in Munich, Germany. Wood traveled with Frei to oversee and assist with the production of the window, which took much longer than expected, requiring them to remain in Munich for three months. During this time Wood worked closely with highly skilled craftsmen in a guild-like setting, learning the technique of a centuries-old art form (fig. 91).[60] His stay in Munich introduced him to a city full of 19th-century eclectic, revival architecture (neo-Gothic,

Fig. 91: Grant Wood with colleagues at Emil Frei Art Glass Company, Munich, Germany, fall 1928. Gift of Joan Liffring-Zug Bourret.

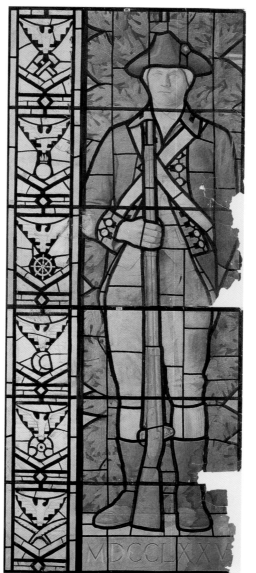
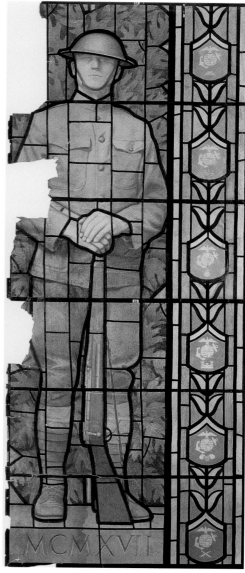

neo-Baroque, neo-classicism, Jugendstil), Bavarian *Völkerkunst* [folk art], and 15th- and 16th-century Netherlandish and German painting, particularly works by Dirk Bouts, Hans Memling, Lucas Cranach, and Albrecht Dürer on display at the Alte Pinakothek, Munich's major art museum (figs. 18, 19). Looking at paintings by these masters, Wood found himself drawn to their "naiveté", their setting of Biblical scenes in European landscapes, their dressing of Biblical persons in medieval costumes, their unsophisticated and inconsistent use of perspective, and their fondness for shallow or even flat stage-like compositions. These narrative scenes, which used landscape as a backdrop, architectural constructs as a stage, and the people as actors with symbolic "props" captured Wood's

imagination, while the opportunity to work with the craftsmen harked back to his formation in the Arts and Crafts Movement—(which itself drew inspiration from medieval art and guilds.) His German experience, as compared to his sojourns in France and Italy, resonated with his own sensibilities.

As Grant Wood scholar James M. Dennis has observed, this commission "marked a time of significant change from an intuitive approach to painting small-panel oil sketches to the development of a strong inclination for finished craft, which he had already been putting to use in creating house interiors for his more affluent friends and acquaintances in Cedar Rapids. ... Work on stained glass, with its symmetrical formality of architectural design and its

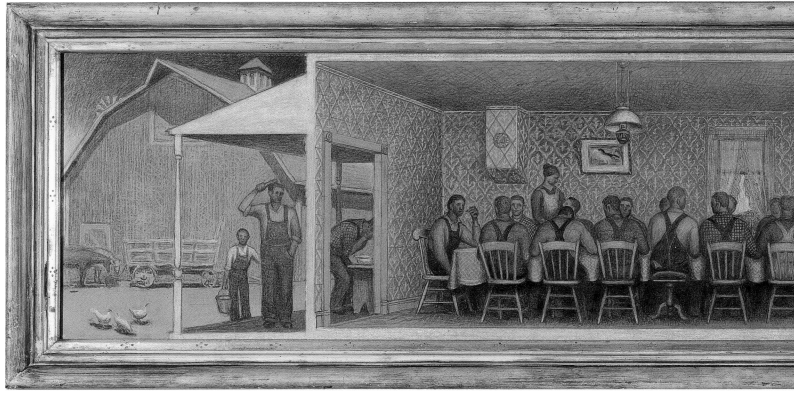

Fig. 94: Grant Wood, Study for *Dinner for Threshers*, 1934. Charcoal, graphite and chalk on tan paper, 18 × 72 in. Private Collection.

meticulously refined forms glazed in translucent colors, more than likely provided a new incentive for Wood to investigate Late Gothic and Northern Renaissance painting."[61] The project brought about a greater awareness of the relationship between painting and craft, whether on stained glass or canvas. The artistry of craft was always present in his work, but Wood's experience of painting on flat, geometric pieces of glass led him to experiment with flatter, more geometric and delineated forms in his painting. He began to apply his craftsman-like approach to painting, emulating Old Masters' glazing techniques by applying multiple thin layers of oil on panel. At the same time, some of his painting techniques and his imagery— reduced to basic volumetric forms and flat abstract patterns— reveal the influence of Modernism and result in a stylistic synthesis.[62] Wood explained his revelatory experience:

> Until several years ago I was strongly influenced by the Impressionist school, probably because I was taught to paint after their manner. However, my natural tendencies were towards the extremely detailed. … at this point my work was never accepted in any important exhibition. It happened that several years ago I went to Munich to have a stained glass window completed. While I was there the annual exhibition at the Glass Palace [Glaspalast] was in progress. There I found

myself experiencing a reaction against so-called Modernism and felt myself drawn toward rationalism. It appeared to me that the Modernists went to the Primitives for inspiration. I wondered if I could anticipate what was to follow. It seemed to me the Gothic painters were the next step. I had always admired them, especially Memling, whom I had studied assiduously. To me the Gothic seemed the next line of advancement, so I retained what I thought was lasting in the Modern movement and to it added a story-telling quality as a logical opposition to abstraction. Here I was on dangerous ground, because story-telling pictures can so easily become illustrative and depend on their titles. For this reason I leaned strongly to the decorative and also, I endeavored to paint types, not individuals. The lovely apparel of the Gothic period appealed to me so vitally that I longed to see pictorial and decorative possibilities in our contemporary clothes and articles. Gradually, as I searched, I began to realize that there was real decoration in the rickrack braid on the aprons of the farmers' wives, in calico patterns and in the lace curtains. At present, my most useful reference book, and one that is authentic, is a Sears, Roebuck catalogue. And so, to my great joy, I discovered that in the very commonplace, in my native surroundings, were decorative adventures and that my only difficulty had been in taking them too much for granted.[63]

Grant Wood, 1932

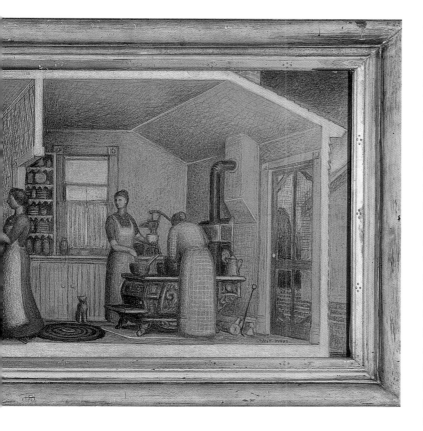

After his trip to Munich, Wood returned to Iowa and his studio with a new appreciation for the freedom it offered for attempting something new in his paintings. Just as Wood had experimented freely with different artistic styles and forms in his design of 5 Turner Alley and other decorating projects, he finally allowed himself that same freedom in his painting, borrowing from a *mélange* of materials for their good design or decorative effects. It seems fitting that one of Wood's first paintings to exhibit the germination of a new stylistic direction was a portrait commissioned by David Turner, of his 84-year-old father, *Portrait of John B. Turner, Pioneer* (fig. 22). Perhaps Wood felt free to experiment with this commission in a way that seemed impossible with other commissions since he already had Turner's ardent support. As Wood began to look close to home for inspiration, he turned to pre-existing representations of the Iowa frontier. The background for his portrait *John B. Turner, Pioneer* includes the 1869 Linn County map, while Wood's next painting, *Woman with Plants,* represents a type, a "saint" of the prairie with an Iowa landscape as its background (pl. 2). Wood depicted the woman's everyday costume as rich and unique as the costumes he had seen in the paintings at the Alte Pinakothek. With his mother posing as his model, Wood painted an idealized portrait of her

depicted as a pioneer woman holding a plant known for its hardiness and its ability to survive extreme conditions. His studio became the stage upon which he posed his subjects. For their background, instead of the Alpine landscape or Tuscan hills, he painted the rolling farmland and architecture of Iowa. In the fall of 1929 Wood's *Woman with Plants* was accepted into the *Forty-Second American Exhibition of Paintings and Sculpture* at the Art Institute of Chicago. The following year he entered the annual show again, and his work won an award and was purchased by the museum. This time the painting was *American Gothic*, and it became *the* work that served as the dividing line between his early and mature work.

Wood's rise to fame, almost overnight with the success of *American Gothic*, encouraged him to continue painting in his new style, which only later became known as Regionalism. At about the same time he completed *American Gothic*, Wood painted a landscape in his new style, *Stone City, Iowa* (pl. 4). The place of inspiration for this work came from his past, the countryside of Wood's youth, and anticipated the future home of his summer art colony, Stone City Art Colony, in 1932 (figs. 26–28). *Stone City, Iowa* is a "decorative adventure" that moves beyond "story-telling" or describing a specific location. Instead its stylized landscape seen from a bird's-eye view makes it epic: the reductive forms, tight design, and repeating decorative patterns arrest and hold the viewer's attention. Between 1930 and 1934, Wood painted most of the works for which he is best known: *Arnold Comes of Age, Victorian Survival, Appraisal, Daughters of Revolution, Midnight Ride of Paul Revere, Birthplace of Herbert Hoover, Young Corn, Arbor Day, Plaid Sweater, Dinner for Threshers, Portrait of Nan, Death on the Ridge Road* (pls. 5, 9, 8, 10, 11, 12, 13, 14, 18, 15, 19 and fig. 126). One of Wood's last works while he was living at 5 Turner Alley is the mural-like painting, *Dinner for Threshers*, for which he had completed an almost identical preliminary drawing (fig. 94). The humble brown paper on which it is drawn as well as Wood's drawing "marks" reflect his Craftsman's sensibility to materials and surfaces, while the monochromatic effects resemble a carved frieze. The cut-away view of the farmhouse recalls Wood's earlier Christmas-card rendering of 5 Turner Alley, and draws on other compositional sources, from Renaissance painting to the triptych-like format used in *Adoration of the Home* and proscenium arch that outlines the stage in his studio. It appears as if Wood used his studio as the model for many of the decorative details that make-up this regimented and tightly composed work: the hanging lamp in the middle of the composition; the thin porch column bearing a marked resemblance to the metal pole he designed for his stage; the neatly arranged dinnerware on the cupboard shelves; the overall division of the painting with

Fig. 95: Grant Wood, Showroom display for *The Grant Wood Lounge Chair*, 1938. Manufactured by H. R. Lubben Company, Cedar Rapids. Courtesy of Figge Art Museum, Grant Wood Archives.

diagonals; the rounded and arched figures; and the mottled shadings. The architectural elements, decorative finishes, and furnishings detailed in this "Last Supper"-like drawing, sum up the impact of 5 Turner Alley on Wood's work in a powerful way.

From 5 Turner Alley to Iowa City

In the early 1930s, Wood's career flourished as he gained recognition as a celebrated artist. But in 1935 Wood left 5 Turner Alley to pursue other opportunities, and his career—as well as his lifestyle—changed dramatically. In 1934, Wood had been appointed director of the Public Works of Art Project (PWAP) mural project for Iowa, and at the same time became a professor of art at the University of Iowa, Iowa City.[64] In 1935 Wood married and then moved to Iowa City, leaving Cedar Rapids and his strong support base. Both his marriage and his university position turned out to be tumultuous situations, and for the first three years after the move, he completed only one major painting, *Spring Turning*. Wood and his wife had purchased a pre-Civil War home in Iowa City, and he spent most of his first year there renovating and decorating the

home in a refined Grant-Wood style (figs. 112, 113, 128).[65] Just as he had done at 5 Turner Alley, he designed, built, modified, mixed, and arranged. In his new, modern-eclectic environment, he prominently displayed his collection of flint glass, iron stone china, and majolica (fig. 113). Even though the result was praised as "the most beautiful house in America," behind the scenes his personal life was not in order. He turned his attention to illustration, commercial and decorative arts projects and, while teaching at the university, tried several new ventures. One of Wood's prized possessions in his new home was an upholstered lounge chair and elongated ottoman of his own design—a *chaise-longue* when pushed together—and it briefly went into mass production (fig. 95).[66] Marketed in 1938 with a cardboard cut-out of Wood as "The Grant Wood Lounge Chair," its deep tufted seat, streamlined form, rolling headrest, and gently curved arms are reminiscent of the rolling landscape found in his paintings.

Iowa farmland is also the theme of a mural Wood designed while he was director of the Public Works of Art Program. *Breaking the Prairie* was designed for the library at the State University at Ames, Iowa (fig. 29). For this work Wood again mined Allen Philbrick's bank murals for thematic and compositional inspiration.[67] While

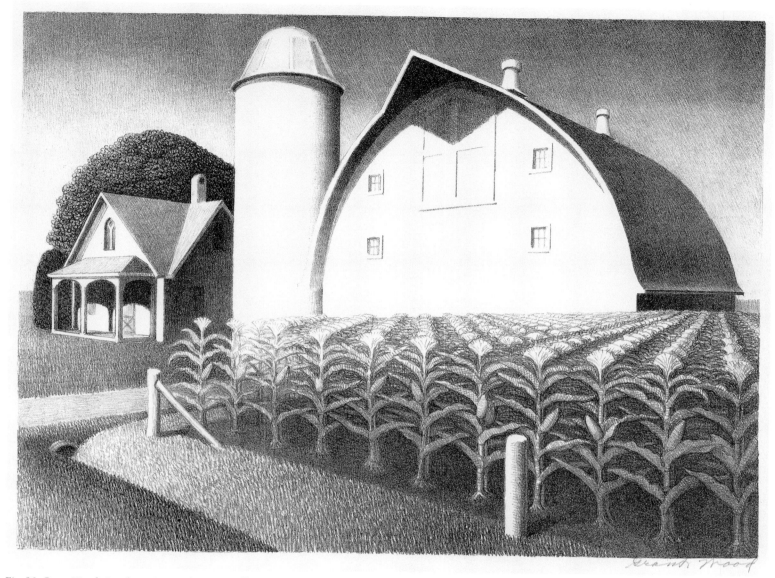

Fig. 96: Grant Wood, *Fertility*, 1939. Lithograph, 8 $^{15}/_{16}$ × 11 $^{7}/_{8}$ in. Gift of Harriet Y. and John B. Turner II. 72.12.67

working on his mural projects, Wood participated in another major venture. In 1937 the Associated American Artists (AAA) in New York commissioned Wood to produce a series of lithographs to be sold through their mail-order catalogue. This idea greatly appealed to Wood, as it was a new and democratic approach, allowing those who could not afford one of his paintings to purchase a well-crafted print. One of his lithographs, *Fertility*, is a tribute to shape, textures and motifs that Wood embraced: the *American Gothic* house in the distance, the proscenium arch formed by the silhouette of the pregnant barn, the rocket-shaped silo which performs like a bell tower, the barn as an agrarian cathedral, and the rows of corn, so close together that their leaves join to form a series of Gothic arches (fig. 96).

While working on his ambitious AAA print commission, Wood was also called upon to design two decorative art works for limited production—one in glass and the other in fabric. The first commission was from Steuben Glass, which commissioned 27 contemporary artists (Henri Matisse was among them and was invited to select the other artists) to design vases for their 1939 series, *Twenty-Seven Artists in Crystal*. Wood based his etched design closely on an earlier mural painting, *Farmer's Wife with Chickens*, one of several panels for his *Fruits of Iowa* series, which he created for the Hotel

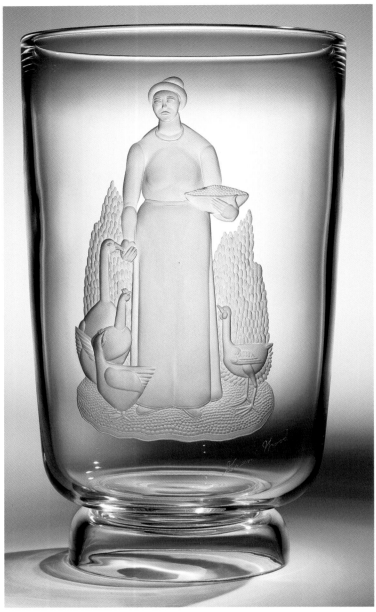

Fig. 97: Grant Wood, George Thompson, "Vase with Woman Tending Geese," from *Twenty-Seven Contemporary Artists* series, 1939. Colorless glass, blown and engraved, height: 14 in. The Corning Museum of Art, Gift of Harry W. and Mary M. Anderson in memory of Carl G. and Borghild M. Anderson and Paul E. and Louise Wheeler. 89.4.33

Montrose (now installed in the library at Coe College, Cedar Rapids; figs. 24, 25). However for the vase design, Wood substituted geese for chickens. A tightly packed composition of repeating shapes and forms, the woman's robust figure is mimicked in the inverse shape of the vase (fig. 97). The second project was for a fabric design, *Spring Plowing*, though it never went into production

(fig. 98). His design of a rolling farmland scene is depicted like a patchwork quilt, repeating miniature images found in many of his landscapes, especially *Spring Turning*. The fabric pattern includes a zigzag road that is reminiscent of the rickrack design on his mother's apron in *Woman with Plant* and his sister's apron in *American Gothic*.

Four years after Wood left 5 Turner Alley, he completed *Parson Weems' Fable* (pl. 20). One of his last major paintings, it contains all of the elements that make Wood's work powerful and, at the same time, uniquely his own. Mixed in with Wood's characteristically gentle satire, are oblique references to 5 Turner Alley. The stage is set by a thick heavy curtain, while repeating patterns and shapes lead the eye through the composition. An approximation of Wood's Iowa City house is depicted in the background within a series of diagonals and rounded, arched forms and surrounded by the Iowa landscape. Parson Weems as narrator and observer holds back the curtain and points out the action center stage. We might think of Grant Wood in this same narrative role, pointing out to us new ways of looking at familiar images within equally familiar surroundings.

Before 5 Turner Alley, Wood's career seemed to be following two parallel paths: he was a decorator/craftsman with a flair for artistic design; and he was a painter imitating and trying out different artistic styles. He had already experimented with Art Nouveau, Impressionism, Pointillism, and even Modernism, without ever feeling entirely at home in any of these styles. Though Wood had been developing his personal style with plaster, metal, and other materials, he was primarily a painter. That was where he focused his creative energy and made use of his inspiration. The decisions Wood made in creating his studio provided him with the first paradigm of his imaginative world—the world he would eventually paint.

The creation of 5 Turner Alley prepared Wood to make the great change in his art that came several years later. Given the opportunity to create a studio home from what had been an old hayloft, without any commercial or artistic pressures, Wood felt free to experiment, to be humorous, to mix and match, to create an environment in which he could simply feel at home. Though 5 Turner Alley was recognizably in the *tradition* of the Arts and Crafts Movement, it was not slavishly in the *style* of the Movement. Rather, it was filled with design elements, forms, and motifs, theatrical effects, and European details that appealed to Wood personally. What Wood began to discover was that using the most common and familiar materials and the most natural and instinctive methods could result in a masterful creation. The greatest embodiment of this was in 5 Turner Alley itself.

Fig. 98: Grant Wood, *Spring Plowing* (Textile Design). Tempera on paper, 16 × 38 in. Collection of Mr. Ernest Johnston Dieterich.

If Wood had found his muse in 5 Turner Alley, it led him to further self-discovery in Europe. When he went to Munich in 1928, Wood discovered a painting style and techniques that, like 5 Turner Alley, made him feel at home. He began to paint in this style, adapting it to his own craftsmanlike ethos. His painting became more decorative, and his decorative arts more artistic, but now the style in both art forms was almost the same. The hard-edged forms and stylized images, tightly designed compositions, and indigenous subject matter which he painted mirrored what he had already achieved in the creation of his studio. As Wood made the connection between craft and painting he found the cohesive style that marked his greatest work. The first step in this process was the creation of 5 Turner Alley. Without it Wood might never have perceived the artistic possibilities inherent in a man, a woman, a pitchfork and a Gothic window in Eldon, Iowa.

Grant Wood: Uneasy Modern

Wanda M. Corn

Fig. 100: Grant Wood, *Victorian Survival*, 1931. Oil on composition board, 32 ½ × 26 ¼ in. Dubuque Museum of Art, on long-term loan from the Carnegie Stout Public Library, made possible by the Lull Art Fund. LTL 99.09

skilled finger work that has shaped the tight knot at the back of her head. With eyes like glazed marbles, she stares vacantly at, or more aptly, through us. Her nose slides down between her eyes, ending in a bulbous mass. Two old-age lines lead from that nose to the corner of her clamped mouth. Her mouth is so tightly shuttered that she appears lip-less, perhaps even without teeth. Through the exertion of her own facial muscles, she has so firmly gagged herself that she appears both unwilling and incapable of speech.[1]

Other details dissect this Victorian body. The part in her straight black hair, slightly off center, is a knife cut, slicing through the silken hair mass to the whiteness of the skull. Around her exceedingly long neck a black ribbon, tight and taut, throttles her pronounced muscles and vocal cords. This choker cuts across the woman's thick neck like the blade of a guillotine. All of these bodily incisions add tension and darkness to this figure from the past. Her surface correctness is over drawn, her gentility tinged with meanness and intolerance.

She wears two other decorations, a pin in the middle of her neckline and a gold wedding band on the ring finger of her left hand. The brooch, a typical piece of Victorian jewelry and often among a simple woman's most prized possessions, is the most ornate and unrestrained detail of her clothing (fig. 101). It has a metal filigree top and bottom which set off a bit of ivory work in the shape of a bust. Its texture and center alignment lead the eye to the similarly patterned rug on the table and down to the desiccated surfaces of the woman's hands. With pronounced veins and leathery

What an odd couple: the Victorian lady seated next to the modern dial telephone! The two creatures in *Victorian Survival* could not be less compatible (fig. 100). The woman wears a widow's black dress with a scooped neckline that renders her head and neck a portrait bust. Her hair is tightly pulled back behind her oversized ears that flare out from the sides of her head. Not a strand has escaped her

Fig. 99: Interior view of 5 Turner Alley showing arched niche with candlestick phone, *c.* 1925. Cedar Rapids Museum of Art Archives.

Fig. 101: Detail of brooch in *Victorian Survival*

skin, one bare hand clasps the other in a parlor pose that signifies feminine politeness but also hides the lower body from our probing eyes. Overall, this torso proclaims: "Do Not Touch."

This type of woman steps right out of 19th-century photographic portraiture. We know the stiff pose, black dress, dour face, and sepia coloring from countless daguerreotypes, ambrotypes, and tintypes taken in studios during the Victorian age. The composition is a conventional one: a female sitter next to a table looking straight into the camera. The quotation from early photographic practices is underlined by the painting's custom-made, gilded frame whose design mimics the archway and curved corners of 19th-century mounts used in photograph albums and handheld cases. The surprise, of course, is the object on the table. In the 19th-century photograph, the decoration would have been a vase of flowers, a family bible, or, on occasion, a book. On this table, however, sits an open-mouthed telephone, stretching like a daffodil to the sun, inviting the woman to pick it up, hold it, and talk into its mouthpiece. Known as the "candlestick" phone, it is everything the woman is not. It is outgoing and alive while she is reserved and repressed. It represents speech and communication while she conveys silence and anti-sociability. She appears to disregard its presence while it seems to beg for her attention. Her stoic resistance could, of course, be all show. She might be waiting for a call.

There is great amusement in this setup between the lively telephone and the unyielding lady, augmented by the subtle analogy linking their bodies. The anthropomorphic shape of the black metal phone and the anatomy of the black-clad matron mimic one another. Both have heads, long necks and black torsos; the dial on the phone is a spot of light much like the clasped hands in the woman's lap. This correspondence suggests intercourse between the two of them, but one that will never be consummated.

Painted in 1931, the year after *American Gothic*, *Victorian Survival* belongs to a series of paintings Grant Wood made in the early 1930s in which he opposed brute opposites, the one vying with the other in an uneasy contest. These "narratives of confrontation," as I will call them, could be conflicts between two different cultures as in *Victorian Survival*, two body types as in *Honorary Degree* (fig. 50), or child and parent as in *Adolescence* (fig. 118). Wood also liked to set up confrontations between his viewers and the life-sized figures in his paintings as he did in *American Gothic*, inviting spectators to judge themselves against those on the canvas (pl. 3).

Though *American Gothic* is a classic image of confrontation, I want to look first at three other paintings in which Wood made opposition the structural dynamic: *Victorian Survival*, *Appraisal*

(pls. 9, 8), and *Adolescence* (fig. 118), all completed in the three years after the better known canvas of the couple with the pitchfork. I will then return to *American Gothic*, interpreting it as a template for Wood's future work. I'll then end the essay by considering two other important paintings of confrontation: *Daughters of Revolution* (pl. 10) and *Death on the Ridge Road* (fig. 126).

Most viewers find *Victorian Survival* a humorous painting, knowing that the modern has already won out, demolishing Victorian insularity in its wake. As moderns they confront an extinct species of American woman. But in 1931, we need remember, when people smiled at the painting, they may also have felt the tug of personal memories. The arrival of the telephone in the family home—along with electricity, modern plumbing, the radio, the cinema, and the car—was a momentous event and often remembered as an exciting expansion of one's world but also as destructive of older patterns of living. Indeed, there is an intimation of defeat in the tense and unbridgeable chasm that separates the Victorian from the modern world in Wood's painting; she is the loser, the machine the winner. The artist's humorous construction thinly veils what were very real social and cultural upheavals as the Midwest began to modernize in the 1910s and 1920s, a process that for some families lasted deep into the century. The interval between 1890 and 1925, the sociologists, Robert and Helen Lynd, wrote in *Middletown*, was probably "the era of greatest rapidity of change in the history of institutions." It was during those years that the Industrial Revolution "descended upon villages and towns, metamorphosing them into a thing of Rotary clubs, central trade councils, and Chamber of Commerce contests for 'bigger and better' cities."[2] Wood lived through these transformations and repeatedly used his art to explore radical changes in lifestyle and his personal sense of displacement.

Art historians who have studied the artistic response to modernity have focused primarily on French artists during the second half of the 19th-century. In his book, *The Painting of Modern Life*, for instance, T. J. Clark looked hard at the ways in which works by Edouard Manet and other Impressionists responded to the radical transformation of Paris by Baron Haussmann in the middle of the 19th century.[3] Haussmann, an urban planner of immense ambition, essentially erased the medieval character of much of Paris, replacing narrow streets and small walkup buildings with a layout of wide boulevards and deep sidewalks, lined by seven- to eight-floor apartment houses for bourgeois families. Haussmann introduced modern plumbing and sanitation systems to the city's infrastructure and expanded roadways to handle increased vehicular traffic. The painters' response to Haussmannization, Clark argues, was immediate and complex. On one hand they painted the spectacle of the

Fig. 102: Edouard Manet, *Bar at the Folies-Bergère*, 1882. Oil on canvas, 37 ³/₄ × 40 ¹/₂ in. The Samuel Courtauld Trust, Courtauld Institute of Art Gallery, London.

new boulevards and the glamorous new apartment buildings and department stores, and mined the city's new leisure entertainments for pictorial fodder: the parks, opera house, circus, cafés, *café-concerts*, bars, and dance halls. In such pictures they recorded the effects of modern commercialism and captured the shifts in social and class formations. They paid particular attention to the emergence of a new urban bourgeois class as well as the increasing prominence of certain professions, such as the banker, the salesperson, the shopper, the courtesan, and the prostitute.

On the other hand, Clark shows us, Impressionists deployed experimental styles and pictorial organizations that embodied the ways modernization had changed how urbanites lived, moved, observed, and interacted. The radical surfaces of Impressionism, he argues, constructed a new visual language for modern ways of being in the world. In Clark's analysis of Manet's *Bar at the Folies-Bergère*, for example, he describes the "glorified beer hall" that was the *café-concert*, a brightly lit, heavily mirrored place where people of all classes went to drink and eat, listen to bawdy songs sung by *chanteuses* in skimpy dresses, and to slum with people from all walks of life (fig. 102). This was a place to masquerade, to shift or lose identities, to merge into the general rabble. From many perspectives, the *café-concert* and its invitation to carouse and indulge oneself was a coarse incursion into urban life, an invention, as Clark put it, intended "to be loud, vulgar, and above all modern."[4]

Having historicized this entertainment, Clark looks more closely at Manet's *Bar at the Folies-Bergère*, a painting of one of the better known Parisian *café-concerts* of the 1870s. Through Clark's eyes, we see its modernity and its vulgarity in spectacular array—all of it caught in a mirror: brazen electric lights, glitzy décor, and a crush of people. Not only the *habitués* are there but the entertainment is too, in the two little legs on a trapeze in the upper left. And in a long consideration of the barmaid, selling drinks to and being propositioned most likely by the bourgeois man whose image is in the mirror, Clark sorts out the different ways in which she exemplifies the modern—her cheap version of fashionable dress that disguises her working-class status; her tough job as barmaid selling consumables (and probably herself); and finally, her dulled detachment from all that swirls around her. Manet, in this interpretation, is not only a painter of modern life but also a painter grasping the ennui and alienation that comes with it.

Just as Clark probes Manet's relationship to modernity, this essay will consider Grant Wood as a "painter of modern life." Both made paintings that registered the shock of the new. While Wood painted the upheavals of modernity in far more confrontational and literal terms than Manet, he was no less sensitive to the ways in which the modern had become an invasive force in his environment. The telephone in *Victorian Survival* performed much like the gawdy entertainment hall in Manet's bar. It was a brazen intrusion into a world that had seemed relatively quiet, stable and secure. And the Victorian lady, in her muteness, her glazed eyes, and her cultural distance from us and her surroundings shares an alienated detachment and sisterhood with Manet's urban worker at the flashy new bar.

What Wood shared with Manet was the experience of living through tumultuous social change. By the time both men emerged as mature artists the worlds they knew as children had been radically modernized. Manet developed as an artist in the "new" Paris of the 1860s, Wood in the "new" American rural landscape of the 1920s. This comparison reminds us that the radical changes the industrial revolution brought to the city in the late 19th-century, those so profoundly embedded in Manet's painting, took another 50 years (on some farms nearly a century) to penetrate the American countryside. The transformations wrought by modern technologies, commerce, and transportation systems did not everywhere obey the same timetable. Yet the changes in 1920s' and 1930s' Iowa were no less alienating and disruptive than in 1860s' and 1870s' Paris. In the 19th century, it was the train, the elevator, the electric light, the arrival of steel and glass architecture, and modern sanitation systems that reworked the fabric of Parisian living. On American farms in the 1920s, it was electric lights, modern plumbing, cars, radios, tractors, and paved roads that were transforming the ways people moved through space and calculated time. Wood never

Fig. 103: Charles Sheeler (1883-1965), *Self-Portrait*, 1923. Conte crayon, gouache, and pencil on paper, 19 ³/₄ × 25 ⁵/₈ in. The Museum of Modern Art, New York, Gift of Abby Aldrich Rockefeller. 146.1935 Digital Image © The Museum of Modern Art/Licensed by SCALA/Art Resource, NY.

knew a telephone, an indoor bathroom, an alarm clock, or a car until he moved from the family farm into the modernizing town of Cedar Rapids in the early 1900s (fig. 99).

Thus the telephone in Wood's painting emblematized modern technology; it was a meta-symbol for the trains, the cars, the planes, the tractors, the harvesters, the movie theaters, the brand-name goods, the ready-made garments—even the scissors and curling irons that bobbed and marcelled woman's hair—that were transforming all aspects of American culture. In choosing a single signifier for the modern, Wood was participating in a broader cultural practice in which artists and writers singled out specific innovations to denote the sweeping changes new technologies were imposing on traditional cultures. In the 19th-century, artists often located the modern in images of the moving train or in the steam and smoke captured by the new glass-and-iron train stations. Later they created images of the Eiffel Tower or Brooklyn Bridge or the New York skyscraper as emblems of the modern, and invented ways to represent the depersonalized physicality and interactions of modern city streets. This was an iconography of the modern, one that artists and writers constructed over time as a way of interpreting their changed landscape.

After World War I, artists in America added sleekly designed commercial products and domestic technologies to modernist iconography. The billboard, the toilet, the electric light bulb, the fountain pen, the alarm clock, the safety razor, and the telephone all began to show up in novels, poems, paintings, and photographs as signifiers of the new age. The type of telephone in *Victorian Survival* was a distinctly modern, streamlined design intended to sit on a table or a desk as an independent object. Earlier phones were big, boxy fixtures of wood and metal affixed to the wall. By the 1910s, the candlestick phone was replacing the wall-phones, but still required an operator to place a call. Then, in the early 1920s, when dial candlestick telephones became available, they became the latest apotheosis of domestic modernity.[5]

Artists interpreted the telephone, as did sociologists in the early 20th century, as a transformative technology, like the train or the car. They seized upon the ways it fundamentally changed how people interacted at home and in the office (as has email and the computer in our own day.) The telephone signified sped-up communications, intrusive noise, impersonal exchanges, and the increased presence of modern machine-made artifacts in living and work spaces. The first generation of artists to use the phone as representative of the modern also saw in it ironic analogies to the natural world. To their eyes, the metal casing of the candlestick telephone looked amusingly like a long-stemmed flower, such as a daffodil. (Surely the designer had something like this in mind.) Robert Frost in his 1920s' poem *The Telephone* pointedly avoided naming the object in his poem, picturing it as "the flower on the window sill" that talked. The first-person protagonist in the poem picks "the flower" and holds it "by the stalk" to hear words from a lover.[6] This naturalizing of the mechanical captured the strangeness of the telephone in homes but also spoke, sardonically, about the way the telephone had replaced the bouquet. Wood's telephone, like Frost's, also mimics a flower. With its head tilted upwards, the phone looks like a freshly cut bloom, waiting to be smelled.

The New York artist Charles Sheeler interpreted the phone as a thing that violated privacy and solitude but also as an exquisitely beautiful object (fig. 103). His drawing of the pre-dial candlestick telephone is at odds with the artist's own human presence, with his shadowy reflection in a window behind the table. The solidly rendered telephone thrusts itself into the artist's spectral body, while a window blind cuts across the artist's face at the mouth. Calling the work a *Self-Portrait*, Sheeler presents the telephone as both beautiful object and modern machine. In that Sheeler was a reticent man and not much of a talker, the drawing is also self-effacing, the artist allowing it to stand in for his own absent mouth and facial features. Sheeler's commentary is less tense than Frost's and Wood's, less bittersweet. He underlined his considerable respect for the modern design of the telephone, while Frost and Wood dramatized the devices as an alienating new object replacing the traditional household bouquet.[7]

Sheeler depicted his own body invaded by the modern telephone; Wood used that of his great aunt Matilda, or Aunt Tillie as she was called. Matilda Weaver Peet was a sister of Wood's maternal grandfather. She had lost her husband, James Melvin Peet, in 1888, before the artist was born, and lived with other members of the Weaver family.[8] Though she wears a wedding ring in the painting, young Grant always thought of her as one of his "maiden aunts " and a "prude, " the artist's sister told me.[9] Wood felt that way about not only Aunt Tillie but also about his maiden aunt Sarah who played a large role in his boyhood. To his biographer Park Rinard, Wood described Sarah as being much like the character in *Victorian Survival*: "A tall gaunt old maid, a strange mixture of Quaker austerity and Victorian romanticism." Wood also recalled Aunt Sarah's severe hairdo, wondering "how she could close her eyes at night—so tightly was her hair combed to her head. Her hair was deadblack

Fig. 105: Hattie Weaver Wood as a child. Courtesy of Figge Art Museum, Grant Wood Archives.

Fig. 106: Grant Wood, *Yearbook illustration*, 1908. Cedar Rapids High School Reveille. Cedar Rapids Museum of Art Archives.

Fig. 104: Matilda Peet, tintype, 3 $^1/_2$ × 2 $^1/_8$ in. Courtesy of Figge Art Museum, Grant Wood Archives.

photograph of his mother, Hattie Weaver Wood, as a child (figs. 105, 106). By the 1920s and 1930s, some of Wood's contemporaries were similarly inspired by old photographs. Morris Kantor's *Daguerreotype* was a surrealist conceit, the figure of the woman and the space around her rendered in tones of black and white while other parts of the room are in color (fig. 107). The woman is ghostly, an apparition from the past, while the room fades in and out of color as if in and out of present time. George Bellows

Fig. 107: Morris Kantor, *Daguerreotype*, 1931. Oil on canvas, 26×30 in. Sheldon Memorial Art Gallery and Sculpture Garden, University of Nebraksa-Lincoln, UNL-F.M. Hall Collection.

and she wore it parted austerely in the middle so that it framed the long pale oval of her face with mourning. Her expression was stiff and humorless, with long nose and chin and thin lips."[10]

Such memories were bundled into the lady in *Victorian Survival*, along with information Wood took from a small tintype that his family had of Matilda Peet, one of several 19th-century family photographs the artist deeply treasured (fig. 104).

Wood had begun to glean ideas from old photographs as early as 1908 when he based a high-school yearbook drawing on a vintage

Fig. 108: George Bellows, *Mr. and Mrs. Phillip Wase*, 1924. Oil on canvas, 51 ¼ × 63 in. Smithsonian American Art Museum, Gift of Paul Mellon. 1967.39.1

similarly evokes a sense of passing time in portraits of elderly people that recall old photographs. Seated on antique furniture and in darkened interiors, Bellows painted aging women wearing antique gowns and dresses they had once worn in their youth; one even wears her wedding dress. Painted in Bellow's characteristic brushy and sensuous style, the incongruity of elderly puffy flesh against the sheen of silken, long dresses from a much earlier era, is very touching. In the portrait of *Mr. and Mrs. Philip Wase.* Bellows substituted an old photograph for an antique dress (fig. 108). The photograph on the wall behind the couple is of a younger woman, no doubt Mrs. Wase as she appeared a half-century earlier in a black dress with a white collar, her long dark hair piled high on her head. It is the melancholy dialogue between the old photograph and the living couple seated uncomfortably on a Victorian horsehair sofa that gives the painting its *frisson*. The photograph helps to index their bodily decay.[11]

Like Kantor and Bellow, Wood used vintage artifacts to evoke a past that had slipped away. But for Wood, the use of the late 19th-century family photograph was more than a meditation on the passing of time. It was also a way to access what he had come to identify as his region's cultural roots. As an early student of material culture, Wood was anthropological in his use of objects from the past. He looked to photographs and other local antiques—early Iowa maps, Currier and Ives prints, Prang chromolithographs, Blue Willow china, handmade quilts, and pieces of neo-Gothic

furniture—for the stories they contained about how ordinary Iowans had lived and what they valued a half-century earlier. In Wood's first major portrait of a "pioneer" *John B. Turner, Pioneer* (fig. 22), he chose an 1869 map of Linn County as the backdrop for his sitter (fig. 109), and in his *Overmantel Decoration* (pl. 7) he adopted the oval format used to frame the individual houses along the map's edges. He particularly cherished antiques from the generation of his grandparents who, like his mother's and father's families, had migrated to the Midwest from more settled areas in the East and South in the 1850s and 1860s; they often brought with them prized household pieces to embellish their new homes on the prairie. As Wood began to develop a Regionalist artistic program in the late 1920s, he turned to ordinary things used by his family and relatives as the Midwest's "authentic" historical past.[12] Much as New Englanders in the early 20th century began to prize colonial furnishings as emblematic of their regional heritage, Wood turned to late 19th-century Midwestern Americana. Although most Americans in the 1930s held things Victorian in contempt, Wood rightfully understood that era to be the period in which early Iowan history was rooted. So he became an early advocate of Victoriana, sometimes poking fun at the era's pretentiousness but also initiating a new taste for its architecture and decorative arts.[13] When he bought a house in the mid-1930s, he chose a 1858 brick Federal-style house in Iowa City that had fallen into disrepair (fig. 110). He meticulously restored it and decorated the living spaces with Midwestern antiques he had collected or which had come down through his family. These included a neo-Gothic clock, sewing box, and piecrust tea table as well as the daguerreotypes, ambrotypes, and tintypes of his ancestors. He installed these pieces in modernist fashion, on white walls, with generous spaces around them (figs. 112, 113).

As Wood developed his Regionalist style, he often borrowed—and then modernized—characteristics from older pieces. From Blue Willow china he took his hallmark stylized bulbous trees; the family quilts and ordinary calicos justified, he quipped, his insistent patterning; and the family daguerreotypes and tintypes, he discovered, gave him ways of dressing and posing his models in pictures such as *Victorian Survival* and *American Gothic*. In *Victorian Survival* he also took the sepia tones and framing style from routine studio portraiture of the late 19th-century. By "channeling" bits and pieces of his Midwestern past, Wood was able to defend his mature realist style as both a modern and a Regionalist expression. In other words, it was not just the farm landscape or the country people that Wood began to paint in 1929 that marked his work as "Midwestern," but also the subtle ways in which he called upon design features taken

Fig. 109: Detail of 1869 Map of Linn County, Iowa, Thompson & Everts, Geneva, Illinois. Compiled, surveyed and drawn by D.W. Ensign, C. E. Color engraving on paper, 58 × 66 in. Gift of Harriet Y. and John B. Turner II. 76.2.1

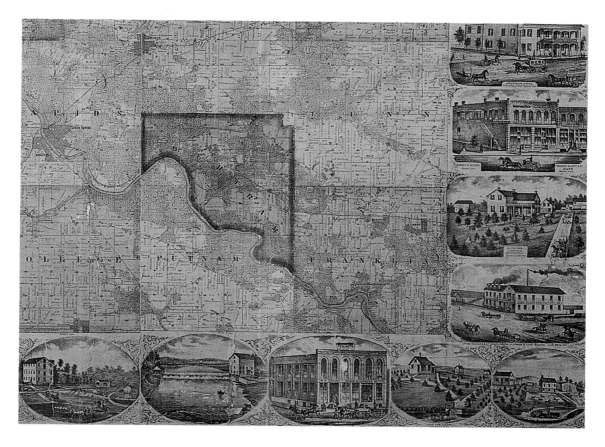

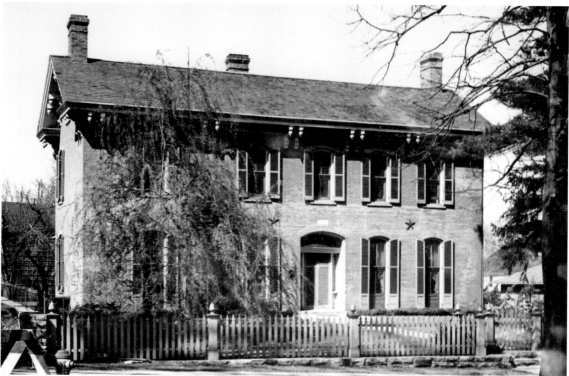

Fig. 110: Exterior view of Grant Wood's restored pre-Civil War home in Iowa City, Iowa, where he lived from 1935 to 1942. Courtesy of Figge Art Museum, Grant Wood Archives.

Fig. 111: Wood owned and admired this plate for its stylized vegetation and imagery, which is based on willow ware china patterns. Some of the flowers in his *Overmantel Decoration* recall those found on this plate.

ture. Much of his success was in calling upon old things that resonated not just regionally but with any American who felt a kinship to the antiques he drew upon and the rural past that he recalled. In his lifetime and continuing to the present day, the appeal of many of Wood's paintings is that he had found a way to recall a late Victorian rural culture without bombast or heroics. He was driven by the belief that many of his subjects were on the verge of extinction, that modernization was washing away the 19th-century foundations of Midwestern farm and small-town culture. Keenly aware of the cultural transformation underway, he referenced the Victorian past to preserve it—at least in memory—and to express his personal uneasiness with modernity's relentless eradication of his own history. He framed his discomfort as a dueling match, a modern technology against an older social order.

Wood modernized the narrative of confrontation. He borrowed it from an older visual and literary tradition, one perfected by Realists and Naturalists in the 19th century who used it to convey different types of people and styles of living in the contemporary world. Realists pictured city streets as places where distinct urban types were in confrontation with one another: the manual laborer next to the black-suited gentleman; the poor woman peddler offering flowers to the fashionable lady; the young bootblack with worn-out pants next to the young girl in a picture-perfect party dress; or the vulgarly dressed prostitute with the bourgeois man in a top hat. Both painters and novelists became exceedingly proficient in

from his artifactual past. He would modernize these details—they would not be precise quotations—through abstraction, stylization, and patterning.

His programmatic goal, then, was to give the Midwest its own school of painting, based on, in part, its post-pioneer material cul-

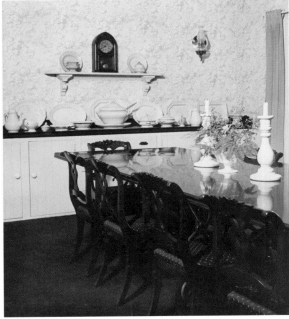

Far left: Fig. 112: Interior view of Grant Wood's bedroom at his Iowa City home, *c.* 1935.

Left: Fig. 113: Interior view of Grant Wood's dining room at his Iowa City home, *c.* 1935. Courtesy of Figge Art Museum, Grant Wood Archives.

Fig. 114: Edward L. Henry, *Capital and Labor*, 1881. Oil on canvas, 12 1/2 × 15 1/4 in. Collection of the New-York Historical Society.

describing the details of dress, hairstyles, manners, voice, and body types that signified different classes, ages, and professions. And they often used their new skills to tell stories of conflict, particularly those of class, and sometimes of age and race.

American genre painters of the 19th century often represented the privileged confronting the poor and the disempowered. In *A Visit from the Old Mistress* (1876), a powerful post-Civil War painting, Winslow Homer pictured a white Southern gentlewoman paying a call upon three of her former black slaves, one of them with a young child (fig. 115). Clothes help tell the story. The mistress is dressed in a long black dress, her gray hair tied in a bun. The African–American women, in comparison wear homespun, exceedingly worn working clothes and aprons, their heads covered in kerchiefs. The visit takes place in a rudimentary dwelling, the home of the former slaves. Homer framed his confrontation, obviously, to underline the racial and economic inequities that followed the war, offering moving commentary on the failure of reconstruction to create parity between Southern whites and blacks. In *Capital and Labor* (1881), E. L. Henry also used confrontation to highlight disparities of class and income. In his painting, a wealthy young lady visits the home of a poor older woman. Bedecked in her Parisian fashions and accompanied by her pedigree pug, she appears like an apparition to the woman dressed in common working clothes (fig. 114). A young African–American boy, in stereotypical tatters, stands nearby while a mongrel dog slaves to churn the butter by treadmill, Henry's all-too-obvious metaphor for the struggles of the poor.

By the turn of the 20th century, artists as well as writers turned to confrontations between Modern and Victorian styles of living. As new models of female behavior emerged, and the so called "New Woman" was invented to describe women who went to college, enjoyed outdoor sports, wore shirtwaists, and led increasingly independent lives, it became popular to play her off against her Victorian lady counterpart. These confrontations spoke anxiously about how modern female behavior strained genteel 19th-century etiquette and more often than not, ridiculed the brazen New Woman's lack of conventional feminine attributes. In her 1901 short story, *The Steel-Engraving Lady and the Gibson Girl*, Caroline Ticknor brilliantly stereotyped competing models of femininity. A young Lady, with her "alabaster" white skin "glossy, abundant hair...smoothly drawn over her ears" finds herself face to face with the Gibson girl in "a short skirt and heavy square-toed shoes, a mannish collar, cravat, and vest, and a broad-brimmed felt hat tipped jauntily upon one side." The Gibson Girl has come to interview the Lady for a paper on "Extinct Types."[14] As they talk, they agree on nothing, the distance between their views on dress, sports, marriage, education and work, clashing as violently as Wood's dial telephone and Victorian lady. There is no middle ground, no accommodation, no love lost.

This "type-confronting-type" genre as a way of exploring or critiquing the profound revolution modernization was exerting on all walks of life, continued well into the 20th century. The change in

Fig. 115: Winslow Homer, *A Visit from the Old Mistress*, 1867. Oil on canvas, 18 × 24 in. Smithsonian American Art Museum, Gift of William T. Evans

women's bodies and fashions, as well as their new independent behaviors continued to be the butt of negative comparisons. In 1926, a cartoon published in the *Saturday Evening Post* juxtaposed James McNeill Whistler's portrait of his mother with her flapper counterpart, the "now and then" confrontation offering an ideal companion piece to *Victorian Survival* of just a few years later (fig. 116).

The narrative of confrontation, then, as a literary and visual form, had currency in both high and popular culture during Wood's formative years; it was there for him to absorb and rework. One source he drew on was contemporary stories about the Midwest by writers who created "types" of people, some modern, some old-fashioned. Wood particularly admired Sinclair Lewis, whose *Main Street* (1920) and *Babbitt* (1922) made provincial settings and small-town types—and occasionally, a rural farmer type—respectable artistic fodder. Lewis's forte was creating exaggerated portraits of Midwestern provincials whose lives were often desperate and rarely fulfilling. He penned them with acidic humor. For Wood, a man well known for his wit, Lewis offered a mentor in crafting comic provincial types. But the two men also had their differences. Lewis was older and more despairing and critical of provincial life than Wood would ever be. What Lewis was apt to indict, Wood was likely to enjoy. The writer belonged to an earlier generation that had fled small towns for the big city. Wood began his career traveling every few years to Europe but once he committed himself to Regionalism, he chose to stay at home and live his material.

Returning to home and heartland was a prevailing theme in the work of a Midwestern school of writers who began to speak out for a new Regionalist literature in the 1910s, well before Wood's turn to the local. Centered around the University of Iowa, with *The Midland* as their little magazine, Iowan writers such as Ruth Suckow and Jay Sigmund alongside their counterparts from Indiana, Nebraska, and Missouri, wrote about local Midwestern small town and farm life,

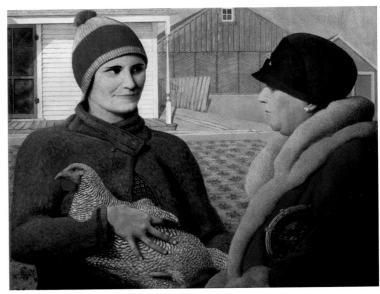

Fig. 117: Grant Wood, *Appraisal*, 1931. Oil on composition board, 29 1/2 × 35 1/4 in. Dubuque Museum of Art, On long-term loan from the Carnegie-Stout Public Library, acquired through the Lull Fund. LTL.99.08

subjects they felt earlier generations had ignored or disparaged.[15] They argued for a new vision of the Midwest, one having its own regional types of people, architecture, and lifestyles, different from those of New England and the South.[16] For some it was the small-town types: the doctor, the spinster, the club woman and the Rotary man. For others, the focus was the stalwart pioneers and their descendants, particularly the hard-working farmers and their families. As Clarence Andrews, a literary historian of Midwestern Regionalism, explains, the 1920s were the heyday of farm literature. "Some 80 farm novels were published in that period—more than in all the other years of US history together," he wrote.[17]

These writers were much kinder to their subjects than Sinclair Lewis. And they characteristically drew on their own memories of growing up in the agrarian Midwest.[18] They often documented older ways of life and the impact of modernization on families and farm life. Their texts pictured culture clash as generational: older farmer folk confronted by their car-driving children or grandchildren who sought to escape their provincial upbringing by going to college or moving to more urban environments. And their sympathies, as so often was the case with Wood, were with those who had grown up in rural isolation.

As Wood turned to inventing a Regionalist style of painting, he drew sustenance from this local school of writers that had, as yet, no counterpart in the visual arts. Their confidence in the artistic worth of local material, their desire to invent regional "types" of

Fig. 116: "Portrait of his mother" cartoon in *Saturday Evening Post*, June 12, 1926.

country and small-town people, their use of autobiography, and their ability to find both humor and tragedy in cultural upheaval, all found a place in his figure paintings of 1929–35.

Appraisal, Wood's first figure painting after *American Gothic*, pictures a rural woman confronting an urban matron (fig. 117 and pl. 3). Wood dressed the farm woman simply and without pretension; he clearly identified with her. Standing in front of a simple farmhouse, the barn and shed to one side, she is a natural part of her environment. Her face is taut and lean, her stance strong, her working hands exposed. The visitor, on the other hand, is an overdressed matron uneasy in the rural homestead; her fashionable dress, her soft and pudgy double chin, and her absent hands buried in fur cuffs, mark her as a city slicker, a woman of means and leisure.

It seems that the fashionable woman has come to buy a fresh chicken from the farm woman, providing Wood with an older narrative setup: the woman of means calling upon her poorer counterpart. Wood updates the scenario by opposing two female types who represent modern economic systems: the 20th-century consumer who no longer grows her own food but buys it from others, and the countrywoman who sells the fruits of her labor directly, without middlemen. In this transaction, each woman "appraises" the other. The farm woman appraises the city woman's carefully orchestrated self-fashioning. The buyer, in turn, appraises her soon-to-be-purchased dinner in the seller's arms. The two women's costumes—like the necks of the lady and telephone in *Victorian Survival*—pun one another. The farm woman's plain knitted cap parodies the city lady's stylish cloche hat with its glittery crystal pin. Except for a few unruly hairs, the rural woman's hat covers her head; the city woman's hat leaves just enough room to show off a glistening pearl on her ear. The farm woman's misshapen coat, held together by a safety pin at the neck, contrasts sharply with the fashionable fur-trimmed coat and beaded bag of the caller.[19] With obvious glee, the artist renders the fat Plymouth Rock fowl as having an exquisitely soft natural coat as compared with the dead animal trim on the city coat. Of the three creatures in *Appraisal*, the chicken is clearly the most beautiful!

Wood's affection for chickens—it had been his job as a child to feed them and collect their eggs—led him to another painting of confrontation, this time not the modern against the traditional, but the child in conflict with his elders.[20] In *Adolescence*, he imagined a young, gaunt fledgling hemmed in by two very imposing parental figures (fig. 118).[21] All three are perched on the ridge of the roof. Although stars can still be seen in the darkened sky, the light of dawn appears on the horizon. With the coming of day, the

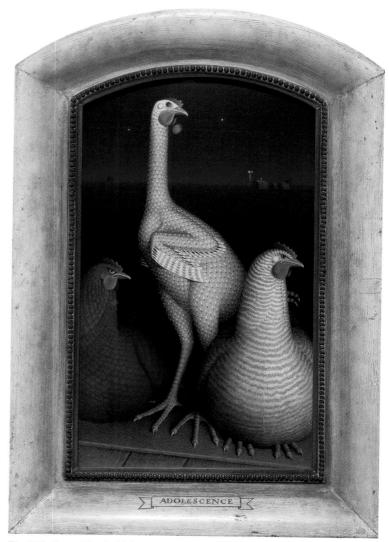

Fig. 118: Grant Wood, *Adolescence*, 1940. Oil on Masonite panel, 20 3/8 × 11 3/4 in. Abbott Laboratories.

adolescent chicken has stood up, shy and unsure. Standing like a gaunt nude child, trying to shield its pubescent body from our gaze, the adolescent is nearly toppled by the fat, stern hens on either side. Their plumpness pushes against the young chick's skinny and undeveloped legs. The young chicken is vulnerable and ill at ease while the adult hens swell with protective authority and overbearing self-satisfaction.

The awkwardness of youth is an old theme in art and Wood had tried his hand at it in an earlier painting, *Arnold Comes of Age* (1931) (pl. 5). Arnold Pyle was a friend, a young artist, and assistant to Wood. He had just turned twenty-one, and Wood painted him making the passage to manhood. In the background, a river of life

Fig. 119: Arthur Fitzwilliam Tate, for *Currier and Ives*, *Quail and Chicks*, 1865. Lithograph.

flows across the picture separating the young man's youth—represented by the sapling and two young swimmers on the near riverbank—from his adulthood, symbolized by the mature trees and bales of ripened wheat on the shore beyond. At the boy's elbow, a butterfly hovers, a creature of beauty that, like adolescence is short-lived. This portrait, like so many European precedents, depended on symbols and metaphors. *Adolescence*, on the other hand, was Regionalist, Wood rendering it as a stage of life in the life-cycle of the chicken, a farm subject familiar in the Midwest.

With his fondness for things Victorian, Wood found inspiration for paintings such as *Adolescence* in popular 19th-century prints. He and his friend Jay Sigmund had developed a taste for images by the New York firm Currier and Ives long before they had become expensive collector's items.[22] Some prints, like Arthur Fitzwilliam Tait's *Quail and Chicks*, were happy domestic scenes of baby birds and their parents, a theme Wood turned inside out in creating his own more sardonic reading of childhood (fig. 119). The artist also drew on his own Victorian autobiography. By nature shy and gentle, he told others of his trials and tribulations when growing up, recalling both his father and some of his aunts as authoritarian and rigid. His Quaker father in particular, he remembered as a very strict man who forbid his son to read fairy tales or to draw because these were imaginative activities and not "true." Wood's father, who died when he was but ten years old, left an indelible wound. "We loved him and revered him," Wood says in Rinard's biography, "yet knew that he was not of us. To me he was more god than father. His low, carefully spoken words were law."[23] The artist's memories of his father as a remote, austere, and unemotional man—and of his over-

bearing aunts—are written into the tension Wood insinuated between the young, vulnerable chick in *Adolescence* and the tough birds to either side.

Let us now turn to *American Gothic*, the painting that catapulted Wood to national fame (fig. 120, pl. 3).[24] It was not his first attempt to invent an Iowan type—*The Portrait of John B. Turner, Pioneer* (pl. 22) and *Woman with Plants* (pl. 2) came earlier—but it was his first work to succeed with the public, giving the artist confidence in his new turn to Regionalism and the desire to create more works like it (figs. 3, 5, 18, 19). He rendered the country man and woman in *American Gothic* with enough generality that people perceived them as representatives not just of agrarian Iowa but rural communities across the land. Many people felt they knew these rural, independent, don't-tread-on-me types from their own experiences, whether in the Midwest, in rural New England, or even California.[25] Or they remembered them as the kind of Americans they had seen in old photographs. Part of Wood's success came from posing the man and woman as if they were, he said, "tintypes from my old family album." Many Americans felt the couple looked like their relatives, too.

Having looked closely at the figural paintings Wood painted after *American Gothic*—*Appraisal*, *Victorian Survival*, and *Adolescence*—we can better understand the tensions, humor, and structure in this landmark piece. For *American Gothic* served as something like a template for Wood's figure paintings of the next few years, many of them drawing from family photographs and from humble pieces of Iowa's past. Central to this template is the notion of or the style we call "Gothic." In his appreciation of early Iowan artifacts, Wood had become enamored of local uses of the Gothic style. His family had several neo-Gothic pieces of 19th-century furniture, and there were Victorian-Gothic houses in every Iowan town. It both pleased and amused Wood that a celebrated ecclesiastical style of monumental stone cathedrals in Europe (he had painted French cathedrals in his early career) had found its way onto the prairie, usually in a very humble domestic dwelling. He included one such 1880s' farmhouse as a backdrop in *American Gothic*. Having seen the house in Eldon, Iowa, he chose it for its imposing window and repeating board-and-batten design but also because it typified local Victorian architecture (fig. 121). Associating the couple with a late 19th-century house was one more way he imbued his two figures with "pre-modern" or ancestral character. He called them "American Gothic people," seeing in their long faces, "a vertical complement to their Victorian farmhouse."[26]

American Gothic was Wood's first narrative of confrontation. By placing the couple in the immediate foreground of the painting,

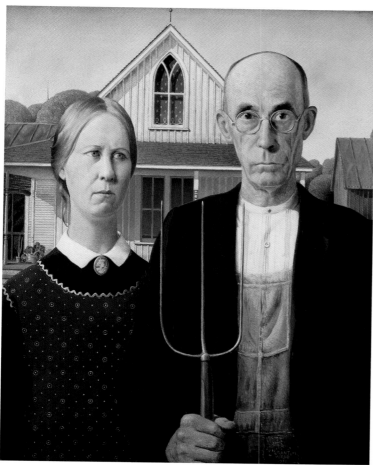

Fig. 120: Grant Wood, *American Gothic*, 1930. Oil on beaverboard, 29 1/4 × 24 5/8 in. Friends of American Art Collection, All rights reserved by the Art Institute of Chicago and VAGA, New York, NY. 1930.934. Reproduction, The Art Institute of Chicago.

In 1930, when the painting was first exhibited, even viewers who identified themselves as members of farm families responded to the two figures as unlike themselves, as "other." They found the couple anachronistic and old-fashioned. They also felt angry, assuming Wood was making fun of their kind. One farm woman called the figures "oddities," claiming the "woman's face would positively sour milk."[27] Another wrote to say that Wood did not know modern Iowan farmers. "Perhaps he hasn't been in Iowa since he was a little boy, and that must have been in the 'dear dead days beyond recall.'" She continued: "Not one of the men carries a THREE tined pitchfork when having his portrait painting, neither does he wear a 'boiled' shirt minus a collar."[28] A third was upset by the pitchfork, knowing that modern farmers now used mechanical haying equipment, horse-or tractor-drawn, rather than working exclusively with hand tools. She complained: "We at least have progressed beyond the three-tined pitchfork stage."[29]

Such sour reactions to the painting came from locals who felt it lacking in "realism" and "accuracy." They found Wood's man and woman archaic types from another era, hardly up-to-date representatives of the contemporary farm belt. These farmer-viewers personified the modernizing process that was extinguishing *American Gothic* types from the rural landscape.

One of the anachronisms clearly embedded in the painting was its formal resemblance to 19th-century photographs.[30] The man leaving no pictorial space in front of the two flattened bodies, the hand and the pitchfork, viewers are forced into a provocative face-to-face encounter with these country folk. We have no choice but to eyeball them directly. We look into the man's dark, glassy pupils and sense that the woman's averted eyes may be her reaction to our (too) close proximity. She seems discomforted or annoyed by our probing gaze. The confrontation in this case is not between the people in the painting—they are of a similar type—but between them, relics of another place and age, and us, the modern viewers. As moderns, we are the modern telephone confronting the ancestral tintype in *Victorian Survival*. We *read* the two people as hidebound rustic types fiercely protective of an older way of life. They guard their home and their values from us, the modern intruders from the outside world.

Fig. 121: Grant Wood, Sketch for house in *American Gothic*, 1930. Oil on paperboard, 12 5/8 × 14 5/8 in. Smithsonian American Art Museum, Gift of Park and Phyllis Rinard.

Fig. 122: Maria Littler Wood, *carte de visite*, 3 ¼ × 2 in. Collection of Figge Art Museum.

houses, gardens, furniture and workhorses—as they were about the family members. In both studio and itinerant photographs, men and woman often held tools of their trade: the men shovels, pitchforks, and guns; the women potted plants, brooms, or babies. What men or women held or sat next to gendered them male or female. Men, not women, held pitchforks, and women, like the one in *American Gothic* were associated with potted plants, as Wood depicts over her right shoulder. (In *Woman with Plants*, Wood had his mother hold one plant while posing with others nearby. [pl. 2].)

Wood introduced other gender differences into *American Gothic,* but they turned out to be too subtle to produce the confrontational tension between the man and woman that he intended. He conceived of the man with balding head and lined face as a generation older than the woman at his side, his stay-at-home, unmarried daughter. They were to be an "odd" couple, a father and spinster daughter living modestly in a small town. The artist thought of spinsters, his friend, Park Rinard said, as "symbols of the Victorian Age."[31] They were also stock characters in Midwestern Regionalist literature, particularly in the work of Suckow and Sigmund from whom Wood drew considerable inspiration. Suckow, perhaps because she was female, generally presented the unmarried adult woman as tragic in that she had never created her own home and family and was assigned by society's expectations to caring for aging parents. She lived as a member of the older generation, not her own modern one.[32] Sigmund found the spinster comic and could be merciless, portraying her as a sexually stunted figure, old-fashioned in dress, tidy and meticulous in housekeeping, and sometimes a malicious gossip and overly zealous guardian of community morality. In one poem, Sigmund characterized the spinster as a "smug and well-kept" woman with a "saintly smile" that belied her hypocrisy, an "arch-assassin of reputation" whose fangs were no "less cruel and deadly for being hidden."[33]

Wood's spinster in *American Gothic* lacked Sigmund's sharp detail, and the public, with good reason, has almost always interpreted her as the wife of the man. Though Wood carefully chose models with thirty-two years difference in age—his thirty-year-old sister, Nan, and his sixty-two-year-old dentist, B. H. McKeeby—he gave them such similarly shaped heads, equally dour faces, and generalized features that their generational difference was indecipherable. And given their shoulder-to-shoulder solidarity and their formal similarities to 19th-century photographs of married couples, they have not surprisingly been seen as wedded. Had it been easier to read the woman as the unmarried daughter, then the public might have interpreted her as the proverbial farmer's daughter (a genre of jokes as well as literature) and perceived her in a

and woman in *American Gothic* appear to be holding a pose, frozen for all time, as American forebears appear in antique photographs. Their clothes, too, have faint resemblances to the ways people dressed in the 1880s and 1890s. The woman's hair is pulled back in a bun, and her black dress with a white collar and brooch were characteristic of how women presented themselves for photographs in an earlier era. The *carte de visite* of one of the artist's aunts, Maria Littler Wood, is typical (fig. 122). She does not wear an apron—Wood's woman does to render her occupation as housekeeper—but she has a similar cast to her body and its dress. Maria also wears rimless glasses similar to those Wood gave the man. The man's collarless shirt offered another disconnect with the present, as by 1930 even farmers no longer wore collars as separate pieces but modern shirts where collars were built in and integral to the garment.

The format of a rural family, posing in front of their home, was also an earlier photographic convention. Whether conscious or not, by placing the man and woman squarely in front of their house, and using the pitchfork as an occupational attribute, Wood referenced the compositions used by many post-Civil War itinerant photographers in the provinces. Itinerants such as Solomon D. Butcher who photographed in rural Nebraska (1856–1927), made what we might call "estate" portraits of couples and families standing in front of their modest sod or wooden homes, as in the two examples here (figs. 123, 124). These portraits were as much about what the sitters had accomplished as first- or second-generation pioneers—their

confrontational relationship with her father who hems her in and (overly) protects her. When Wood created his next family painting in *Adolescence*, he made sure the offspring/parental roles were wholly clear.

Though he seems to have encouraged his sister and other friends to talk about his spinster/father intentions in *American Gothic*, Wood did little himself to dispute public opinion about the relationship between the two figures.[34] He was so surprised and delighted with the painting's national acclaim, he was in no rush to correct the record, letting *American Gothic* enjoy its own independent life as a rural married couple. On one occasion, after the painting had been out in the world for a few years, a magazine reported that Wood called the man the woman's "husband."[35] But this might well have been the words of an interviewer or an editor succumbing to the general public's reading of the picture.

The artist's most succinct statement about the painting came in a letter of 1941, summarizing nicely what he had said in bits and pieces to others for many year. In it he clarifies the father–daughter relationship but then immediately adds that what he intended should not matter to the public:

> The persons in the painting, as I imagined them, are small town folks, rather than farmers. Papa runs the local bank or perhaps the lumber yard. He is prominent in the church and possibly preaches occasionally. In the evening, he comes home from work, takes off his collar, slips on overalls and an old coat, and goes out to the barn to hay the cow. The prim lady with him is his grown-up daughter. Needless to say, she is very self-righteous like her father. I let the lock of hair escape to show that she was, after all, human.
>
> These particulars, of course, don't really matter. What does matter is whether or not these faces are true to American life and reveal something about it. It seemed to me that there was a significant relationship between the people and the false Gothic house with its ecclesiastical window.
>
> Incidentally, I did not intend this painting as a satire. I endeavored to paint these people as they existed for me in the life I knew. It seems to me that they are basically solid and good people. But I don't feel that one gets at this fact better by denying their faults and fanaticism.[35]

Nan Wood Graham, the artist's sister and model, on many occasions gave interviews and wrote autobiographically about the painting, always telling a similar story. She relayed how her brother intended her role to be that of an old maid, and that he had an unmarried woman in Cedar Rapids in mind as a model but dared not asked her to sit for him.[36] She delighted in her brother's success while he felt badly that he had sent her image out into the world as

Fig. 123: Solomon D. Butcher, John Curry sod house near West Union in Custer County, Nebraska, 1886. Solomon D. Butcher Collection, Nebraska State Historical Society. Photo: Solomon D. Butcher.

Fig. 124: Solomon D. Butcher, Mr. Story, 1 mile N.E. of Miller on Wood River, Buffalo County, Nebraska, 1909. Solomon D. Butcher Collection, Nebraska State Historical Society. Photo: Solomon D. Butcher.

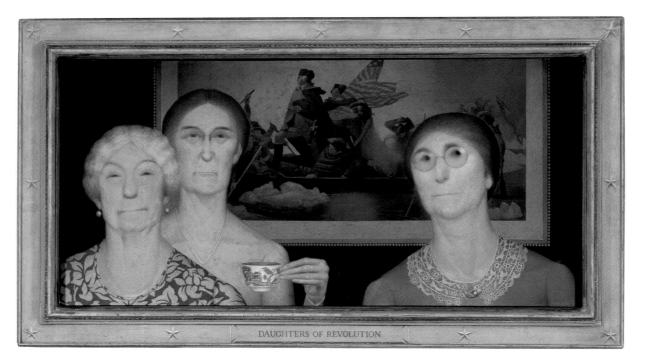

Fig. 125: Grant Wood, *Daughters of Revolution*, 1932. Oil on Masonite panel, 20 × 40 in. Cincinnati Art Museum, The Edwin and Virginia Irwin Memorial. 1959.46

humorless, flat-chested, and outmoded. Wood also had misgivings over having pictured his married sister as single, there being so much prejudice at the time against women who did not marry. So he made a portrait of her with her long marcelled blond hair, rendering her as the modern and stylish woman he knew her to be (pl. 9). This was the only work in his mature style that he kept for himself, hanging it as the centerpiece of his living room in Iowa City (fig. 128).

Though the public's misreading of the man and woman never disadvantaged the artist—indeed, seeing the couple as married helped make it famous—*American Gothic* taught Wood a lesson he took to heart. If he wanted his narratives of confrontation to work to full advantage he had to stage his types with more precision. And that is what he succeeded in doing in *Appraisal* and *Victorian Survival*.

He also created a very exacting type in *Daughters of Revolution*: the modern day club woman (fig. 125 and pl. 10). His ploy here was to create three variations of the same stiff and smug woman and put them in dynamic confrontation with the turbulent and courageous activity in the print of *George Washington Crossing the Delaware* on the wall behind them. They are staid and stolid; their hero is a man of action. There is commotion, too, in the design on the Blue Willow teacup, a chinoiserie pattern Wood associated with Iowa's early settlers who brought their imported heirloom china with them when they migrated west (fig. 111).

Here, as never before, Wood brought all his skills as a caricaturist to bear: he exaggerated the egg-shaped faces and attached them to absurdly long, thick necks pushing up from a rounded or V-shaped collar. The heads and necks are like asparagus spears or, more wickedly, like fleshy phalluses. The sexual metaphor is not far-fetched given the way Wood shaped the three noses, particularly the two on the left side that look decidedly like the male member. Wood staged the figures carefully, pressing their hair tight to their heads and giving them slotted mouths, indented at the edges, hinting at a smirk or supercilious smile. Each has a slightly different pair of eyes: slits on the far left figure, crescents in the next, and beady pupils on the right. All in all, the three figures bear witty resemblances to the three chickens in *Adolescence*. The hand holding the teacup, bony and ringless (suggesting another spinster) are of similar length and texture as the chickens' mean-looking claws. Others have found humor in the women's masculine bodies, seeing the figure on the left as George Washington in drag.[37]

In *Daughters of Revolution* Wood was at his most biting, his anatomical exaggerations of the female necks and faces going well beyond the milder simplifications in *American Gothic*, *Appraisal*, and *Victorian Survival*. The zealous patriotism of his subject unleashed his comic side and his bitterness about members of the local D.A.R. chapter, along with local veterans, who criticized the large stained glass Memorial Window Wood had created for a new public building in Cedar Rapids (pl. 1). These overly fanatical locals had kept

Fig. 126: Grant Wood, *Death on the Ridge Road*, 1935. Oil on Masonite, 32×39 in. Williams College Museum of Art, Gift of Cole Porter. 47.1.3

the window from being dedicated because Wood had constructed it with glassmakers in Germany, the country of the late enemy. Wood took his revenge by painting his only true satire. It was also a painting in which Wood most clearly expressed his kinship with Sinclair Lewis. For the Daughters were modern types who, like Lewis's characters George F. Babbitt and Carol Kennicott, populated Midwestern small towns and cities. When Wood painted the women in *American Gothic*, *Victorian Survival*, *Daughters of Revolution* and the fashion maven in *Appraisal* he sharpened his brush. His anxiety about the modern, as well it would seem about women, played out through his hyperbolized female bodies.

In *Daughters of Revolution*, as in other paintings, Grant Wood's humor disguised his unease. But his continual return to the theme of modern intrusions into rural America speaks more directly to his own sense of displacement. In one painting, *Death on the Ridge Road*, he suppressed his comic side and painted an impending accident on a narrow ridge road (fig. 126) The confrontation, unlike any he had posed before, was between modern machines: a large red truck lunging over the hill, a sleek sedan, and a family car. Who

will hit whom is not clear, but disaster is about to happen. The four telephone poles, two on the right, two in the distant left, are grave markers, their crossed members repeated in the cross-hatchings of the painting's construction. The sky is stormy and threatening, its heavy gray clouds enacting the impending death on the ridge road promised by the painting's title. Even its overall Art Deco composition, its large zigs and zags of fences and field markings, bring to mind the creased and dented metal that will come with collision.[38]

This highway confrontation pits contemporary urban culture against older, agrarian ways. The truck signified the advent of modern commerce into the farm belt while the long sedan, looking like a 1934 Nash, dramatized the incongruous appearance of wealth and sophistication on a country road. The third vehicle, a stumpy Model T Ford of the sort ubiquitous among farmers and villagers, alone seems to fit the proportions of the roadway and travel at a speed suitable for the ridge road. That the Ford faces into the picture, as does the viewer, and is stable—it is the only vehicle solidly in its lane—weds our gaze to its occupants and their plight.

That this drama is playing itself out on a ridge road is an important detail. Ridge roads are historical markers in the American

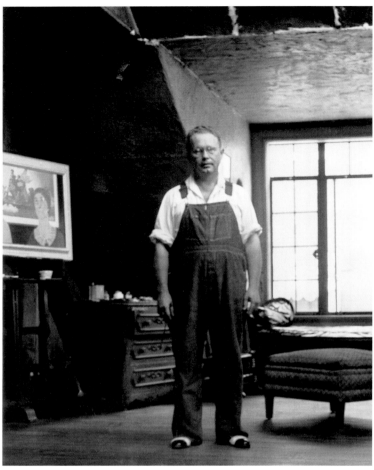

Fig. 127: Grant Wood next to *Daughters of Revolution* at 5 Turner Alley, 1932. Cedar Rapids Museum of Art Archives.

Fig. 128: Grant Wood and his sister Nan Wood Graham in the living room of his Iowa City home. He designed and made the fireplace hood, lounge chair with ottoman, and many other features. Photo *c.* 1939.

Middle West. Carved out by settlers crossing the plains by wagon and by foot, these pioneer pathways traversed the higher ridges, avoiding the mud and slush of the lowlands. As territories developed, ridge roads often became major arteries between towns. In Wood's lifetime, they were newly paved to accommodate advances in motor travel and lined with fences to keep intruders from the fields and animals from the roads. Having never been intended for the speed and density of modern automotive traffic, a ridge road makes the drama here tense and the outcome uncertain.

What Wood renders is once again a collision between opposing social and economic forces. The faster-paced modern world is literally about to crash head-on with the simpler and slower traditions of agrarian living. The ridge road, once a route to settlement and betterment has become a battleground, a place where technology, machinery, and modern ambitions dramatically changed the way

people lived and died. Wood's confrontation is not conclusive but his compassion appears to be with the traditional folks in the family car. Like his earlier figurative paintings, *Death on the Ridge Road* is an uneasy meditation on the impact of modernization on the Midwestern countryside. It also held personal meaning for him: his good friend Jay Sigmund had recently been in a serious car accident and nearly lost his life.[39]

It was common, we have seen, for Midwestern Regionalist writers and artists to use material drawn from their own lives. Wood was no exception, though he did so with more complexity than many. In this light, *Victorian Survival*—to return to the work we started with—allegorizes the artist's life story. He had begun life in the era of the tintype, living his boyhood within the isolation and set routines of a small family farm where visits from commanding relatives such as Aunt Tillie and Aunt Sarah were, in the eyes of a

small boy, major activities. He had then moved to the burgeoning town of Cedar Rapids where he began to know modern comforts and a faster life. When he painted *Victorian Survival*, he had traveled abroad several times, become a nationally recognized artist, and was living in a self-fashioned artist's space in Cedar Rapids that boasted a bathroom, electric lights, a car, and a telephone. His was less a rags-to-riches biography than one of country to city, provincial to cosmopolitan.

It was not until he matured, and gained distance from his farm roots and its pre-modern culture that Wood saw his past as distinctive, its erasure as poignant. He had to become a modern sophisticate before he could see humor and pathos in his rural childhood—and in the local club women—and take on the transformations of Midwestern life as his theme. But no matter how much of a celebrity Wood became, he never forgot where he started. He relished his upward mobility and worldliness while being equally immersed in his past and local history. His figure paintings, we have seen, were fashioned out of this very dichotomy. So was his Regionalist garb, those bibbed denim overalls that became his signature dress in the early 1930s. A comfortable work outfit, overalls were worn in the Midwest by both farmers and factory workers. In adopting them as his studio outfit, Wood aligned himself with the home folks. But in wearing his denims with a starched, long-sleeved white shirt and two-toned shoes, he crossed the regional with the modern in what was for him a characteristic, and always uneasy, hybrid (fig. 127).

In the mid-1930s, Wood took his final step into a mainstream lifestyle by accepting a university teaching position, leaving his loft-styled studio to become a home owner in Iowa City, and discarding his bibbed overalls for shirt, trousers, and an occasional tie. He took with him a drawing and a painted first draft of a *Self-Portrait* he had made in 1932 (fig. 49 and pl. 16). In it, he had pictured himself in overalls and white shirt, presenting his face for our inspection and looking us in the eye, as do so many of his figures. He placed his bust against his emblematic Midwest: shocks of grain, rolling hills, and a statuesque windmill. Windmills, Wood feared, were yet another casualty of modern technology. They were becoming extinct, and he made sure that at least one or more appeared in all of his Regionalist landscapes, their daisy-like vanes peeping out over hills, trees, and barns. Like a watchful eye, making sure that all is in order, the windmill vanes became for him a covert signature.

When Wood turned again to the *Self-Portrait*, sometime near the end of his life, he painted out the overalls and put himself in a plain green shirt, a change in fashion that was consistent with his more urban dress at the University where his Regionalist beliefs increasingly came under attack as overly narrow and parochial. In this new environment he began to dress more modishly and shy away from overalls that might be misread as hokey (fig. 128). But in reworking his clothes in the painting, he did not change the synoptic rural, Iowan landscape behind him. The *Self-Portrait* is the artist's last narrative of confrontation: the modern artist against the traditional landscape that shaped his life but which he no longer worked in nor occupied. This gulf between artist and land allegorizes the artist's life story and the modern estrangement that drove his art.

Notes

Joni L. Kinsey, *Cultivating Iowa*

1 The other two major Regionalists, Thomas Hart Benton and John Steuart Curry, were also controversial. For more on this aspect of their careers see especially Henry Adams, *Thomas Hart Benton: An American Original* (New York: Alfred A. Knopf, 1989); Patricia Junker, et al., *John Steuart Curry: Inventing the Middle West* (New York: Hudson Hills Press in association with the Elvehjem Museum of Art, 1998); and M. Sue Kendall, *Rethinking Regionalism: John Steuart Curry and the Kansas Mural Controversy* (Washington: Smithsonian Institution Press, 1986).

2 The fact that Wood often wore overalls, especially when painting, was a point of critique by some who saw this either as an affectation or evidence of his lack of sophistication. As Park Rinard later pointed out, however, Wood regarded it as "a sensible and functional garment for a painter to wear, and it was even cheap in those days. In any event Grant had worn overalls for work of various kinds all of his life from the days of his boyhood on the farm…" Park Rinard, "Wood Had an Emotional, Mystical Feeling for the Land," *Des Moines Register* (January 15, 1984), section C, 1. That overalls were the uniform of both farmers and industrial laborers in Wood's home region was surely also significant to the artist as he sought to identify his imagery with their world. On a more personal level wearing the clothing of *work* may have helped him psychologically justify art-making as a legitimate vocation.

3 For more on this see James M. Dennis, *Renegade Regionalists: The Modern Independence of Grant Wood, Thomas Hart Benton, and John Steuart Curry* (Madison: University of Wisconsin Press, 1998), 69–89.

4 Wanda Corn, *The Great American Thing: Modern Art and National Identity, 1915–1935* (Berkeley: University of California Press, 1999), xvi.

5 Recountings of Wood's childhood by those who knew him may be found in Park Rinard, "Return From Bohemia, A Painter's Story, Part I," (M.A. Thesis, University of Iowa, 1939); and Nan Wood Graham, with John Zug and Julie Jensen McDonald, *My Brother Grant Wood* (Iowa City: State Historical Society of Iowa, 1993). Rinard's plan to finish his biography of Wood (which was written in first person as if Wood was the author and ends at 1901 with their departure from the farm) was never realized. Studies that contain significant biographical information on Wood include Wanda Corn, *Grant Wood: The Regionalist Vision* (New Haven: Yale University Press in association with the Minneapolis Institute of Arts, 1983); James M. Dennis, *Grant Wood: A Study in American Art and Culture* (New York: Viking Press, 1975; revised edition, Columbia: University of Missouri Press, 1986), and Joseph S. Czestochowski, *Marvin D. Cone and Grant Wood: An American Tradition* (Cedar Rapids: Cedar Rapids Museum of Art, 1990).

6 http://www.quakeroats.com/qfb_AboutUs/history.cfm. The company's website notes that the corporation was founded in 1901 with the merger of three entities, Ravenna Ohio's Quaker Mill Co., the Cedar Rapids cereal factory, owned by John and Robert Stuart and George Douglas, and the German Mills American Oatmeal Company of Akron, Ohio.

7 Graham, *My Brother Grant Wood*, 11–12.

8 Ibid., 14.

9 See Czestochowski, *Marvin D. Cone and Grant Wood.*

10 For a detailed discussion of Batchelder's influence on Wood, as well as parallel theories of design see James M. Dennis, "Grant Wood's Native-Born Modernism," in Brady M. Roberts et al., *Grant Wood: An American Master Revealed* (Rohnert Park, Calif.: Pomegranate Artbooks, 1995), 47–62.

11 "Aim of the [Stone City] Colony" (1932), Edwin Green Papers, Grant Wood Files, University of Iowa Special Collections.

12 The biography was contracted with Doubleday Doran in 1935. Later in *Revolt Against the City*, Wood would echo the sentiment expressed here, saying, "True, he may travel, he may observe, he may study in various environments, in order to develop his personality and achieve backgrounds and a perspective; but this need be little more than incidental to an educative process that centers in his home region." Grant Wood, *Revolt Against the City* (Iowa City: Whirling World Series Press, 1935), 23; reprinted in Dennis, *Grant Wood,* 231.

13 The school changed its curriculum, reducing art class time from over three hours per week to ninety minutes, a reduction Wood strongly opposed. He would be embroiled in a similar controversy at the University of Iowa in the late 1930s.

14 Wood hung curtains from the overhanging beams and set up chairs for as many as sixty people in the small space. See Graham, *My Brother Grant Wood*, 50–52.

15 Corn, *Grant Wood,* 18–19.

16 Corn, *Grant Wood,* 68. Although Nan Wood Graham remembered *John B. Turner, Pioneer* as being painted after *Woman With Plants, after* Wood's 1928 trip and the shift to his regionalist style, Wanda Corn's research reveals that it had been begun *before* the trip and that Wood continued to refine the picture after his return, dating the picture twice, with 1928 appearing in the lower left corner and 1930 on the man's sleeve. See Graham, *My Brother, Grant Wood,* 70; Corn, *Grant Wood*, 68.

17 This phenomenon has been discussed widely. For just a few excellent examples that address the issue in regard to American art see Corn, *The Great American Thing*; Matthew Baigell, "American Art and National Identity," *Arts Magazine*, 61 (February 1987), 38–55; and Erika Doss, "American Folk Art's Distinctive Character: The Index of American Design and New Deal Notions of Cultural Nationalism," in Virginia Tuttle Clayton, et al., *Drawing on America's Past: Folk Art, Modernism, and the Index of American Design* (Chapel Hill and Washington: The University of North Carolina Press in association with the National Gallery of Art, 2002), 61–73.

18 Emil Frei (1869–1942) studied at the Munich Academy of Art before immigrating to the United States in the late 1800s. In 1900 he opened the Emil Frei Art Glass Company in St. Louis, Missouri. His firm produced stained glass windows for many buildings in St. Louis and throughout the United States. The company today is run by Emil Frei's great grandsons. Emil Frei Associates Inc., 1017 W Adams Ave, Kirkwood, MO 63122.

19 The idea that Wood was influenced by Neue Sachlichkeit was the focus of H.W. Janson's article, "The International Aspects of Regionalism," *College Art Journal (Art Journal)* 2 (May 1943), 110–15, which interpreted this stylistic affinity in political terms, implying that Wood was not only a reactionary painter but also even fascist. More recently the stylistic influence has been discussed, although without the political implications, by Brady M. Roberts, "The European Roots of Regionalism: Grant Wood's Enduring Stylistic Synthesis," in Roberts, et al., *Grant Wood*, 19–27. Corn, on the other hand, argues that Neue Sachlichkeit's significance for Wood was minimal, either stylistically or politically, an opinion shared by Wood's friend and biographer Park Rinard who said the idea was "Bull!" Corn, *Grant Wood*, 30; and Rinard interview with Corn, August 1976. I am grateful to Professor Corn for sharing her notes on this with me.

20 For a thorough discussion of *American Gothic* and its enduring role in American art and culture see Corn, *Grant Wood,* 128–42.

21 Benton returned to Missouri in 1935, taking a job at the Kansas City Art Institute, and Wood helped Curry obtain a similar teaching position at the University of Wisconsin in 1936. See Corn, *Grant Wood,* 43. Benton's return was not solely due to Wood's influence; as Henry Adams has argued Benton's opposition to modernism had made him so controversial that it was no longer possible for him to remain in New York. See Henry Adams, *Thomas Hart Benton: An American Original* (New York: Alfred Knopf, 1989), 208. For more on Curry see Patricia Junker, et al., *John Steuart Curry: Inventing the Middle West* (New York: Hudson Hills Press in association with the Elvehjem Museum of Art, 1998).

22 Allen Jackson, "U.S. Scene," *Time* 24 (December 24, 1934), 24–27. There were, of course, many other articles about the same time in a variety of newspapers, magazines, and art journals that emphasized the significance of American Scene painting, pointing to Regionalist art as one of its most important components.

23 For more on these and their context see Karal Ann Marling, *Wall to Wall America: A Cultural History of Post-Office Murals in the Great Depression* (Minneapolis: University of Minnesota Press, 1982); Marlene Park and Gerald E. Markowitz, *Democratic Vistas: Post Offices and Public Art in the New Deal* (Philadelphia: Temple University Press, 1984); and Lea Rosson DeLong, *A Catalogue of New Deal Mural Projects in Iowa* (Des Moines: L.R. DeLong and G.R. Narber, 1982).

24 Although Wood is listed as author of *Revolt Against the City,* most scholars agree that it was a joint endeavor, with Mott playing a major role in the writing. The issues it addresses, however, were ones Wood had been lecturing about for some time by 1935. For more on the issue see Graham, *My Brother, Grant Wood,* 124; and Dennis, *Renegade Regionalists,* 255, note 13.

25 Unfortunately only three pages of the untitled document, dated June 1934, remains in the University of Iowa Special Collections file. The first paragraph lays out the issue: "This brief explanation of the present problem in the department Graphic and Plastic Arts at the University is placed in this cornerstone in June 1934 with the thought that the outcome of the conflict between the conservatives and the liberals of the faculty will be known when this comes to light and can be interpreted with perspective. The leader of the conservatives is Professor Catherine Macartney, Acting head of the Department and an influential member of the Iowa Art Guild established by Professor C.A. Cumming; while the leader of the liberals is Professor Grant Wood, who has played an important part in the Iowa Artists Club." It proceeds with a history of the department to date, but ends just as the dispute is being described; the subsequent pages are obviously missing. Perhaps at some point the cornerstone of the 1934 building will be opened and the conclusion of the document finally, indeed, "brought to light." In 1935, in an unrelated controversy, some of the artists in the PWAP mural project became disgruntled, presumably over the higher pay Wood received as director, and circulated a petition calling for his removal. When he learned of it, Wood (who had, in fact, never accepted the government paychecks) promptly resigned from the program. Graham, *My Brother Grant Wood,* 117–18.

26 Grant Wood to Earl Harper, Director of the School of Fine Arts, University of Iowa, January 26, 1940. Edwin Green Papers, Grant Wood File, University of Iowa Special Collections.

27 "Notes on Conference between Earl Harper and Prof. Grant Wood" (5/9/[1940]); Director [Earl Harper] to Dean George Kay, College of Liberal Arts, May 22, 1940; Carl Seashore to Grant Wood, June 21, 1940; Edwin Green Papers, Grant Wood file, University of Iowa Special Collections.

28 Notes dated May 8, 1941 of meeting between UI President Virgil Hancher, Park Rinard, and Dan Dutcher, held May 7, 1941. Edwin Green Papers, Grant Wood file, University of Iowa Special Collections. Rinard reported this information to Hancher and added that Lamar Dodd of the University of Georgia had subsequently written him to report John Steuart Curry had witnessed Longman's presentation and had been shocked by it. Ironically, of course, Fletcher Martin did not go on to a prominent artistic career. A self-taught artist, he did murals in Los Angeles during the Depression. After his brief stint at Iowa he was an artist-correspondent for *Life* magazine in North Africa during World War II. He later taught at the Kansas City Art Institute and the University of Florida. http://www.namos.iupui.edu/artists/martin.htm.

29 The source was ultimately never determined. Wood believed, at least at first, that it was Martin; Martin denied it. See Wood to Fletcher Martin, November 26, 1940; Martin to Wood, November 21, 1940. Edwin Green Papers, Grant Wood file, University of Iowa Special Collections.

30 Wood to Fletcher Martin, November 26, 1940, Edwin Green Papers, Grant Wood file, University of Iowa Special Collections.

31 Wood to George F. Kay, Dean of the College of Liberal Arts, November 19, 1940, Edwin Green Papers, Grant Wood file, University of Iowa Special Collections.

32 Longman to Welch, November 18, 1940 "Statement Made to *Time* Magazine Upon Request," Edwin Green Papers, Grant Wood file, University of Iowa Special Collections.

33 Notes of meeting with Virgil Hancher, Park Rinard, and Dan Dutcher, held May 7, 1941 (dated May 8, 1941); Edwin Green Papers, Grant Wood file, University of Iowa Special Collections.

34 Dean Kay to President Virgil Hancher, 6 December 1940; Notes of meeting with Virgil Hancher, Park Rinard, and Dan Dutcher, held May 7, 1941 (dated May 8, 1941); Edwin Green Papers, Grant Wood file, University of Iowa Special Collections.

35 Lester D. Longman, "Better American Art," *Parnassus* 12 (October 1940), 4–5. Longman described his own role in "The Art Critic," *Parnassus* 13 (January 1941), 53–54 in which he wrote revealingly of his zeal in the Wood controversy, "[the critic] has a special interest in and devotion to the present and therefore directs all his breadth of knowledge into a single channel, which as it nears a contemporary and momentous problem narrows into a torrent of profound conviction."

36 Upon learning of the meeting between Longman, the other faculty members, and the *Time* reporter the Director of the School of Fine Arts telephoned the Dean of the College of Liberal Arts to say that "the fat was in the fire." "Notes on the Art Department Crisis, Dictated Wednesday, November 27, on the basis of notes on numerous conferences, discussions and developments beginning Friday, November 15" [unsigned typewritten notes of Earl Harper, Director of the School of Fine Arts], Edwin Green Papers, Grant Wood file, University of Iowa Special Collections. Confirmation that Janson and Okerbloom were at the meeting is only found in a later document: "Notes of meeting with Virgil Hancher, Park Rinard, and Dan Dutcher, held May 7, 1941," (dated May 8, 1941).

37 The list included Peyton Boswell, editor *Art Digest*; Agnes Rindge, Vassar College; Roland McKinney, Director, Los Angeles County Museum of Art; Forbes Watson, Associate Editor, *Magazine of Art*; William Varnum, chair, Department of Art Education, University of Wisconsin; Thomas Munro, chair, Art Department, Western Reserve University; Millard Meiss, editor, *Art Bulletin* and professor at Columbia; Carl Zigrosser, Curator of Prints, Philadelphia Museum; Daniel Catton Rich, Director Art Institute of Chicago; Norman Rice, Dean Art Institute of Chicago; Ulrich Middledorf, chair of the University of Chicago Art Department and president of the College Art Association; Alfred Barr, Director, Museum of Modern Art; Hermon More, Curator at the Whitney Museum of Art; Paul Parker, Director, Colorado Springs Fine Arts Center; Sheldon Cheney, critic in Westport, Connecticut; Rensselaer Lee, professor, Smith College; Blakemore-Godwin, Director, Toledo Museum; and Lloyd Goodrich, Curator of American Art, Whitney Museum of Art. See undated "LIST OF LEADING ART EDUCATORS AND ART CRITICS IN THE COUNTRY" in Edwin Green Papers, Grant Wood file, University of Iowa Special Collections.

38 Memorandum from Lester Longman to Dr. Harper and Dean Newburn "to provide bases for a fair and workable, a constructive and stable solution of the Wood problem." Undated, but would appear to be from the spring of 1941. Edwin Green Papers, Grant Wood file, University of Iowa Special Collections.

39 Ibid. The emphases are Longman's.

40 This diagnosis has been confirmed by Drs. Randy Lengeling and Emeritus medical professor Lew who examined Wood's medical records in 1992. See the summary in the University of Iowa Special Collections, Grant Wood files.

41 For details on Wood's new appointment see Grant Wood to Harry K. Newburn, June 25, 1941; Memo re: Grant Wood, signed H[arry] K. N[ewburn; Associate Dean and Dean-elect of the College of Liberal Arts], June 25, 1941; and Press Release, June 28, 1941. Ibid.

42 The articles Longman forwarded were "Knocking Wood." *Art Digest* 17 (December 1, 1942), 12; and "Chicago Critic Attacks Wood's Art," *Art Digest* (November 15, 1942).
 Earl Harper to Harry K. Newburn, December 12, 1942. Newburn wrote back to Harper a few days later saying, "I find myself reacting enthusiastically to the last sentence of your letter ["the dead burying the dead"]. I hope that in some way we can convey this impression to Longman, particularly insofar as his overt activities are concerned. I am glad to know what the critics think but I am not sure that they are quite willing to recognize the part the public plays in determining artistic ability." Newburn to Harper, December 16, 1942. Edwin Green Papers, Grant Wood file, University of Iowa Special Collections.
43 Lester D. Longman, "Contemporary Painting," *Journal of Aesthetics and Art Criticism* 3, no. 9 (1944), 8–18; Lester D. Longman, "Why not Educate Artists in Colleges?" *Art Journal* 4 (March 1945), 132–34.

44 Lester D. Longman, "Contemporary Painting," *Journal of Aesthetics and Art Criticism* 3, no. 9 (1944), 15.
45 Interview with H.W. Janson by Wanda Corn, August 11, 1974. I am grateful to Professor Corn for sharing her notes of this meeting with me. Janson himself recounted the episode in a lecture at the College Art Association conference in 1974. The lecture was subsequently published; see H.W. Janson, "Artists and Art Historians," *Art Journal* 33 (summer 1974), 334–36.
46 H.W. Janson, "The International Aspects of Regionalism," *College Art Journal* [*Art Journal*] 2 (May 1943), 110–15; and "Benton and Wood, Champions of Regionalism," *Magazine of Art* 39 (May 1956), 184–86; 198. For the larger context of fascism and the art of the 1930s see Dennis, *Renegade Regionalists*, 69–89 and Cecile Whiting, *Antifascism and American Art* (New Haven: Yale University Press, 1989).
47 For other aspects of this issue in Iowa see Evan R. Firestone, "Incursions of Modern Art in the Regionalist Heartland," *The Palimpsest* 72 (fall 1991), 148–60.

James M. Dennis, *Grant Wood Works on Paper*

1 Wood's letter is quoted in full in a "Letter to the Editor from Cyril Clemens, *Saturday Review of Literature*, 25 (February 28, 1942), 11.
2 The information regarding Wood's drawing of Charles Manson as Silenus, including the embarrassed reaction it provoked, was conveyed to the author by Cedar Rapids businessman Gordon Fennell, a Chamber of Commerce member, during a conversation in Cedar Rapids, summer, 1973.
3 This information regarding *The Birthplace of Herbert Hoover* is contained in a letter to the author from the artist's sister, Mrs. Nan Wood Graham, dated February 7, 1975. Mrs. Graham also stated in an interview at her home in Riverside, California in September, 1971 that her brother, Grant, was a political independent who had become a Democrat by the time of his death.
4 "A Patriot First to Edward Rowan," Letters to the Editor, *Cedar Rapids Gazette and Republican*, May 14, 1933.
5 After working for months on full-scale cartoons, Wood and his young assistant, Arnold Pyle, mounted twenty-four by twenty feet of them on fifty-eight sections of wood paneling in the recreation room of the Quaker Oats plant in Cedar Rapids. The overall design was approved in January 1928 by the Memorial Window Commission and the Emil Frei Art Glass Company of Saint Louis was contracted to stain and assemble its glass panels in Munich, Germany. In September Wood traveled there to go over his figures with chalks to approximate the desired color scheme. He also quickly learned the techniques of painting on glass with iron-oxide stain in order to reproduce the facial features he had drawn on his section-by-section cartoons. The hundreds of meticulously refined shapes involved were

fire-glazed with translucent hues in time to be installed during the month of March 1929. See Naomi Doebel, "Memorial Window for Island Building Will be Symbol of Peace and Tribute to Heroic Dead," *Cedar Rapids Gazette*, January 13, 1929.
6 Art historian Horst Woldemar Janson attempted to legitimize the defeathered fowl of *Adolescence* art historically by insisting that it had to be based on the plucked chicken representing the "Platonic biped" in the chiaroscuro woodcut *Diogenes* by Ugo da Carpi (d. 1532) after Parmigianino. See "The Case of the Naked Chicken," *College Art Journal,* 15 (winter 1955–56), 124–27.
7 Photos taken by Cedar Rapids photographer John W. Barry of John Steuart Curry visiting Grant Wood at the Stone City Colony and Art School during the summer of 1933 show both wearing white shirts and bibbed overalls. Unlike Curry, Wood wears his collar wide open and flattened out under his shoulder straps.
8 As quoted in "Many Turn Out for Lecture by Iowa Artist," *Dubuque Telegraph-Herald and Times-Journal*, March 9, 1932, Wood's full statement was "Modernism has added a new force, a new drive, and a lot of valuable tools to the kit of the artist."
9 The identification of the tall figure as Edward Rowan is credited to Arnold Pyle who worked at The Little Gallery for Rowan and knew him well. Pyle shared this identification, along with the identification of Rowan (pictured to the right of Wood in fig. 26) as the model for the farm woman in Wood's painting *Appraisal*, during a conversation with the author in May 1972.
10 As quoted by Bob Sherwood in "Grant Wood Disdains Desire to Belittle Washington," *Cedar Rapids Gazette*, February 26, 1939.
11 Leo Stein, *the ABC of Aesthetics* (New York: Boni and Liveright, 1927), 169.

Jane C. Milosch, *Grant Wood's Studio*

In May of 2002 the Cedar Rapids Museum of Art engaged Gilmore Franzen Architects, Inc. (GFAI), Oak Park, Illinois, to provide a historic structure report for Grant Wood's Studio at 5 Turner Alley, to serve as a roadmap for restoring the studio to its circa 1931 condition. Leslie M. Gilmore, principal-in-charge of the project, compiled their findings in the "Historical Structure Report for the Grant Wood Studio 5 Turner Alley," (July 2003). This has been an invaluable source of information on the architectural and structural components of the studio.
Other significant sources include: Grant Wood Scrapbooks at the Figge Art Museum (formerly the Davenport Museum of Art), compiled by Wood's sister Nan Wood Graham, comprised 18 volumes of published articles and pertaining to Wood's life and work as well as correspondence. These are on microfilm at The Archives of American Art, Smithsonian Institution, Washington D.C. as "Grant Wood Scrapbooks, 1900–1962." Two standard monographs on Grant Wood, the first by James M. Dennis and the other by Wanda M. Corn, provided essential, art-historical content, as well as their interviews with Grant Wood's sister which yielded illuminating personal anecdotes.

1 "Quaint Studio Was Once a Feed Loft: Now Rich in Antiques," *Cedar Rapids Republican*, October 18, 1925. This article includes the earliest known description of 5 Turner Alley with photographs of the studio. A year later the same photographs appeared in Edna Barrett Jackson, "Cedar Rapid's Art Colony: Seed Sown in Turner Alley," *Cedar Rapids Republican*, September 12, 1926.
2 The carriage house had no official address. The Turner Mortuary is located at 810 Second Avenue at Eighth Street, and the studio is located off of the alley. Wood's sister Nan reports that Wood adopted this address and name for his studio when he received a postcard addressed to him at this address. Nan Wood Graham, *My Brother, Grant Wood* (Iowa City, 1993), 51.
3 Forbes Watson, "Mid-Western Optimism," *The Arts,* December 1929, 215, found in Edward Rowan Papers, Archives of American Art, Washington, DC. Rowan was affiliated with the Fogg Art Museum at Harvard University before moving to Cedar Rapids to become director of The Little Gallery which was founded to promote art education in Cedar Rapids.
4 For their personal accounts on Grant Wood see William Shirer, *20th Century Journey, A Memoir of a Life and the Times, The Start: 1904–1930,* (Boston, 1976), and MacKinlay Kantor, *I Love You Irene* (New York, 1972).

5 James M. Dennis, *Grant Wood: A Study in American Art and Culture*, rev. ed. (Columbia, Missouri, 1986), 19. For a thorough study of the impact of Ernest Batchelder's teachings on Wood see James M. Dennis, *Grant Wood: Still Lifes as Decorative Abstractions* (Madison, 1985), and "Grant Wood's Native-Born Modernism," in Brady M. Roberts, et. al., *Grant Wood: An American Master Revealed* (Rohnert Park, Calif.: Pomegranate Artbooks 1995), 43–63.

6 In Ernest Allen Batchelder's "Design in Theory in Practice: A Series of Lessons: Number VII," *The Craftsman* vol. 14, no.1 (April 1908), 89–99, Batchelder notes that the "roles of artist and artisan had become increasingly separated over time, leaving the artist limited to the ideal, the artisan to the real" and advocates for "shop-trained artists and theoretically-trained artisans," to remedy this situation. Wood followed this formative advice in his training as an artist and craftsman.

7 Some of Wood's early craft work is in the collection of the Cedar Rapids Museum of Art and the Figge Art Museum in Davenport, Iowa (formerly the Davenport Museum of Art).

8 Interview with Mrs. D.W. Warren in "Grant Wood is One Artist of Renown Appreciated in His Own City; Local Tributes." *Cedar Rapids Evening Gazette and Republican*, February 11, 1931.

9 In correspondence with Chicago scholar Darcy Evons, I learned that two metalsmithing shops with the name Volund existed in Chicago during the 1920s, which has caused some uncertainty about the attribution of work produced at these two shops. Wood worked with Kristoffer Haga at the "Volund Crafts Shop" which closed in the summer of 1916. (For several months after Wood's January 1916 departure for Cedar Rapids, Haga appears to have remained in business alone.) The second is listed in *Donnelly's Directory of Chicago District* in January 1923 under the name, "Volund Shop," which was owned by another former Kalo silversmith and in business from 1919 to 1926. I am grateful to Evons for sharing her Volund research with me, especially the different makers' marks to be published in her forthcoming book on Chicago silversmiths of the early 20th century.

10 "House Built by Grant Wood is Again an Artist's Home," *Cedar Rapids Gazette*, August 1, 1943. This was probably the first house in Cedar Rapids to have a magnesite stucco finish, which, applied in freezing weather, was still in good condition in 1943.

11 Graham, *My Brother, Grant Wood*, 25.

12 Louis Sullivan commissioned Allen Philbrick (1879-1964) to complete four murals for the interior of the Peoples Savings Bank in Cedar Rapids which he designed. Philbrick was primarily a mural and landscape painter who taught composition and anatomy from 1903 to 1953 at the School of the Art Institute of Chicago. Wood may have studied with Philbrick during his sporadic studies at the School. See Allen Philbrick Papers, 1902–1990, Archives of American Art and correspondence with Art Institute of Chicago Archives in possession of author.

13 The Don Hanson Papers at the Cedar Rapids Museum of Art contain valuable information as to the identity of Wood's models for *Adoration*. The inscription on the frame of *Adoration of the Home* reads, "This Mural Celebrating Cedar Rapids As a City of Homes Was Painted by Grant Wood for Henry S. Ely Company." For a thorough description and comparison to Philbrick's painting *Industry—Banking—Commerce* see Dennis, *Grant Wood*, 63.

14 "Adoration of Home Motive in Life of Energetic Realtor," *Cedar Rapids Republican*, August 22, 1923. Like other rapidly growing cities in the Midwest, Cedar Rapids could be considered a model of the sort of civic pride and boosterism which Sinclair Lewis satirized in *Main Street*, 1920. Wood was later dissatisfied with the boosterism of *Adoration*. Graham, *My Brother, Grant Wood*, 42. It was perhaps to compensate for *Adoration* that Wood later struck a very different tone in *Shriner Quartet* and several other similar images. In 1937 he illustrated a special edition of *Main Street*.

15 The property was later sold to the Sinclair family, and was purchased in 1924 by John B. Turner and his son David Turner for their funeral home business. A pioneering family with roots in Iowa dating back to the early 19th century, the Turners had made their fortune in the mortuary business. The Douglas family did not remain long in this home and in 1906 traded properties with another prominent and prosperous Cedar Rapids family, the Sinclairs, receiving in exchange a much larger home with larger grounds situated well outside the Cedar Rapids downtown area. *Cedar Rapids Republican*, October 16, 1906.

16 Two of these casket biers were donated in 2004 to the Cedar Rapids Museum of Art.

17 *National Register of Historic Places*, Inventory Nomination Form, 1982, sec. 7, 1.

18 John B. Turner, "Paintings by Grant Wood Hung in Turner Mortuary," Cedar Rapids, 1926, found in library of Davenport Art Museum (includes tribute by Henry S. Ely).

19 "New Turner Mortuary to Be Opened Next Week; Is a Fine Establishment," *Cedar Rapids Evening Gazette*, December 13, 1924.

20 Graham, *My Brother, Grant Wood*, 49.

21 Interview with Grant Wood in *The Palette & Chisel*, May 1931 (Wood: "I have been warned many times in the past by other painters that there was no chance for me to gain recognition if I persisted in living in a mid-west town no larger than Cedar Rapids. I was told that I must go to New York, or at least to Chicago and cultivate friendships with all the people who might be upon juries.") Found in Grant Wood Scrapbooks, Figge Art Museum.

22 The Turner Collection and the 5 Turner Alley studio were donated to the Cedar Rapids Museum of Art by Happy Young and John B. Turner II. The majority of the works by Wood in the collection of the Cedar Rapids Museum of Art come from the Turner Collection.

23 Francis Kelly, *The Studio and the Artist* (New York, 1974),114.

24 Clarence Cook, "Shall Our Rooms Be Artistic or Stylish," *Monthly Illustrator* 5 (July 1895), 52–53.

25 See Wanda M. Corn, "Artists' Homes and Studios: A Special Kind of Archive," in *American Art* (University of Chicago Press in association with the Smithsonian American Art Museum, Spring 2005, vol. 19, no. 1) 2-11.

26 In a 1925 photograph of 5 Turner Alley the west dormer window had not yet been added. I am grateful to Mark Hunter, historian, at the Carl & Mary Koehler History Center, Cedar Rapids, Iowa, for bringing this photograph to my attention.

27 A newspaper article reported a fire at 5 Turner Alley in January 1932. There is mention of a storeroom, where the fire broke out, but not a bedroom. See "Grant Wood and Sister Burned," *Cedar Rapids Evening Gazette and Republican*, January 14, 1932. According to a personal account by Hazel Brown, the conversion of the storeroom into a bedroom occurred after the fire. See Hazel Brown, *Grant Wood and Marvin Cone: Artists of an Era* (Ames, 1972), 34. According to the findings of Gilmore Franzen Architects, Inc., which includes a paint analysis of the walls, this room was not finished with gypsum board until c.1931 (so was probably not yet a bedroom), and the door to this room was added in 1931 or 1934. See *Historical Structure Report for the Grant Wood Studio*, 14, 29. Nan Wood Graham recalls that the conversion of storeroom to bedroom occurred in late February 1935, after their mother had suffered a heart attack. This date is relatively late given the other findings. See Graham, *My Brother, Grant Wood*, 51.

28 Gustav Stickley, "Utility-Simplicity-Beauty," in Barry Sanders (ed.), *The Craftsman: An Anthology* (Santa Barbara and Salt Lake City, 1978), 17 (unsigned article originally published in vol. 1, no. 2, November 1901 issue of *The Craftsman*).

29 "Quaint Little Studio Was Once a Feed Loft: Now Rich in Antiques," *Cedar Rapids Republican*, October 18, 1925.

30 Wood's extensive and creative use of fiberboard soon after the development of this material is noteworthy. Fiberboard did not come into widespread use as a building material in the United States until the 1930s. Gilmore Franzen Architects, Inc., *Historical Structure Report for the Grant Wood Studio*, 22-23.

31 For an extensive explanation of Wood's use of fiberboard as a support for his painting, see James S. Horn and Helen Mar Parkin, "Grant Wood: A Technical Study," in Roberts et al., *Grant Wood*, 67-91.

32 Graham, *My Brother, Grant Wood*, 133, and the Masonite ad which appeared in *Coronet* (magazine ad can be found in Grant Wood Scrapbooks at Figge Art Museum in Davenport, Iowa).

33 Graham, *My Brother, Grant Wood*, 51-52.

34 For a discussion of the symbolism of the phone in *Victorian Survival*, see Wanda Corn's essay in the present work.

35 During the summer of 1929, Wood visited Ed Rowan and his wife at a summer house they were renting in Eldon, Iowa. Rowan noted that Wood was "quite taken" with a Gothic window he discovered in a little house during a drive through

the country. Rowan to McCosh, October 31, 1930, Edward Rowan Papers, Archives of American Art, Washington, DC.

36 Around 1931 Wood replaced the original windows with steel casement windows. These new windows are clearly visible in photographs of the studio. Gilmore Franzen Architects, Inc., *Historical Structure Report for the Grant Wood Studio*, 20.

37 "Grant Wood-A Genius of Iowa Prairies. Life Story of Local Artist Proves Assertation that Truth is Stranger and More Interesting than Fiction; He had Great Faith in a Splendid Ideal," *Cedar Rapids Republican*, June 7, 1925.

38 According to conservation studies done on Wood's paintings, decorative arts and the interior walls of 5 Turner Alley, Wood applied paint in a similar manner on different materials. As a ground, he often used a common white house paint which contained barium sulfate and zinc white. Wood was known to mix lacquers into his oils, using this as a glaze; traces of nitrocellulose lacquer have been found on many of his works. For studio see Gilmore Franzen Architects, Inc., *Historical Structure Report for the Grant Wood Studio*, 100–116. For paintings see James S. Horns and Helen Mar Parkin, "Grant Wood: A Technical Study";James S. Martin, "Technical Study of Materials Comprising Fourteen Paintings by Grant Wood"; and Inge Fiedler, "A Study of the Materials Used in Grant Wood's *American Gothic*," in Roberts et al., *Grant Wood*. For decorative arts see Nathan Otterson, Upper Midwest Conservation Association, *Conservation Report, Grant Wood's Decorative Arts Works in the Collection of the Cedar Rapids Museum of Art* (Minneapolis, 2005).

39 Wanda M. Corn, *Grant Wood: The Regionalist Vision* (New Haven, 1983), 64.

40 Though Wood's tiles were probably from a local source, Lesley Gilmore observed that the tiles in 5 Turner Alley closely resemble the color of the tiles found in the home of Ernest Batchelder in Pasadena, California. Batchelder was Wood's instructor at the Minneapolis School of Design, Handicraft, and Normal Art during the summer of 1910. Gilmore Franzen Architects, Inc., *Historical Structure Report for the Grant Wood Studio*, 23.

41 New floors are evident in a photograph of Grant Wood standing next to his easel with the almost-finished *Midnight Ride of Paul Revere*, published with an article that also provides a description of the studio walls as "rough creamy plaster," and the floor as "great planks riveted together with extending nail heads." See Adeline Taylor, "Wood Hailed From West To Berlin As Discovery," *Cedar Rapids Sunday Gazette and Republican*, January 25, 1931. Key alterations to the studio—oak-plank floor, steel casement windows, addition of the west dormer—were made prior to this c.1931 photograph. Gilmore Franzen Architects, Inc., *Historical Structure Report for the Grant Wood Studio*, 14.

42 Gilmore Franzen Architects, Inc., *Historical Structure Report for the Grant Wood Studio*, 17.

43 Wood's sister Nan thought enough of this silver metallic wallpaper to preserve a swatch of it in her Grant Wood Scrapbooks, Figge Art Museum, Davenport, Iowa. This same sample recalls the description of wallpaper described by Hazel Brown in her book, *Grant Wood and Marvin Cone: Artist's of an Era*, 49. She reports that Wood used "silver China tea paper left over from a job he was doing," and papered a small room in the Hobby House, a home furnishings boutique owned by Hazel Brown and Mary Lackersteen. In May 1924 Hazel Brown and Mary Lackersteen first opened their Hobby House gift shop in Cedar Rapids, which sold all types of home furnishings. Wood worked with them for years, purchasing and borrowing articles from their shop, for his decorating projects. The best account to date of Wood's decorating projects in Cedar Rapids appears in Brown's book.

44 Marvin Cone, Regionalist painter and friend of Grant Wood. "Discussion between Marvin Cone and David Turner," radio transcript, April 17, 1942, in Joseph Czestochowski, *Marvin D. Cone and Grant Wood: An American Tradition* (Cedar Rapids, Iowa, 1990), 209.

45 MacKinley Kantor, "K's Column," *Des Moines Tribunal-Capital*, December 29, 1930.

46 MacKinley Kantor, *I Love You, Irene* (New York, 1972), 141.

47 This bronze *Self-Portrait* has previously been dated at *c.* 1917 in Czestochowski's *Marvin Cone and Grant Wood*. But in Graham's, *My Brother, Grant Wood*, 55, she reports late 1925. I think her date is correct since the image so closely resembles a 1923 photograph of Wood (fig. 7). The original plaster casts included a heavy piece of thread which attached to the pince-nez glasses. In a letter of May 7, 1972 to John B. Turner, Nan granted him permission to make reproductions of this *Self-Portrait*. (Accession Files, Cedar Rapids Museum of Art.)

48 Garwood wrote that, "Grant's pupils pounded out designs onto flattened tobacco tins, and they were nailed as facing onto a balustrade between the studio and storeroom." Darrell Garwood, *Artist in Iowa: A Life of Grant Wood* (New York, 1944), 81. This is the only reference to recycled tobacco tins, but, since the sheets of tin are long and continuous, this seems improbable.

49 The Cedar Rapids Museum of Art has in its collection wrought-iron hooks, handles, and a bell that were forged by George Keeler.

50 For more on principle of thirds see Jay Hambidge, *The Elements of Dynamic Symmetry* (New York, 1967; first published by Brentano's Inc. in 1926).

51 *Fire Screen*, c.1929–30, designed by Grant Wood and fabricated in hand-wrought iron by Wood's cousin George Keeler, and probably with the assistance of George Wilhelm, had previously been dated at 1923, but it is most likely that these were completed between 1929 and 1930, when Wood worked on the entire decorating project for the Hamilton home. David Turner recalls "excellent iron work which Grant did either by himself or more often with George Wilhelm." Julie Jensen McDonald, et al.,*Grant Wood and Little Sister Nan* (Iowa City, 2000), 97.

52 "Planned Space for Books Adds Pleasure to Reading," *Cedar Rapids Gazette*, April 12, 1959. These doors were originally installed with a painted arch design above them, to form a "loggia," and this completed their visual reference to Raphael's *Logetta of Cardinal Bibbiena* (1516) in the Vatican Palace, Rome.

53 This 1869 map of Linn County, the second oldest detailed map of the county and the first with illustrations around the border of early landmarks (Thompson & Everts, Map Publishers of Geneva, Illinois, and compiled, surveyed and drawn by D.W. Ensign, C.E.), served Wood numerous times as source material for his work. While decorating the Turner Mortuary, Wood found this map in the attic of the mansion and had it conserved for display in the reception room of the mortuary. See "New Turner Mortuary To Be Opened Next Week: Fine Establishment," *Cedar Rapids Evening Gazette*, December 13, 1924.

54 Much work is to be done in documenting the many interior design projects completed by Wood. In the course of my research on the studio, two were brought to my attention. The first was a 'marine room' interior for the Submarine Sweet Shop in Waterloo, Iowa, reported in "Art News of The Little Gallery," *Cedar Rapids Evening Gazette and Republican*, October 15, 1929. The article describes Wood's designed and painted interior for this shop, including murals, ceiling decorations, and light fixtures: "I do not recall having seen a more pleasant interior—the treatment is purely modernistic—one feels the artist is enjoying a new freedom—one could sense Grant's playfulness throughout. … Modernistic lights resemble white scallop shells and other forms of sea life while white table lamps take their golden form from the chambered nautilus." The second was a decorating plan for the First Congregational Church in Cedar Rapids. Wood completed this plan the same month he discovered the now famous Gothic-windowed house in Eldon, Iowa which inspired him to paint *American Gothic*. The church's funds were exhausted before the stage and curtain in the church hall could be decorated but Wood completed the job *gratis* in exchange for the use of the hall by the Community Players, a local theatrical group to which he belonged. I am grateful to Deba Foxley Leach for bringing both of these decorating projects to my attention and providing archival evidence of the church commission.

55 The Hotel Chieftain in Council Bluffs, Iowa, opened in February 1927. "Bluffs Drive to Restore Wood Murals," *Des Moines Register*, July 12, 1959. In 1926 Wood also completed murals for the "Pioneer" room (called the "Kanseville Mural") of the Hotel Martin in Sioux City; these corn murals were conserved in 1985, and are now in the collection of the Sioux City Art Center (*Grant Wood: A Mural Restored*, [Sioux City Art Center, 1985] reports that both the Cedar Rapids and Sioux City murals were similarly painted: "Wood applied a transparent glaze over the painted surface and then removing areas of the glaze to suggest the panoramic view [through the discrepancies of flat and shiny], a technique described as 'negative painting.'")

56 One of the corn-cob chandeliers from the Hotel Montrose is now in the collection of the Cedar Rapids Museum of Art. This was conserved in 2004-05 with funds from The Henry Luce Foundation, New York. The restoration was completed by Nathan Otterson, Associate Objects Conservator at Upper Midwest Conservation Association, Minneapolis.

57 Brown, *Grant Wood and Marvin Cone,* 58.

58 Montgomery Schuyler, "The Peoples Savings Bank," in *The Architectural Record,* January 1912.

59 Wood copied, almost verbatim, the stance and gesture of the central female figure in Philbrick's *Summer Noon.* In Wood's rendering of *Dinner for Threshers,* the same female figure appears but differs in that she stands parallel to a dividing wall, instead of a tree as in Philbrick's mural.

60 Wood talked to the press numerous times about his trip and work in Munich, Germany. See "Grant Wood, Local Artist, Finds German People are Friendly, Does 20 Paintings, *Cedar Rapids Republican,* December 28, 1928; and Naomi Doebel, "Memorial Window for Island Building will be a Symbol of Peace and Tribute to Heroic Dead," *Cedar Rapids Sunday Gazette,* January 13, 1929.

61 Dennis, *Grant Wood,* 68.

62 See Roberts, "The European Roots of Regionalism: Grant Wood's Stylistic Synthesis," in Roberts et al., *Grant Wood,* 20–21.

63 Irma René Koen, "The Art of Grant Wood," *Christian Science Monitor,* March 26, 1932.

64 Edward Rowan, director of The Little Gallery in Cedar Rapids, moved to Washington DC, when he was appointed Chief, Public Buildings Administration in 1934, and Rowan appointed Wood director of the WPA/PWA project in Iowa. In September of 1934, when Wood was appointed Associate Professor of Fine Arts at the University of Iowa, the university was then called the State University of Iowa.

65 For a description of furniture he made and decorative arts he collected see John Selby, "Denies Carrying 'Culture' to Midwest," found in Grant Wood Scrapbooks, Figge Art Museum.

66 Lubben and John Cary Company in Cedar Rapids manufactured the chair for a short period of time starting in 1938, but with little success. Part of the reason may have to do with the fact that, for production purposes, they had to alter the artist's original design, truncating the ottoman into a stubby form that ruined its elongated and elegant lines, which mimicked the streamlined forms of 1930s' transportation. Naomi Doebel, "Downy Lounge Chairs Irk Grant Wood so he Transfers Art to Furniture Designing, *Cedar Rapids Gazette,* November 27, 1938; "Artist Grant Wood Designs Unique Furniture Items," *Furniture Age,* 1939, found in Naomi Doebel, "Downy Lounge Chairs Irk Grant Wood so he Transfers Art to Furniture Designing, *Cedar Rapids Gazette,* November 27, 1938; "Artist Grant Wood Designs Unique Furniture Items," *Furniture Age,* 1939, found in Grant Wood Scrapbooks, Figge Art Museum.

67 The subject matter of this work recalls Philbrick's mural, *Fall Evening* (1910) in the Peoples Savings Bank, Cedar Rapids, Iowa, which depicts a farmer at the plow in the center of the composition. The two other murals on the left and right walls, adjacent to *Fall Plowing,* include other farmland depictions. Both Philbrick and Wood's murals wrap around the walls to form an almost cycloramic installation.

Wanda M. Corn, *Grant Wood: Uneasy Modern*

1 In this essay, I consider Wood's figural work anew, extending the discussion I began in *Grant Wood, The Regionalist Vision* (New Haven and London: Yale University Press, 1983). I borrow passages occasionally from this earlier work. My thanks to Jane Milosch, Joni Kinsey, Jason Weems, Amanda Glesmann, and Joseph Corn for their helpful responses to an earlier draft. I also thank James G. Rogers Jr., for helping me with a reference.

2 The Lynds' analysis of small-town America was based on fieldwork they conducted in Muncie, Indiana. See Robert S. Lynd and Helen Merrell Lynd, *Middletown: A Study in Contemporary American Culture* (New York: Harcourt, Brace and Co., 1929), 5–6.

3 T. J. Clark, *The Painting of Modern Life, Paris in the Art of Manet and His Followers* (Princeton, N.J.: Princeton University Press, 1984).

4 Ibid., 211.

5 For a very useful essay on the candlestick telephone, see Kenneth Haltman, "Reaching Out to Touch Someone? Reflections on a 1923 Candlestick Telephone," in Jules David Prown and Kenneth Haltman (eds.), *American Artifacts: Essays in Material Culture* (East Lansing, Mich.: Michigan State University Press, 2000), 21–92.

6 *The Telephone, Collected Poems of Robert Frost* (New York: Henry Holt and Company, 1930), 147.

7 Morton Livingston Schamberg, a painter and friend of Charles Sheeler, in 1916 and in a Cubist style made a modern painting of a candlestick telephone. Called *Painting I (Telephone),* painted in a Cubist style, it is in the Ferdinand Howald Collection of the Columbus Museum of Art in Columbus, Ohio.

8 Matilda Peet was born August 15, 1825 as Matilda Weaver, the daughter of Lodowick and Matilda Weaver. She married John Melvin Peet July 5, 1877 and was widowed August 13, 1888. She died June 28, 1905. This biographical data was sent to me by Diane R. Brinkmeyer in a letter of June 15, 1989.

9 Undated notes from a conversation with Nan Wood Graham sometime in the late 1970s or early 1980s.

10 Park Rinard, "Return From Bohemia, A Painter's Story, Part I," Master's thesis, University of Iowa, August 1939, 118. On page 98 Rinard calls Mathilda Peet Wood's "maiden aunt." Rinard was very close to the artist and intended to write Wood's official biography. He wrote the first chapter of the biography as his thesis in the University of Iowa's Creative Writing Program but never wrote more of it. Rinard was an elegant writer. He, along with Nan Wood Graham, the artist's sister, offered me a fund of information about the artist; I am indebted to both of them and grateful for their friendship. Graham died in 1990 and Rinard in 2000.

11 The large number of American portrait paintings of elderly peaople in the 1920s and into the 1930s, especially women, needs more investigation. Gertrude Fiske, a New England artist, created a portrait of an aged woman in a long dress seated in a Windsor chair that she called *Spinster.* Painted circa 1920, it is in the Colby College Museum of Art, Waterville, Maine.

12 His earliest testimony as to how much he had come to value Midwestern material culture is in Irma René Koen, "The Art of Grant Wood," *Christian Science Monitor* (26 March, 1932), 6.

13 In the mid- to late 1930s, Wood created a neo-Victorian décor for the clubroom of the Society for the Prevention of Cruelty to Speakers, a room for entertaining speakers at the University of Iowa. He used floral wallpaper and carpet, black walnut furniture, a parlor organ, a marble fireplace and hung chromolithographs and Currier and Ives prints on the wall. See Frank Luther Mott, "The S.P.C.S.", *The Palimpsest* 43 (March 1962), 113–32 and Wanda Corn, *Grant Wood: The Regionalist Vision* (New Haven: Yale University Press in association with the Minneapolis Institute of Arts, 1983), 44–46.

14 Caroline Ticknor, "The Steel-Engraving Lady and the Gibson Girl," *The Atlantic Monthly* 88 (July 1901), 105–108.

15 For a good history of the magazine, see Milton M. Reigelman, *The Midland, A Venture in Literary Regionalism,* (Iowa City: University of Iowa Press, 1975). See also Clarence A. Andrews, *A Literary History of Iowa* (Iowa City: University of Iowa Press, 1972).

16 See, for example, Ruth Suckow's essay advocating a Midwestern school of literature: "Iowa," *American Mercury* 9 (September 1926), 39–45.

17 Clarence A. Andrews in a letter to the author, March 9, 1984.

18 For a collection of reminiscences by writers associated with Midwestern Regionalism, see Clarence A. Andrews (ed.), *Growing Up in Iowa, Reminiscences of 14 Iowa Authors,* (Ames: Iowa State University Press, 1978).

19 At one point the painting was titled, alternatively, *Clothes.* See Grant Wood Scrapbooks, Archives of American Art, Smithsonian Institution, Washington, D.C. 1216/290, 297.

20 See Rinard, *Return from Bohemia*, 83, for a description of young Wood having several Plymouth Rocks as pets. As a child, Rinard wrote, Wood found young chicks so sympathetic that he rubbed "tallow on their wings to relieve sun-burn" when they passed through their "featherless, adolescent stage."

21 Wood made a full-size finished drawing for *Adolescence* in 1933, but he did not get around to making a painting from it until 1940. The preparatory drawing and painting are virtually the same composition. The painting originally included a chicken-wire fence in the foreground, which the artist cut off, in order to make the painting a horizontal composition. See Corn, *Grant Wood*, p. 80, fig. 114.

22 In 1935, The Little Gallery in Cedar Rapids had an exhibition of Currier and Ives prints, some of them borrowed from Jay Sigmund. Adeline Taylor, the very sensitive art critic for the *Cedar Rapids Gazette*, and friend of both Wood and Sigmund, reported that Sigmund owned twenty-five Currier and Ives prints and that critics had found "a certain Currier and Ives' influence in Grant Wood's paintings." Taylor, "Currier and Ives Prints, Now In Their Second Heyday, Depict American Scenes of 75 Years Ago," *Cedar Rapids Gazette* (March 10, 1935).

23 Rinard, *Return from Bohemia*, 16.

24 For fuller treatments of this painting, please see my two earlier essays: Wanda M. Corn, "The Birth of a National Icon: Grant Wood's *American Gothic*," in Moshe Barasch and Lucy Freeman Sandler (eds.), *Art, the Ape of Nature, Studies in Honor of H.W. Janson*, (New York: Harry N. Abrams, Inc., 1981), 749-768; and Corn, "*American Gothic*: The Making of National Icon, in Corn, *The Regionalist Vision*, 128-142.

25 The public reception of *American Gothic* from its first exhibition in 1930 to the present is a complicated story that I am covering in a forthcoming book about the painting. In my own informal surveys of audience response to the work, people define the couple as rural and American but not necessarily from the Midwest.

26 Koen, "The Art of Grant Wood."

27 Letter from Mrs. Earl Robinson of Collins, Iowa, printed in "The Sunday *Register's* Open Forum," *Des Moines Register*, Nov. 30, 1930, in Grant Wood Scrapbooks, 1216/283.

28 Letter from Mrs. Inez Keck of Washta, Iowa, Dec. 14, 1930, in Grant Wood Scrapbooks, 1216/283.

29 Letter from Mrs. Ray R. Marsh of Washta, Iowa, printed in "The Sunday *Register's* Open Forum," *Des Moines Register*, December 14, 1930, in Grant Wood Scrapbooks, 1216/283.

30 The impact of the Flemish painters on Wood's *American Gothic* has so often been noted that I am putting it aside here to underline another influence, that of vintage photography. The Art Institute of Chicago publicity about the painting in 1931 nicely captured several sources, writing that Wood depicted "the figures as faithfully as a daguerreotype would.... The heads are modeled with the careful skill of some Flemish miniature painter while the light, delicate color scheme with its accents of dark pattern reminds one of the series of Florentine portraits executed in the fifteenth century." *Bulletin of the Art Institute of Chicago*, February 1931, in Grant Wood Scrapbooks, 1216/280.

31 Interview with Park Rinard, August 1976. No one that I know of has studied the images of "old maids" that infiltrate Midwestern Regionalism, whether in literature or in the visual arts. A good start in thinking about the subject in other areas of literature is Laura L. Doan (ed.), *Old Maids to Radical Spinsters, Unmarried Women in the Twentieth-Century Novel*, (Urbana and Chicago: University of Illinois Press, 1991).

32 See Ruth Suchow, "Best of the Lot," *Smart Set* 69 (November 1922), 5–36; "Midwestern Primitive," *Harpers Monthly Magazine* 156 (March 1928), 432–42; and "Spinster and Cat," *Harper's Monthly Magazine* 157 (June 1928), 59–68.

33 "The Serpent," *Frescoes*, Boston (1922), 40–42; see also "Hill Spinster's Sunday" in *Jay G. Sigmund: Select Poetry and Prose*, Paul Engle (ed.), (Muscatine, Iowa: Prairie Press, 1939), 19.

34 "An Iowa Secret," *Art Digest* 8 (October 1933), 6. This is the only instance I know of when Wood reportedly referred to the man as "husband"; I suspect this was wishful thinking on the part of the interviewer or editor.

35 The first public statement that Wood's couple was father and daughter appeared in a letter to the editor by Nan Wood Graham in "The Sunday *Register's* Open Forum," *Des Moines Register*, December 21, 1930. She probably was coached by her brother as she says the same kind of things about the father and daughter he would say later: "I am not supposed to be the gentleman's wife, but his daughter. I get my ash blond hair from mother's side of the family: papa keeps a food store—or runs the village post office, or perhaps he preaches in the little church.... Anyhow, he is a very religious person. When he comes home in the evening, our Jersey cow out in the barn starts to moo, and so father takes off his white collar, puts on overalls and an old coat, and goes out to hay the cow...." Mrs. Graham gave a fuller account of Wood's original ideas for the painting in "American Gothic," *Canadian Reviews of Music and Art* 3 (February–March 1941), 11–14. She continued to tell this story for the rest of her life. Arnold Pyle and Park Rinard, two of Wood's closest friends, also explained the couple's relationship as father and daughter in *Catalogue of a Loan Exhibition of Drawings and Paintings by Grant Wood* (Chicago, 1935), 6.

36 Letter from Grant Wood to Mrs. Nellie B. Sudduth, March 21, 1941. Quoted with permission of Marjorie Mills Vandervelde.

37 Donald B. Kuspit was the first modern commentator to write perceptively of the women in *Daughters of Revolution* as "sexually ambiguous, as much men in drag as women with a vestige of the male authority evident in the George Washington pictured behind them." See Kuspit, "Grant Wood: Pathos of the Plain," *Art in America* 72 (March 1984), 141. For the witty comment on Washington in drag, see Karal Ann Marling, *George Washington Slept Here, Colonial Revivals and American Culture 1876-1986* (Cambridge, MA: Harvard University Press, 1988), 346.

38 There is a dark sense of threat in much of Wood's work from 1935 on. See particularly his prints, *July Fifteenth*, *Midnight Alarm*, *Approaching Storm*, *February*, and *March*.

39 Much of my discussion of *Death on Ridge Road* is drawn from my entry on the painting in *American Dreams, American Art to 1950 in the Williams College Museum of Art*, Nancy Mowll Mathews (ed.), (New York: Hudson Hills Press, 2001) 158–161.

Selected Bibliography

Batchelder, Ernest A. *The Principles of Design*. Chicago: Inland Printer Company, 1906.

Batchelder, Ernest A. *Design in Theory and Practice*. New York: McMillan Company, 1930.

Bavaro, Joseph J. and Thomas L. Mossman. *The Furniture of Gustav Stickley: History, Technique, and Projects*. New York: Van Nostrand Reinhold Company, 1982.

Blaugrund, Annette. *The Tenth Street Studio Building: Artist-Entrepreneurs from the Hudson River School to the American Impressionists*. Southampton, NY: The Parrish Art Museum, 1997.

Bockol, Leslie. *Willow Ware: Ceramics in the Chinese Tradition*. Atglen, Penn.: Schiffer Publishing, 1995.

Brown, Hazel E. *Grant Wood and Marvin Cone: Artists of an Era*. Ames, 1972.

Clements, Ralph. *Tales of the Town: Little-known Anecdotes of the Life in Cedar Rapids*. Cedar Rapids: Stamats Publishing, 1967.

Corn, Wanda M. *Grant Wood: The Regionalist Vision*. New Haven: Yale University Press in association with the Minneapolis Institute of Arts, 1983.

Corn, Wanda M. *The Great American Thing. Modern Art and National Identity, 1915–1935*. Berkeley and Los Angeles: University of California Press, 1999.

Corn, Wanda M. "Artists' Homes and Studios: A Special Kind of Archive." *American Art*. University of Chicago Press in association with the Smithsonian American Art Museum, vol. 19, no. 1 (spring 2005).

Cummings, Elizabeth and Wendy Kaplan. *The Arts and Crafts Movement*. London: Thames and Hudson, 1991.

Czestochowski, Joseph S. *Marvin D. Cone and Grant Wood: An American Tradition*. Cedar Rapids: Cedar Rapids Museum of Art, 1990.

Darling, Sharon S. *Chicago Metalsmiths: An Illustrated History*. Chicago: Chicago Historical Society, 1977.

DeLong, Lea Rosson. *Grant Wood's Main Street: Art, Literature and the American Midwest*. Ames: Brunnier Art Museum, University Museums Iowa State University, 2004.

Dennis, James M. *Grant Wood: Still Lifes as Decorative Abstraction*. Exhib. cat. Madison: Elvehjem Museum of Art, University of Wisconsin-Madison, 1985.

Dennis, James M. *Grant Wood: A Study in American Art and Culture*. New York: Viking Press, 1975; revised edition, Columbia: University of Missouri Press, 1986.

Dennis, James M. *Renegade Regionalists: The Modern Independence of Grant Wood, Thomas Hart Benton, and John Steuart Curry*. Madison: University of Wisconsin Press, 1998, 69-89.

Garwood, Darrell. *Artist in Iowa: A Life of Grant Wood*. New York: W.W. Norton & Company, 1944.

Graham, Nan Wood with John Zug and Julie Jensen McDonald. *My Brother, Grant Wood*. Iowa City: State Historical Society of Iowa City, 1993.

Hambidge, Jay. *The Elements of Dynamic Symmetry*. New York: Dover Publications, 1967; first published by Brentano's Inc. in 1926, reprinted from *The Diagonal*, Yale University Press, 1919, 1920.

Hiesinger, Kathryn Bloom. *Art Nouveau in Munich*. Munich: Philadelphia Museum of Art in association with Prestel, 1988.

Kaplan, Wendy. *"The Art that is Life" The Arts and Crafts Movement in America, 1875–1920*. Exhib. cat. Boston: Bulfinch Press/Museum of Fine Arts, Boston, 1987.

Kelly, Francis. *The Studio and the Artist*. New York: St. Martin's Press, 1974.

Kinsey, Joni L. *Plain Pictures: Images of the Prairie*. Washington DC: Smithsonian Institution Press, 1996.

Kinsey, Joni L. *Thomas Moran's West: Chromolithography, High Art, and Popular Taste*. Lawrence: University Press of Kansas in association with Joslyn Museum, Omaha, 2005.

McDonald, Julie Jensen with Joan Liffring-Zug Bourret. *Grant Wood and Little Sister Nan. Essays and Remembrances*. Iowa City: Penfield Press, 2000.

Massey, Anne. *Interior Design of the 20th Century*. London: Thames and Hudson, 1990.

Murray, Janette Stevenson and Frederick Gray Murray. *The Story of Cedar Rapids*. New York: Stratford House, 1950.

Naylor, Gillian. *The Arts and Crafts Movement: A Study of its Sources, Ideals, and Influence on Design Theory*. Boston; MIT Press, 1971.

Rinard, Park. "Return From Bohemia, A Painter's Story, Part I," Master's Thesis, University of Iowa, Iowa City, (August 1939).

Roberts, Brady M., James M. Dennis, James S. Horns, and Helen Mar Parkin. *Grant Wood: An American Master Revealed*. Rohnert Park, Calif.: Pomegranate Artbooks, 1995.

Sanders, Barry, ed. *The Craftsman: An Anthology*. Santa Barbara: Peregine Smith, 1978.

Schawe, Martin. *Alte Pinakothek Munich, Prestel Museum Guide*. Munich, London, New York: Prestel, 1999.

Stickley, Gustav. *Craftsman Homes: Architecture and Furnishings of the American Arts and Crafts Movement*. New York: Dover Publications, 1979; originally published by Craftsman Publishing Company, New York, 1909.

Wood, Grant with Frank Luther Mott, eds. *Revolt Against the City*. Iowa City: Whirling World Series Press, 1935 (reprinted in Dennis, *Grant Wood*, 1975).

Grant Wood Chronology, 1891–1942

1891 Born Grant DeVolson Wood to Maryville and Hattie Weaver Wood on farm near Anamosa, Iowa, February 13.

1901 Father dies; moves with mother, two brothers, Frank (1887–?), John (1893–1935), and sister Nan (1889–1990) to Cedar Rapids, Iowa, 25 miles away.

1905 Submits drawing of oak leaves to national contest and wins third prize.

1910 Graduates from Washington High School, Cedar Rapids.

1911–12 Spends two summers studying metalsmithing and design with Arts and Crafts advocate Ernest A. Batchelder at The School of Design, Handicraft and Normal Art, Minneapolis, Minnesota (now called Minneapolis College of Art and Design); teaches all subjects at one-room school house in Rosedale, Iowa, near Cedar Rapids; collaborates with Kate Loomis in her metal craft studio, using Loom Wood as hallmark.

1912 Attends life-drawing classes of academic painter Charles A. Cumming at State University of Iowa, in Iowa City.

1913 Works at Kalo Silversmiths Shop in Parkridge, Illinois, near Chicago; attends night classes at the School of the Art Institute of Chicago.

1914–15 Opens metalcraft studio Volund Crafts Shop with Kristoffer Haga in Park Ridge, Illinois; exhibits metalwork at Art Institute of Chicago.

1916 Begins day classes at Art Institute of Chicago; returns to Cedar Rapids as mother loses home due to financial troubles; with Paul Hanson builds rustic cottage as temporary home in Cedar Rapids for himself, mother and sister Nan, for whom he is now the primary provider.

1917 Builds Arts and Crafts-style bungalow for the Wood family in Kenwood Heights area of Cedar Rapids with the assistance of his friend Paul Hanson; makes miniature house models for Henry Ely, Realtors.

1917–18 Joins U.S. Army as World War I begins; is stationed in Iowa and Washington, DC; paints camouflage on army artillery.

1919–25 Teaches art at Jackson and McKinley Junior High Schools in Cedar Rapids.

1920 Travels with friend Marvin Cone to Paris in summer; resumes teaching; holds his first art exhibition at Killian Company, a furniture store, together with Marvin Cone.

1921 Completes large commission, *First Three Degrees of Free Masonry*, Cedar Rapids.

1922 Directs student art project, *Imagination Isle Frieze* with students; makes *Mourners' Bench*; completes outdoor mural *Adoration of the Home*, commissioned for Henry Ely's downtown office.

1923–24 Takes leave of absence from teaching and travels to attend Académie Julian in Paris; works in Sorrento, Italy during winter and holds exhibit at the Hotel Coccumello.

1924 Commissioned by David Turner to convert and decorate Sinclair mansion into a funeral home; Turner offers him the carriage house/hayloft to convert into studio; begins to fashion the second-floor interior into studio, "No. 5 Turner Alley."

1925 Further adapts No. 5 Turner Alley into living quarters; receives large commission by dairy equipment manufacturer, J. G. Cherry; resigns teaching job; earns income from decorating projects, commercial commissions for graphic design, teaching informal outdoor sketching classes and employment at True-Art; continues easel painting.

1926 June and July exhibits in Paris at Galerie Carmine and at Cedar Rapids Carnegie Public Library; receives commission for *Iowa Corn Room* murals from Eppley hotel company, for the Hotel Montrose, Cedar Rapids; conducts art classes and holds exhibit at Turner Mortuary.

1927 Receives commission from the City of Cedar Rapids for stained-glass window at Veterans Memorial Building, Cedar Rapids; begins full-scale cartoons for the window.

1928 Travels to Munich, Germany for three months to oversee fabrication of Veterans Memorial window; begins *The Portrait of John B. Turner, Pioneer*; The Little Art Gallery opens with funding from Carnegie Foundation and the American Federation of the Arts and Edward Rowan is appointed as director.

1929 Veterans Memorial window is installed; completes portrait of his mother, *Woman with Plants* and exhibits it at the 42nd Annual Exhibition of American Painting and Sculpture at the Art Institute of Chicago; designs rose window at Turner Mortuary; awarded prize for portraiture at Iowa State Fair for his painting, *John B. Turner, Pioneer*; decorates the Submarine Sweet Shop in Waterloo; receives interior decoration commissions for several Cedar Rapids homes, including the residences of the Hamilton, Van Vechten-Shaffer, and Stamats families.

1930 Discovers *American Gothic* house in Eldon, Iowa; paints and exhibits *Stone City, Iowa,* and *American Gothic*, and for latter wins Norman Walt Harris Bronze Medal at the 43rd Annual Exhibition of American Painting and Sculpture at the Art Institute of Chicago; sells *American Gothic* to AIC for $300; The Little Gallery, Cedar Rapids, holds celebratory reception; wins first prize for portraiture and landscape, *Stone City, Iowa*, at Iowa State Fair.

1931 Exhibits *Appraisal* and *Woman with Plants* at 126th Annual Exhibition at the Pennsylvania Academy of Fine Arts, Philadelphia; exhibits *Midnight Ride of Paul Revere* at 44th Annual Exhibition of Painting and Sculpture at Art Institute of Chicago; completes *The Birthplace of Herbert Hoover*, *Fall Plowing*, *Arnold Comes of Age*, *Victorian Survival*.

1932 Helps establish Stone City Art Colony, a summer art program 35 miles from Cedar Rapids and near his boyhood home; begins Robert Armstrong house with Bruce McKay, Cedar Rapids; installs *Fruits of Iowa* murals in Hotel Montrose dining room (commissioned in 1931); exhibits *Arbor Day* and *Victorian Survival* at Exhibitions of Modern American Paintings at the Carnegie Institute, Pittsburgh, Pennsylvania; shows *Daughters of Revolution* at First Biennial Exhibition of Contemporary American Painting at the Whitney Museum of American Art, New York; draws *Study for Self-Portrait* (wearing bibbed overalls); fire in studio injures Wood and sister Nan.

1933 Appointed Director of Public Works of Art Projects in Iowa and Associate Professor of Fine Arts at the University of Iowa, Iowa City (then called State University of Iowa); continues at Stone City Art Colony in the summer; attracts fellow Regionalists John Steuart Curry, Thomas Hart Benton, as well as younger artists whom he hires for work on the PWAP; meets art critic Thomas Craven; establishes Society for the Prevention of Cruelty to Speakers at the University in Iowa City and decorates club room in neostyle Victorian manner; *Daughters of Revolution* is included in the 31st Annual International Exhibition of Paintings at the Carnegie Institute, Pittsburgh; paints *Portrait of Nan*.

1934 Becomes a permanent member of the faculty at the University in Iowa City (Department of Plastic and Graphic Arts); works on murals for the Iowa State University library in Ames; lectures and promotes Regionalism and establishment of regional art centers; paints *Dinner for Threshers*; is proclaimed one of the leading artists in America by *Time* magazine, whose cover story "celebrates the Regionalist 'opposition' to 'outlandish' European modernism as a 'turn in the tide of artistic taste in the U.S.'"

1935 Marries Sara S. Maxon, a former Cedar Rapidian and singer; buys mid 19th-century home in Iowa City, begins to renovate it and moves to Iowa City; Hattie Weaver Wood dies; writes treatise *Revolt Against the City*; signs with agent to go on lecture circuit; receives author's contract and begins to draft an autobiography, *Return from Bohemia* (never completed); exhibits at Lakeside Press Galleries, Chicago, and Ferargil Galleries, New York.

1936 Receives commission for book illustrations for Madeleine Durrough Horn's children's book *Farm on the Hill*.

1937 Focuses on commercial projects: book illustrations, prints, decorative arts; begins to print and sell his lithographs through Association of American Artists; creates illustrations for special edition of Sinclair Lewis' *Main Street*, published by Limited Edition Club.

1938 Separates from Sara Maxon Wood.

1939 Divorces Sara Maxon Wood; completes lithograph series for Associated American Artists; paints *Parson Weems' Fable*; Park Rinard writes first chapter of Wood's autobiography, *Return from Bohemia, A Painter's Story, Part I*, as his Master's thesis, University of Iowa.

1940 Wood's curriculum and subject matter are questioned at University; takes sabbatical from teaching; lectures extensively in and outside Iowa.

1941 Appointed Professor of Fine Arts and given new studio at University of Iowa; works during summer at Clear Lake, Iowa; paints his last two works *Spring in Town* and *Spring in the Country*; enters University hospital for surgery.

1942 Dies of pancreatic cancer in Iowa City, one day before his 51st birthday; as a memorial to him, 48 of his works are shown at the 53rd Annual Exhibition of American Painting and Sculpture at Art Institute of Chicago.

Compiled by Deba Foxley Leach

Index

Index compiled by Hazel K. Bell

The Authors

A scholar of late 19th- and early 20th-century American art, **Wanda M. Corn** is the Robert and Ruth Halperin Professor in Art History at Stanford University. She is the author of *Grant Wood: The Regionalist Vision* (1983) and *The Great American Thing: Modern Art and National Identity, 1915–35* (1999), and is presently writing a book about Grant Wood's *American Gothic*.

James M. Dennis, Emeritus Professor of Art History, University of Wisconsin-Madison, has contributed to the understanding and appreciation of midwestern Regionalism, especially of Grant Wood, in two books and various articles. His *Grant Wood, A Study in American Art and Culture* (1975) received a Distinguished Service Award from The Society of Midland Authors, Chicago. His *Renegade Regionalists: The Modern Independence of Grant Wood, Thomas Hart Benton, and John Steuart Curry* (1998) is available in its third printing.

Joni L. Kinsey is Associate Professor of Art History at the University of Iowa where she teaches American Art. She is the author of numerous articles and several books including *Thomas Moran and the Surveying of the American West* (1992), *Plain Pictures: Images of the American Prairie* (1996), *The Majesty of the Grand Canyon: 150 Years in Art* (1998), and *Thomas Moran's West: Chromolithography, High Art, and Popular Taste* (2005).

Deba Foxley Leach is an independent curator based in Washington D.C. and Iowa City. She was founding director of Foxley/Leach Gallery (later the Carega Foxley Leach Gallery), in Washington, D.C., and has curated numerous exhibitions of contemporary art. In conjunction with her work on the exhibition, *Jacob Lawrence: The Great Migration*, for the Phillips Collection in Washington, D.C., she wrote, *I See You/You See Me: The Young Life of Jacob Lawrence*. On-site curator for the exhibition, *Grant Wood at 5 Turner Alley* at the Cedar Rapids Museum of Art, she is author of the children's book, *Grant Wood: The Artist in the Hayloft*, published together with this book.

Jane C. Milosch is curator at the Renwick Gallery of the Smithsonian American Art Museum, Washington, D.C., and guest curator of the exhibition, *Grant Wood at 5 Turner Alley*. Formerly a curator at the Cedar Rapids Museum of Art, Davenport Museum of Art, and the Detroit Institute of Arts, she has published and lectured on 20th-century and contemporary American decorative arts and worked as an independent curator and editor in Munich, Germany.